Andy Warhol

ANDY WARHOL

by John Coplans
with contributions by Jonas Mekas and Calvin Tomkins

NEW YORK GRAPHIC SOCIETY LTD

International Standard Book Number 0-8212-0397-5
Library of Congress Catalog Card Number 78-115841
Book Design by John Coplans.
Printed in England by The Curwen Press.

Preface

Andy Warhol, like Marcel Duchamp, is a cultural phenomenon. As artists, neither figure belongs to the world of art alone, and neither can be regarded as developmental. They are visionaries — prophetic and radical in their approach to art and their ability to intensify the art dialectic of their times with deliberate, incisive strokes. But in a way that Duchamp never did, Warhol has actively engaged the fascination of the public; he has become a leading symbol and shaper of the very culture he so coolly reflects in his art; he has made his own person and personality a part of the body of his work.

It was Duchamp who first promoted the common object to the status of art. In deflating art Duchamp paradoxically extended the esthetic framework of its boundaries. Obviously, Warhol has been profoundly touched by Duchamp, whom he later knew. Several anomalous paintings of Leonardo's *Mona Lisa* — this time *sans* beard and moustache — appear early in his work, as if Warhol, suddenly realizing what his art is (or will be) all about, pauses to nod his acknowledgment to Duchamp. At the time of Duchamp's death Warhol was engaged in making a film on Duchamp — a project that he unfortunately didn't finish.

The openness of the Los Angeles scene, combined with the natural marriage (if such a term may be used in this context) of Hollywood and the pop environment so definitive of the area, has provoked a deep interest from the art audience in both Duchamp and Warhol as well as in pop art in general. Warhol's first exhibition of 32 canvases of Campbell's soup cans was organized by Irving Blum at the Ferus Gallery in Los Angeles in 1962. Only later that year (and primarily as a consequence of this exhibition) was Warhol's work exhibited in New York. Again in 1962, under the title of "The New Painting of Common Objects," Walter Hopps, then director of the Pasadena Art Museum, organized the first museum exhibition of American pop art, in which he included Warhol, Roy Lichtenstein, Jim Dine and three Los Angeles artists — Joe Goode, Ed Ruscha and Phil Hefferton. In 1963 Hopps organized at the Pasadena Art Museum the first retrospective of Duchamp. In continuation of this general interest in pop art the museum also organized in 1967 the first retrospective exhibition of Roy Lichtenstein, which traveled to Europe. This was followed a year later by another retrospective exhibition, of the Northern California painter of foodstuffs, Wayne Thiebaud.

The occasion for this book is a large exhibition of Warhol's art organized by the Pasadena Art Museum; the exhibition will subsequently travel to Chicago (Museum of Contemporary Art), Holland (Stedelijk van Abbemuseum Eindhoven), Paris (Musée d'Art Moderne de la Ville de Paris), London (Tate Gallery) and finally, New York (Whitney Museum of American Art). Not all the works reproduced will be included in the exhibition, which at the request of the artist concentrates on the Campbell's soup cans, the portraits, the disasters, the flowers and the Brillo boxes. The book sets out to provide the reader through the accompanying illustrations a viewing of a broad spectrum of Warhol's painting and sculpture, especially from 1960 to 1964, by which time the artist had already begun to shift his interest to movies. A number of still shots of his movies are included among the illustrations. The essays by the various authors have been chosen to cover three principal but divergent aspects of Warhol, each of which has equally caught the public's imagination — the man, the art and the movies. In addition, there are a selective bibliography of published writings on Warhol's art, and a filmography.

I am deeply grateful to the many people who have helped in the preparation of this book. David Whitney has been more than cooperative in hunting down and verifying information on Warhol. Irving Blum has made many useful suggestions, and has also personally involved himself in the preparation of the book. He, along with Leo Castelli, Ileana Sonnabend, Elinor Ward and Felice Wender have graciously placed their respective gallery records at my disposal and have provided many of the photographs. Calvin Tomkins and Jonas Mekas have contributed perceptive essays. Mr. Mekas has also gone to extraordinary trouble to research the extensive filmography. Jane Gale Salzfass has provided her usual, unfailingly competent art bibliography. Lastly, I am deeply indebted to Dr. Shirley Blum, who assisted me by suggesting profitable lines of thought on the development of Warhol's art; to Peter Nelson for his help in editing; and to Barbara Haskell, who assisted in research and book production.　　　　—J.C.

Contents

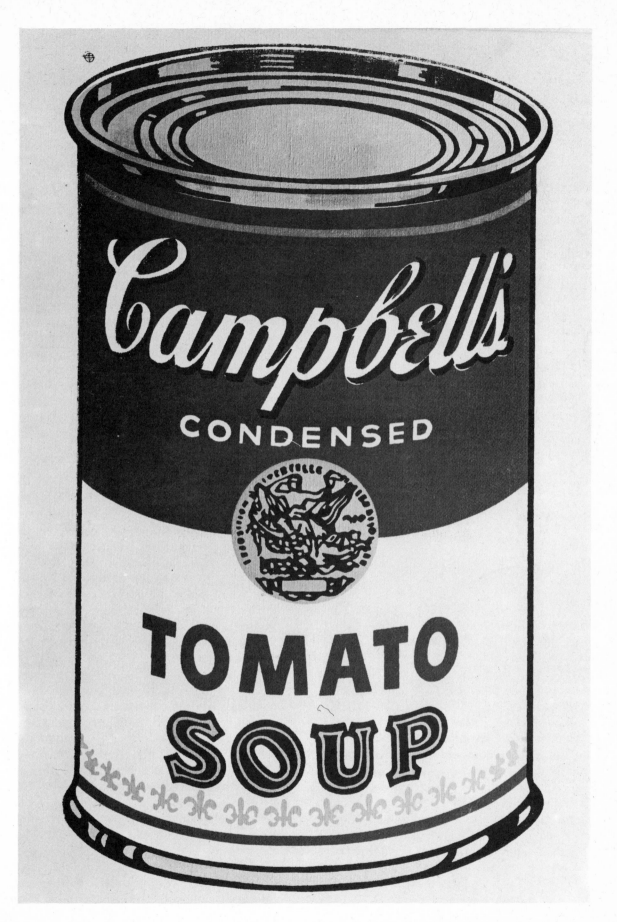

Campbell's Soup Can, 1965. 36 x 24″ (91.5 x 61 cm)
Collection the artist

Raggedy Andy

I'D PREFER TO REMAIN A MYSTERY. I NEVER GIVE MY BACKGROUND, AND ANYWAY, I MAKE IT ALL UP DIFFERENT EVERY TIME I'M ASKED.

There is a snapshot of him at the age of fourteen, taken in one of those do-it-yourself booths in a bus station. The features are delicate and well formed, the expression trusting, angelic. Time treated him unfairly. His face grew coarse, Slavic, with a fleshy nose and narrow eyes weak as a mole's. And of course the famous pallor—an almost total absence of pigmentation, the result of a childhood disease that may have been rheumatic fever although his mother's reference to "nervous fits" suggests other causes. In spite of time's jokes, though, the face of that beautiful fourteen-year-old is instantly recognizable.

The first year Andy came to New York he lived with a whole group of boys and girls in a basement apartment at 103rd Street and Manhattan Avenue. This was in 1949. Everybody did something interesting or planned to— studied dance, painted, wrote, made jewelry. Andy was very much the baby of the family. Although he may or may not have been nineteen at the time (his birth date varies each time he is asked) he seemed even younger. And so shy—he rarely spoke at all. One of the girls in the apartment remembers getting so mad at Andy for not talking to her that she threw an egg and hit him in the head with it. They all had a lot of fun, sharing food and money and clothes and being such good friends—there was no sex involved. They went to the movies a lot, and had a communal crush on Judy Garland. When one of her films played the neighborhood Loew's they all saw it six times.

Andy had no money at all then. Lila Davies, who went through the art school at Carnegie Tech with him and who brought him into the Manhattan Avenue kibbutz, knew that he came from very poor people. Andy's father, a coal miner and part-time construction worker, had come over from Czechoslovakia in 1912 to make his fortune, but fortunes were elusive even in America and it had been nine years before he was able to send back for his wife. Their name was Warhola—Andy shortened it when he came to New York. Andy had two older brothers who had stayed in Pittsburgh, where they all grew up. Not even Lila knew where the money had come from to send Andy through Carnegie Tech. The father had died in 1941, and for a while after that Andy had worked part time in the five-and-ten and sold vegetables from a truck. He occasionally mentioned his mother and his two brothers, but never his father.

To the others in the apartment Andy seemed unbelievably naive—so innocent that you felt the need to protect him. He spent a lot of his time in the apartment, drawing. Andy had worked out an unusual technique. He would sketch with a pencil until he got what he wanted, then copy the sketch very rapidly in ink on tissue and press the tissue down on watercolor paper before the ink dried. The result was a blotted, broken line that looked spontaneous and fluid and, oddly enough, highly sophisticated. Now and then Andy would take his drawings around to magazines and advertising agencies. He couldn't afford a portfolio, so he took them around in a brown paper bag from the A & P.

One day he took his paper bag into the office of Tina Fredericks, who at that time was art director of *Glamour*. She was intrigued both by the drawings and by Andy, pale and shy and a little forlorn in his old chino pants and dirty sneakers, looking not quite of this earth. She told him the drawings were good, but that what *Glamour* really needed at the moment was drawings of shoes. Andy came back the next day with fifty shoe drawings in the brown paper bag. *Glamour* eventually used several of them, and this led to his first commission from I. Miller. For the next few years I. Miller was Andy's meal ticket. Nobody had ever drawn shoes the way Andy did. He somehow gave each shoe a temperament of its own, a sort of sly, Toulouse-Lautrec kind of sophistication, but the shape and the style came through accurately and the buckle was always in the right place. The kids in the apartment noticed that the vamps on Andy's

shoe drawings kept getting longer and longer, but I. Miller didn't mind. I. Miller loved them.

Andy never seemed to be working terribly hard. When his eyes began bothering him, though, Tina made him go to an oculist, who told him he had "lazy eyes" and prescribed rather grotesque glasses to strengthen the muscles —the lenses were opaque, with a tiny pinhole to see through. To everyone's surprise Andy wore them dutifully when he was working and a lot of the time when he was not. It began to occur to the others that Andy worked pretty hard, at that. Still, he wasn't what you'd call ambitious, although he did have this thing about famous people. He was always writing to movie stars to get their autographs. He wrote a letter to Truman Capote once, asking if he could illustrate *Other Voices, Other Rooms* (Capote did not answer), and then he had some wild idea about movie stars' underwear, that you could go into business selling underwear that had been worn by the stars, it would cost five dollars washed and fifty unwashed. But all that was just fun and games, and you didn't take it seriously when Andy said that *he* was going to be famous, himself. Andy was so naive, so out-of-this-world, so fragile. The kids in the apartment would have done anything to shield him from the hard, aggressive urban rat race.

MONEY DOESN'T WORRY ME EITHER, THOUGH I SOMETIMES WONDER WHERE IS IT? SOMEBODY'S GOT IT ALL!

Fritzie Miller felt that her husband, a commercial artist, was not getting the attention he deserved from his agent, so she said "Why don't you let me take your stuff around?" and he said "All right, why don't you?" Her husband and a couple of friends were her first clients. One day in the 1950s, soon after she started out as an agent, she went in to see an art director named Will Burton. In Burton's office when she arrived was a slender boy in paint-splattered clothes, holding a hand-painted Easter egg. The egg was a present for Burton. "Andy, meet Fritzie," Burton said. "You need her."

They never did sign a formal contract. In fact, a month or so after this first meeting Andy called Fritzie in great agitation and said that a friend of his, who in the past had taken his stuff around to the agencies, had just returned from Europe and was very angry with Andy for getting an agent. Andy was worried that his friend might be planning to beat him up. The group in the Manhattan Avenue apartment had broken up by this time because the building was being torn down. Andy had moved into a cold water flat in the East Seventies with his mother, who had come to New York to visit him one day and just stayed on, and he was subject to a lot of anxieties. "Listen, Andy, forget it," Fritzie told him. "You don't owe me anything." But a month later Andy called up again and said he wanted Fritzie to represent him, and that's what happened.

Andy was still doing shoes for I. Miller, and quite a few other things. He designed stationery for Bergdorf-Goodman,

Christmas cards for Tiffany's and Tiber Press, and record jackets for Columbia Records. For a brief period he drew the little suns and clouds in the weather chart on an early-morning television program—only his hand was visible on screen, but he had to get up at five a.m. and go to the studio to have his hand made up because otherwise it looked too white. He took any job he was offered, and everything he did was done professionally and stylishly and on time.

Fritzie got him into the big women's magazines, first *McCall's* and *The Ladies' Home Journal,* and later into *Vogue* and *Harper's Bazaar.* A lot of people in the industry began to notice Andy's magazine work. Whatever he illustrated—shampoo or bras or jewelry or lipstick or perfume, there was a decorative originality about his work that made it eye-catching. It was amazing, Fritzie thought, how someone with Andy's background could hit the right note so unerringly. The childish hearts and flowers and the androgynous pink cherubs that he used were not quite what they seemed to be, there was a slight suggestiveness about them that people in the business recognized and approved. He could kid the product so subtly that he made the client feel witty.

Andy never wore anything but old clothes. He would show up at *Vogue* or *Bazaar* looking like some street urchin in his torn chinos and dirty sneakers—Raggedy Andy—and the editors and art directors found this irresistible. Imagine coming in here looking like that! Actually he was starting to make quite a lot of money—enough at any rate to rent a duplex on Lexington Avenue between 33rd and 34th Street, directly above a bar called Florence's Pinup. Andy and Mrs. Warhola had their living quarters on the lower floor of the duplex. Andy bought some furniture and other objects from Serendipity, but the place never really got to look furnished because Andy was always too busy. He was out all day and half the night, taking art directors to lunch at expensive restaurants, keeping appointments, going to parties. Andy went to all kinds of parties, even the ones given by somebody's secretary, because you could never be sure who you'd meet or what it might lead to. Shy, inarticulate Andy, using his shyness and inarticulateness to superb effect, made a lot of contacts that way; a lot of people found him charming, and somehow fascinating. He hardly ever got home until past midnight, and then he would spend the next three or four hours working. Luckily he had a quick technique, could sketch a whole layout in a couple of hours. He worked on the top floor of the duplex, in a large, incredibly littered room. Magazines and newspapers and clothes and half-full coffee containers and swatches of this and that and discarded drawings and unanswered mail, etc., etc., piled up in drifts on the floor, providing sport and concealment for Andy's cats. There were eight cats, all named Sam. Nathan Gluck, a designer who came in part time to help with layouts, occasionally tried to clean the place up a little, but it was hopeless. The cats lived there. The smell was something.

Through Emile de Antonio, a dropout college English teacher who knew everybody and made a sort of living

then by putting artists and other talents in touch with people who could help them (he is now a film-maker), Andy went to see Eugene Moore at Bonwit's. Gene Moore, one of New York's little-known geniuses, was then in charge of window display there and also at Tiffany's, and he made a point of using serious young artists to do window decoration —Robert Rauschenberg and Jasper Johns supported themselves this way for several years during the Fifties. According to Moore, Andy was unfailingly cooperative. "He worked hard and made it seem easy," Moore remembers. "On the surface he always seemed so nice and uncomplicated. He had a sweet, fey, little-boy quality, which he used, but it was pleasant even so—and that was the quality of his work, too. It was light, it had great charm, yet there was always a real beauty of line and composition. There was nobody else around then who worked quite that way."

Dan Arje, who took over the display department at Bonwit's when Moore went to Tiffany's full time, was equally enthusiastic about Andy. Andy was a real pro. He understood deadlines, and where other artists might freeze up under the pressure of having to do a window in two or three evening hours Andy would just come in and go right to work, painting freehand on the inside of the glass his witty and whimsical images—cherubs, pincushions, ice-cream fantasies. Once he built a wood fence out of scrap lumber and decorated it with graffiti and flowers and suns and the kind of stick people that kids draw. The mannequins looked fab against it.

Andy never stopped pushing. Every week or so, the art directors and fashion editors and display people would get some little reminder—a wash drawing of butterflies in candy mint colors, for example, or a fanciful shoe on gold paper, just in case you forgot that Andy was around. He was furious when other illustrators started to imitate his blotted line and his cherubs. Gene Moore and others explained to him that he had to expect this, anybody with talent was bound to have imitators, but Andy didn't like it a bit. He seemed to want all the accounts, all the windows, all the business. Was it the memory of his grim childhood that drove him? "He does love money," Fritzie Miller conceded. "Not for himself, though—for what he can do with it."

But what was he doing with it?

I DELIGHT IN THE WORLD, I GET GREAT JOY OUT OF IT, BUT I'M NOT SENSUOUS.

Can that be Andy? In chinos and sneakers, a handkerchief knotted at the four corners of his head to ward off the sun, stepping gingerly around the ruins of Angkor Wat? Accompanied by Floyd Davis, the well-known *Saturday Evening Post* illustrator, and Gladys Rockmore Davis, the well-known Floyd's even better-known wife?

Andy and his friend Charles Lisanby are going around the world. Lisanby, who designs sets for television and is an inveterate traveler, happened to mention that he was thinking of such a trip, and Andy, who had never been anywhere except Pittsburgh and New York and perhaps Philadelphia (where he may or may not have been born), said "Gee, can I come?" Lisanby was delighted. He and Andy had met at a party the year before, and taken an immediate liking to one another. As is the case with so many New Yorkers who come from somewhere else, Lisanby, who was born on a farm in Kentucky, had the easy assurance and polish that Andy so much admired; Lisanby was fascinated by Andy's oddness, by the contrast between his naiveté and the extraordinary sophistication of his work. They left in June 1956, flying first to San Francisco and then out to Japan.

Lisanby planned the trip. From Japan they went to Hong Kong, Formosa, Djakarta and Bali, and then to Cambodia where they met the Davises. Andy did a lot of sketching. He seemed interested most of the time, although not what you'd call thrilled about anything; he particularly liked the gold-and-black-lacquer work they saw in Bangkok. After Angkor Wat they went on to India. Lisanby wanted to go up to Nepal, which had recently been opened to tourists, but just before they were to go there he came down with a fever. An Indian doctor pumped him full of antibiotics, but the fever hung on and so instead of going to Nepal they booked tickets on a plane to Rome.

It was August by this time. As their plane came down for a landing at Cairo airport, they looked out the window and saw a great many tanks and soldiers and machine guns ringing the perimeter, and no one was permitted to disembark. Both Andy and Lisanby were quite surprised to learn, later, that there had been some sort of international crisis over Suez and that they had landed right in the middle of it.

At Rome they stayed in the Grand Hotel until Lisanby had fully recovered. Lisanby kept urging Andy to go out and see the sights, but Andy didn't feel like going out alone; he seemed quite content to stay in the hotel. When they got to Florence, though, Lisanby, who had been there several times, insisted on Andy's going into every church and museum, and Andy seemed to enjoy that. Andy's reactions to art were never very verbal. Faced with a Titian or a Botticelli he might produce a mild "Wow!" or "Great," but that would be the end of it. Lisanby once asked him what he really wanted out of life, and Andy replied, rather memorably, "I want to be Matisse." Lisanby interpreted this to mean that he wanted to be as famous as Matisse, so that anything he did would instantly become marvelous. Fame was certainly very much on his mind.

From Florence they went to Amsterdam for a week and from there they flew directly home, stopping neither in Paris nor London.

THE ARTIFICIAL FASCINATES ME, THE BRIGHT AND SHINY.

The boys at Serendipity were helping Andy decorate the apartment over Florence's Pinup. Serendipity, which was partly a restaurant and partly a shop, catered to the kind of taste that had not yet been identified as camp. It had

Tiffany glass before people were buying Tiffany glass. Andy bought a Tiffany lamp and some bentwood chairs, and a great long soft couch, and a lot of white wicker furniture, and from other shops on Third Avenue he picked up some American antiques. He had also started to buy pictures—a Magritte, some Miró lithographs, things like that. One of his friends from this period described the apartment's style as "Victorian Surrealist."

Serendipity carried Andy's work. The original drawings for his I. Miller shoe ads were for sale there, and so were the drawings of imaginary footgear that he had taken to designing, fantastically ornate boots and slippers "dedicated" to famous personalities such as Truman Capote, Julie Andrews, Zsa Zsa Gabor, and James Dean. Serendipity also carried Andy's books. The first of these was called *25 Cats Named Sam and One Blue Pussy.* Andy did the drawings, had them printed and bound, then got his friends to come in and help hand-color them. After the cat book came *The Gold Book,* a collection of Andy's blotted-line drawings of friends, flowers, shoes, etc., on gold paper (the idea came from the gold lacquer work he had seen in Bangkok). Then there was *In the Bottom of My Garden* (slightly suspect cherubs), and *Wild Raspberries,* a joke cookbook with Suzie Frankfurt's recipes for dishes like "Salade de Alf Landon" and "Seared Roebuck." The recipes in the cookbook were written out in longhand by Andy's mother. Mrs. Warhola, who could barely speak English, could not write it at all, but Andy liked her handwriting and so he would give her the text and have her copy it letter for letter, laboriously, missing or transposing a letter here and there, which always delighted Andy all the more. Serendipity also had a book called *Holy Cats* that really was by Andy's mother—she did the drawings herself, as well as the captions, the rather risqué innuendoes of which she probably did not catch.

Andy's friends all thought Mrs. Warhola was fabulous. Although her English never improved very much she was cheerful and sweet, and she liked all of Andy's friends. Some of his friends thought it a shame that Andy didn't let his mother come to the parties that Serendipity gave whenever one of his books appeared. Even when he had a show of his gold shoe drawings in 1959 at the Bodley Gallery, a few doors down from Serendipity's new store on 60th Street, Andy's mother didn't come to the opening. Mrs. Warhola never seemed to mind. She was happy taking care of Andy, and seeing to it that he went to Mass every Sunday. Once, when Andy talked about going somewhere in an airplane, Mrs. Warhola got very upset. "Too many big shot die in the air," she said. Mrs. Warhola knew Andy was a big shot.

I NEVER WANTED TO BE A PAINTER. I WANTED TO BE A TAP DANCER.

In the late Fifties, the fashion crowd started to take an active interest in the New York art scene. This was not without precedent, but it was a change from the recent past. Through-out the heroic period of American art in the Forties and early Fifties, the era that saw New York painting achieve international fame and influence, the artists had kept pretty much to themselves, fighting private battles and forging private myths. *Vogue* and *Harper's Bazaar* had duly noted the emergence of the New York School, had posed their mannequins against abstract expressionist, dripped-paint backdrops and informed their readers that "people are talking about" Pollock and de Kooning, but there had been no real interaction between the worlds of art and fashion. Now, however, a new spirit was coming into vanguard art. Rauschenberg and Johns had broken out of the abstract expressionist net. Rauschenberg's paintings, which incorporated everyday images from the urban environment and actual everyday objects such as coke bottles and street signs, had opened the way for a whole generation of artists who tended to look out at the world rather than in upon their own reactions to it. Magazines like *Life* and *Newsweek,* discovering that art was news, had begun to devote considerable coverage to the New York art scene, and in doing so had helped to swell the public that was already flocking in ever-increasing numbers to galleries and museums. Art was *in.* The fashion crowd, which knew Rauschenberg and Johns as display artists, realized with a slight start that people really *were* talking about Rauschenberg and Johns.

No one realized it more keenly than Andy. "Jasper is such a star," Andy would say, wistfully, to Emile de Antonio. It bothered Andy that Rauschenberg and Johns, who were also friends of de Antonio's, seemed to have no interest in becoming friends of his. Andy often asked very naive questions, and he couldn't resist asking de Antonio ("Dee") why Bob and Jap didn't like him. Dee said that among other things, they felt Andy was too frigging commercial. Bob and Jap took only enough window display jobs to pay the rent on their studios. They clearly did not consider the drawings that Andy showed at the Bodley and at Serendipity essentially different from his commercial work, for which he made close to fifty thousand a year.

De Antonio's wife could not imagine what her husband saw in Andy. To her Andy was just a silly little boy. Behind the innocence and the naiveté, though, de Antonio thought he could discern an iron streak. "Andy was blindingly ambitious," he said. "I was sure he was going to make it, although not necessarily in art—he could have made it in just about anything he tried."

Q. *DO YOU THINK POP ART IS—?*
A. *NO.*
Q. *WHAT?*
A. *NO.*
Q. *DO YOU THINK POP ART IS—?*
A. *NO. NO, I DON'T.*

Andy called up Charles Lisanby one day in 1962. "Listen," he said, "there's something new we're starting, it's called pop art, and you better get in on it because you can do it,

too." Lisanby thought Andy was putting him on. Oddly enough, the whole thing happened so fast that Andy himself almost didn't get in on it.

For the past two years Andy had been more and more intrigued by the art scene. He went around to the galleries with his friend Ted Carey, and occasionally they bought things—paintings by Robert Goodnough and Larry Rivers, a Jasper Johns drawing of a light bulb, a double portrait of themselves by Fairfield Porter. Andy wouldn't buy anything if he thought it was too expensive—in fact, if you ask him today what impressed him about the Johns drawing he will say it was the price: "I couldn't understand how he could get five hundred dollars for a drawing. Even Picasso didn't get that much, did he?" Andy decided against a small Rauschenberg collage that Carey wanted to buy because it cost $250. "I could do that myself," Andy said.

"Well," said Carey, "why don't you?"

Andy lost the I. Miller account about this time. A new art director had come in and decided to change the I. Miller image, and since Andy was totally responsible for the image that meant bye-bye Andy. His income dropped a little as a result, although he was still making more than almost any other illustrator in the business. Andy had started to make some friends in the art world, though, and to see correspondingly less of his friends in the commercial field. Some time in 1960, he did a series of paintings that had no apparent relation either to his commercial work or to the drawings for his books. The new pictures were based on comic strips—Popeye, Superman, The Little King, Dick Tracy. They were painted in the broad, crude style of the originals, from which he would select some detail and present it on a greatly enlarged scale. He also did two large paintings of Coca-Cola bottles. One of them showed a pure, literal, unadorned Coke bottle, greatly enlarged, while the other had a lot of abstract expressionist hashmarks—dripped paint and agitated brushwork—at the bottom. Andy asked de Antonio which of the Coke bottle paintings he like best, and Dee said the unadorned one, absolutely.

Some of Andy's friends from the commercial field didn't like the new paintings at all. They couldn't understand why he had chosen those images, and said there was nothing of Andy in them. What bothered Andy more than his friends' opinions was that he could not get a gallery to show the pictures. For a while he toyed with the idea of renting the Bodley again, but renting was so expensive, and anyway it no longer seemed like the thing to do. By this time Andy was feeling pretty depressed.

Several factors had contributed to his depression. From Ivan Karp, the associate director of the Castelli Gallery, he had learned about Roy Lichtenstein's comic strip paintings. Lichtenstein had done some paintings based on Nancy and Sluggo and Mickey Mouse, among others, and Ivan and Leo Castelli and Andy himself agreed that Lichtenstein's were much more authoritative than Andy's. Soon after this Andy also learned for the first time about James Rosenquist, whose pictures were made up of greatly enlarged

details of common objects—one of them featured a Seven-Up bottle.

Pop art, in fact, was just about to burst upon the scene. Claes Oldenburg's plaster replicas of food and merchandise were shown at his "Store" on East 2nd Street during the winter of 1961-1962. Jim Dine's necktie paintings, George Segal's plaster castings, Lichtenstein's comic strips had been discovered by the newsmagazines, and the artists involved, who in most cases had not previously known one another or been aware of each other's work, found themselves the leaders of the most swiftly recognized and efficiently promoted art movement in history. Almost before the older generation of artists and critics could get around to registering their disapproval, pop had established an impregnable beachhead and set about colonizing the natives. But where was Andy? Leo Castelli liked his work, but Castelli had already taken Lichtenstein into the gallery and he was reluctant to take on another artist who seemed at the moment so similar. Richard Bellamy, the other leading promoter of pop, had taken Oldenburg, Rosenquist, and Tom Wesselmann into the Green Gallery; he, too, balked at Warhol. Andy's paintings were all over town— Castelli, Bellamy, Allan Stone all had a few in the back room—and in the summer of 1962 Andy's comic strip pictures were even seen briefly in the window of Bonwit's annex on 57th Street. But nobody was buying them.

Andy was desperate for ideas. "What'll I do next?" he kept asking his new art world friends. Ivan Karp and Henry Geldzahler, a young curator at the Metropolitan who was taking an especially active interest in new artists, had urged Andy to develop images that were not being used by anyone else, but he couldn't think of any. One evening early in 1962, in the apartment over Florence's Pinup, Muriel Latow told Andy that she had an idea but it would cost him money to hear it. Muriel ran an art gallery that was going broke. "How much?" Andy asked her. Muriel said fifty dollars. Andy went straight to the desk and wrote out a check.

"All right," Muriel said. "Now, tell me, Andy, what do you love more than anything else?"

"I don't know," Andy said. "What?"

"Money," Muriel said. "Why don't you paint money?"

Andy thought that was a terrific idea. Later on that evening Muriel also suggested (gratis this time) that he paint something that was so familiar that nobody even noticed it any more, "something like a can of Campbell's soup."

The next day Andy went out and bought a whole lot of canvas and painted the money pictures and the first Campbell's soup pictures. This was before he had discovered the silk-screen process, so, everything was painted by hand; when he learned about silk-screening it went much faster. The soup can paintings were exhibited that summer, but not in New York. Irving Blum, who owned the Ferus Gallery in Los Angeles, saw them and offered to show them there, which he did in July. The show came in for a lot of heavy ridicule. A gallery up the block from the Ferus piled up

Campbell's soup cans in its window and advertised "the real thing" for twenty-nine cents a can. Irving Blum sold six of the thirty-two soup can paintings for a hundred dollars apiece, but later he bought them back from the customers so that he could have the complete set himself.

In addition to soup cans and dollar bills Andy began doing silk-screen portraits of Marilyn Monroe and other stars. (Andy and his friends thought Marilyn was just great, fab, even better than Judy Garland.) Eleanor Ward, of the Stable Gallery, had come down to the apartment that spring of 1962 to see Andy's work, and although she had liked it she could not offer him a show because she had just given the only free spot on her next season's exhibition calendar to Robert Indiana. During the summer, though, one of her older artists left the gallery. Eleanor Ward called Andy from her summer place in Connecticut and said he could have a show at the Stable in November. Andy was just ecstatic, she remembers. "I'll never forget the sight of him coming into the gallery that September, in his dirty, filthy clothes and his worn-out sneakers with the laces untied, and a big bunch of canvases rolled up under his arm. 'Look what the cat dragged in,' he said. Oh, he was so *happy* to have a gallery!"

Examples of nearly all the paintings that Andy had been doing since 1960 were in the Stable show, with the exception of the comic strip paintings. The show caused a huge sensation. It was widely reported in the press, and it virtually sold out. That same month, November, 1962, Sidney Janis put on his two-gallery show of pop art, and in December The Museum of Modern Art sponsored a symposium devoted to the new movement. Andy had got in just under the wire.

I FEEL I'M VERY MUCH A PART OF MY TIMES, OF MY CULTURE, AS MUCH A PART OF IT AS ROCKETS AND TELEVISION.

In the group of artists who gained prominence through the triumph of pop, not one knows fame on the level that Andy does. As Alan Solomon once remarked, Andy is the first real art celebrity since Picasso and Dali. Housewives in Keokuk who may never have heard of Lichtenstein, or even of Rauschenberg and Johns, are aware of Andy Warhol. His dream has come true.

It all happened so fast, this stardom. After the first Stable show Andy went into mass production. He had taken a studio on East 47th Street—"The Factory," he called it—and with the help of his new friend Gerard Malanga he turned out hundreds of pictures during the next few months: multiple-image silk-screen portraits of Troy Donahue, Roger Maris, Liz Taylor, Ethel Scull; Campbell's soup cans by the hundred on single canvases; the new "death" series (suggested originally by Geldzahler) of grisly automobile wrecks, a suicide in mid-air, the electric chair at Sing-Sing. Every week he would show up at the Stable with another roll of canvases under his arm for the gallery assistants to stretch and mount, and everything he did was immediately bought. Almost everything—the auto wrecks proved too tough for most buyers, although for some reason the electric chairs were hugely popular. For his next show Andy filled the Stable with boxes—wooden boxes made to his order and silk-screened on all sides to look exactly like the cartons of Brillo pads and Mott's Apple Juice and Heinz Tomato Ketchup that you saw in the supermarkets. Visitors threaded their way through narrow aisles between the piled-up boxes. So many people came to the opening that there was a long line on the street outside waiting to get in. After that Andy moved to Leo Castelli's, where he had two shows. The first, in 1964, was all flowers, silk-screened from a photo in a photography magazine; the second, in 1966, consisted of Andy's cow portrait repeated over and over as wallpaper, together with silver, helium-filled pillows that floated. Production at The Factory had continued at full blast. Then, with awesome timing, Andy declared pop art dead and moved on to the next phase.

The Factory, by now a famous pop artifact lined from floor to ceiling with silver foil, was converted from silk screens to movies. The flickering strobe light of Andy's energy illuminated a series of his girls-and-boys-of-the-year: Baby Jane Holzer, Gerard Malanga, Edie Sedgwick, Henry Geldzahler. Andy's early films celebrating the splendors of total boredom won the Independent Film Award—highest accolade of the underground cinema. Andy's Exploding Plastic Inevitable group act plugged into the rock music scene at the Electric Circus, and boomed the fad for multi-media light shows of all kinds. The fashion crowd went gaga with admiration; artists were now dictating the new clothing styles, everyone wore a costume, and Andy, whose soiled chinos and sneakers had been superseded by a black leather jacket and silver-sprayed hair, seemed to be everywhere at once. For two years running he was out every night. Passive, pale as death, wearing his strange melancholia like a second skin, he was supremely visible. At the opening of Andy's 1965 show at the Institute of Contemporary Art in Philadelphia, the huge crowd went berserk at their first sight of Andy and Edie Sedgwick on a balcony; they had to be smuggled out a side door to escape being crushed. Andy Matisse.

But why? Surely those monotonously repetitive flowers and cows, those gaudy portraits and those torpid films are not all that compelling? Not more so, at any rate, than Lichtenstein's drowning heroines or Oldenburg's giant hamburgers. True, Andy went further than the other pop artists. The death series, the endless repetitions, the mass-production methods carried certain ideas implicit in pop to an extreme point, but still, a point not unknown to earlier and more radical artists than Andy. After all, Duchamp removed the artist's hand from art in 1913, when he began signing ready-made objects. It is often said that Andy's real art is the new one of publicity, but even this is debatable. Although Andy knows more or less precisely what he is doing at all times, and continues to capitalize brilliantly on his own drawbacks, he does not really manipulate events.

13

Andy remains essentially a voyeur, letting things take their course and looking on with cool detachment, interested but uninvolved. Then how *do* we explain the fact of his celebrity?

The word, I think, is resonance. From time to time an individual appears, often but not necessarily an artist, who seems to be in phase with certain vibrations—signals not yet receivable by standard equipment. The clairvoyance with which Andy touched the nerve of fashion and commercial art, the energy emanating from God knows where, the inarticulateness and naiveté, the very mystery and emptiness of his persona—all this suggests the presence of an uncanny intuition. Always somewhat unearthly, Warhol became in the 1960s a speechless and rather terrifying oracle. He made visible what was happening in some part to us all.

*I'VE ALWAYS HAD THIS PHILOSOPHY
OR: IT DOESN'T REALLY MATTER.*

A great deal of what took place in America during the last decade is missing, of course, from Warhol's house of mirrors. He has had nothing whatsoever to say to the young militants, the activists on either side of our contemporary conflicts. Participation, confrontation, martyrdom do not interest him; nobody at The Factory today would dream of going on a peace march, and if Andy contributes a painting to a liberal benefit it is only because a refusal would be awkward and un-cool. And no one in the history of cool has ever been cooler than Andy.

One feels that Lichtenstein got to the pop image intellectually, by logical steps, while Andy just *was* there by instinct. The soup can, for example—although the idea may have come from Muriel Latow it was Andy who sensed its absolute rightness and saw just how to present it. Banal, stupid, loaded with sentimental associations as it was, Andy painted his soup can with icy precision and utter objectivity. No interpretation, no reaction, no judgment, no emotion, no comment—and not an echo of his former I. Miller insouciance. The same is true of his other paintings (a possible exception being the Jackie Kennedy series, where some emotion seems evident on the part of the artist), and it is equally true of the films. Every Warhol image comes across frontally nude, without a shred of feeling attached. Andy's camera lens is the ultimate voyeur, but his films, for all their funny-sad sex scenes and their preoccupation with drugs and transvestism and pubic hair, are anti-erotic and utterly, numbingly cool.

The cool style requires a mastery of the put-on, of course, and in this area Andy knows no peer. Asked by a reporter why he painted the soup cans, Andy replies that for twenty years he has eaten soup for lunch. To an interviewer he gives deadpan non-answers and asks at the end, "Have I lied enough?" Alan Midgette, the actor hired to impersonate Andy on a lecture tour, lectures at a dozen or more colleges before the hoax is discovered, whereupon Andy explains that Midgette is "more like what people expect than I could ever be." The put-on, another talisman of the 1960s, has been raised by Andy to the status of a minor art. It is also, let us note, a perfectly valid means of anesthetizing despair, without resort to hypocrisy. The absurd public world and the even more absurd private world are both treated as an in joke, and sanity is preserved a little longer.

Over it all, however, lies the shadow. Vietnam, racism, urban blight, the poisoning of the environment, the alienation of the young, the murder of those few leaders who showed any real stomach for attacking the problems, and the sickening hypocrisy of our elected leaders have drained us of hope. Even Andy has been ripped from grace, shot twice in the stomach by a madwoman who mistook him for a god ("He had too much control over my life," she told the police), his life nearly extinguished and still not wholly restored to him (one of the wounds will not heal; he is in constant pain), and by a truly supernatural irony denied even the fruits of publicity that were due him because forty-eight hours after he was shot another madman killed Robert Kennedy in Los Angeles. Afterwards, he would say that his own life had come to seem like a dream, that he could not be sure whether he was alive or dead. Nor can we.

Andy kept his cool, but things are not the same. His filmmaking has slowed down. For three years Andy turned out an average of a film every week—that incredible energy again—but since the 1968 shooting he has completed only one picture, the banned *Blue Movie*. These days he rarely goes to parties, is hardly ever out after eight p.m. He spends his evenings at home with Mrs. Warhola (now seriously ill herself) in the house they bought a few years ago on Lexington Avenue near 89th Street. He watches TV until very late. At the new Factory down on Union Square (Andy moved out of the old one after a man walked in off the street and started to play Russian Roulette with a loaded gun—another irony) Andy's friend and business manager Paul Morrissey has more or less taken over the Warhol film operation. Andy comes in for an hour or so each afternoon, but his heart is not in it. The superstars have grown restless. Viva says she is "no longer with Andy." Brigid Polk, who has been around since the early Sixties and is one of Andy's established confidants, thinks he may get out of films. "Andy buried painting," Brigid says, "and he may just bury movies, too." Andy is said to be interested in videotape. He wants his own TV show, where people come on and talk and do whatever they like, while Andy watches.

Will his face inhabit the Seventies as it has the Sixties? Ivan Karp suggests that Andy's reputation may rest as much on his face as on anything else—the pale cast of those Slavic features, sensitive/ugly, angelic/satanic, not-quite-of-this-world. "One of the things he would have liked most," says another friend, "was to have been beautiful." Perhaps he is. At the moment, though, what we seem to see reflected in that strange face is a sickness for which there may be no cure. This is the new shudder brought by Warhol's art. Andy, in what one fervently hopes is just another put-on, begins to look more and more like the angel of death.

Calvin Tomkins

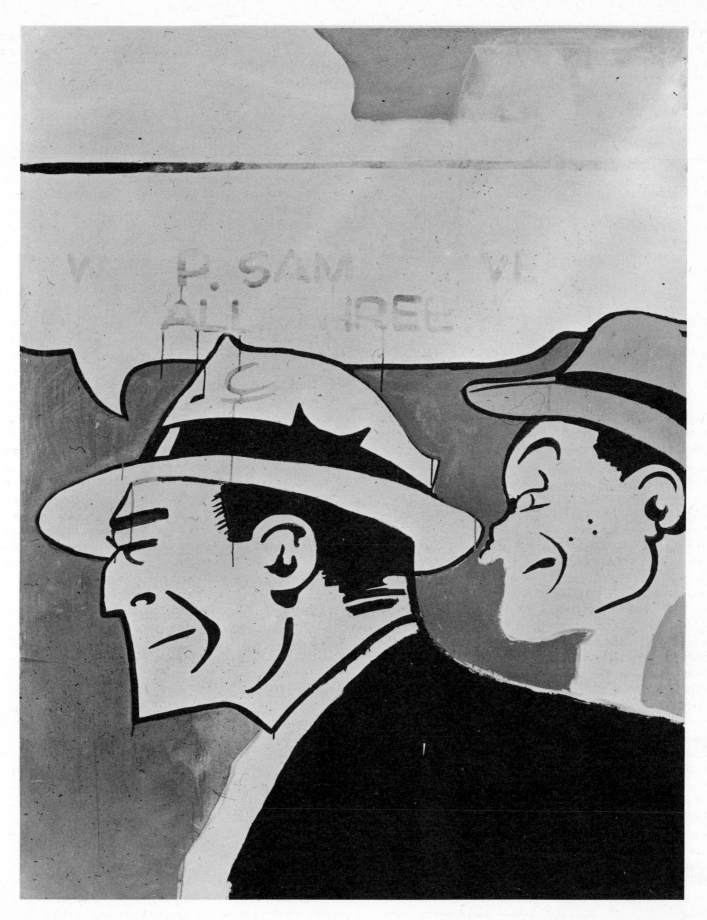

Dick Tracy, 1960. 70⅛ x 52½" (178.2 x 133.4 cm)
Collection Gordon Locksley Gallery, Minneapolis, Minnesota

15

Nancy, 1961. 48 x 48″ (122 x 122 cm)
Private Collection

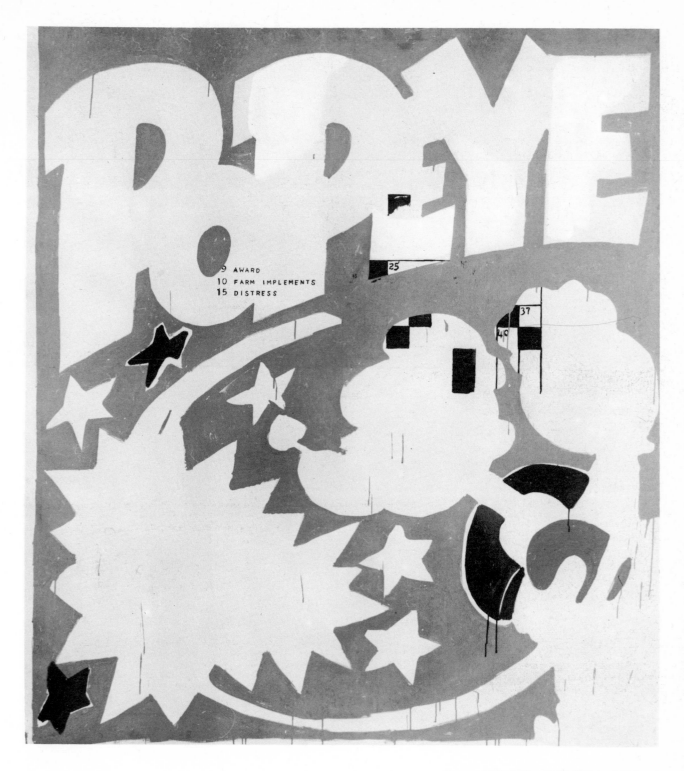

Popeye, 1961. 68¼ x 58½″ (173.4 x 148.6 cm)
Collection Robert Rauschenberg, New York

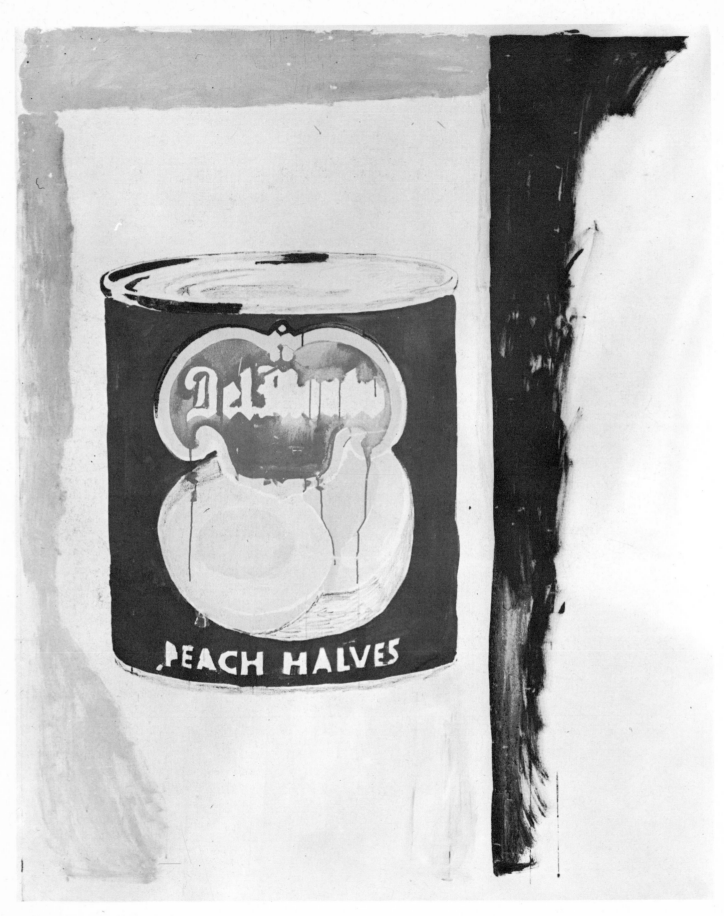

Peach Halves, 1961. 69⅞ x 54" (177.5 x 137 cm)
Collection Staatsgalerie, Stuttgart, Germany

Coca-Cola, 1962. 24 x 17¾" (61 x 45 cm)
Collection Galerie Ileana Sonnabend, Paris

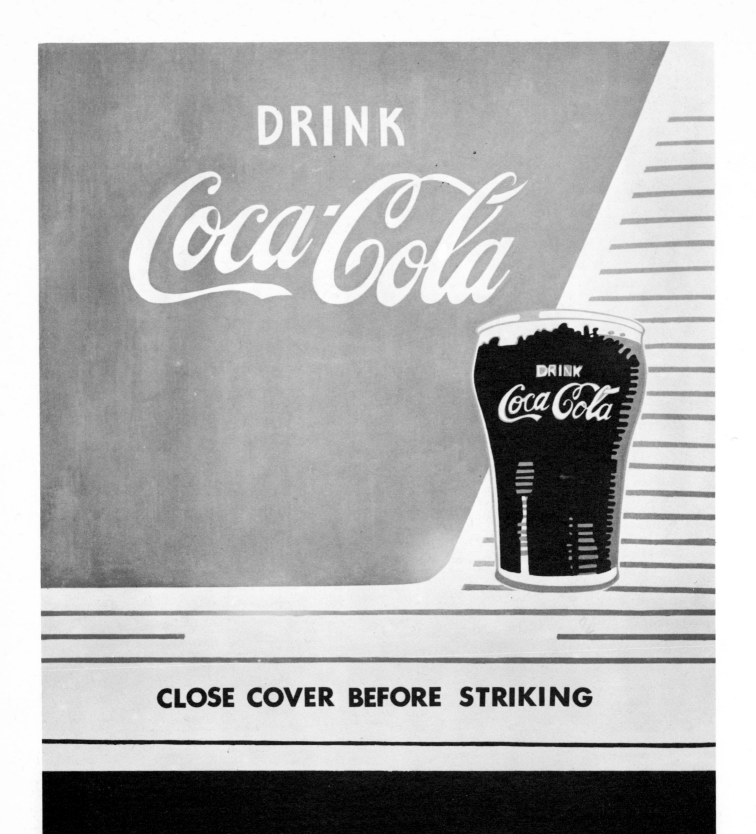

Close Cover Before Striking, 1962. 72 x 54" (182.9 x 138.4 cm)
Collection McCrory Corporation, New York

Close Cover Before Striking, 1962. 72½ x 54½″ (184.2 x 138.4 cm)
Collection Mr. and Mrs. Burton Tremaine, Meriden, Connecticut

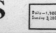

Daily News, 1962. 72 x 100″ (182.9 x 254 cm)
Collection Dr. Karl Ströher, Darmstadt, Germany

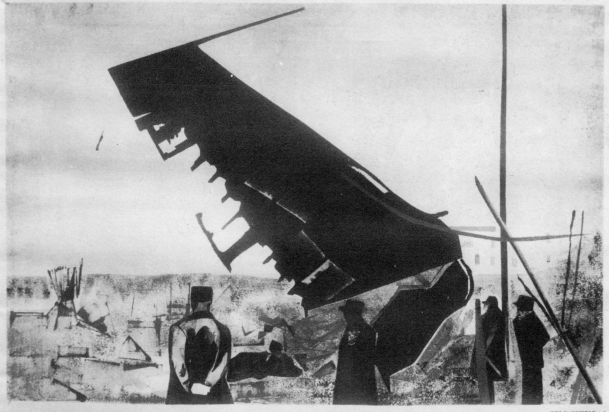

Plane Crash, 1963. 100¼ x 71⅞″ (254.5 x 182.5 cm)
Collection Dr. Peter Ludwig, Wallraf-Richartz Museum, Cologne, Germany

A Boy For Meg, 1961. 72 x 57" (182.9 x 144.8 cm)
Collection International Art Foundation, Gift of Mr. and Mrs. Burton Tremaine

Before & After III, 1962. 80 × 100″ (203.2 × 253.7 cm)
Collection Dayton's Gallery 12, Minneapolis, Minnesota

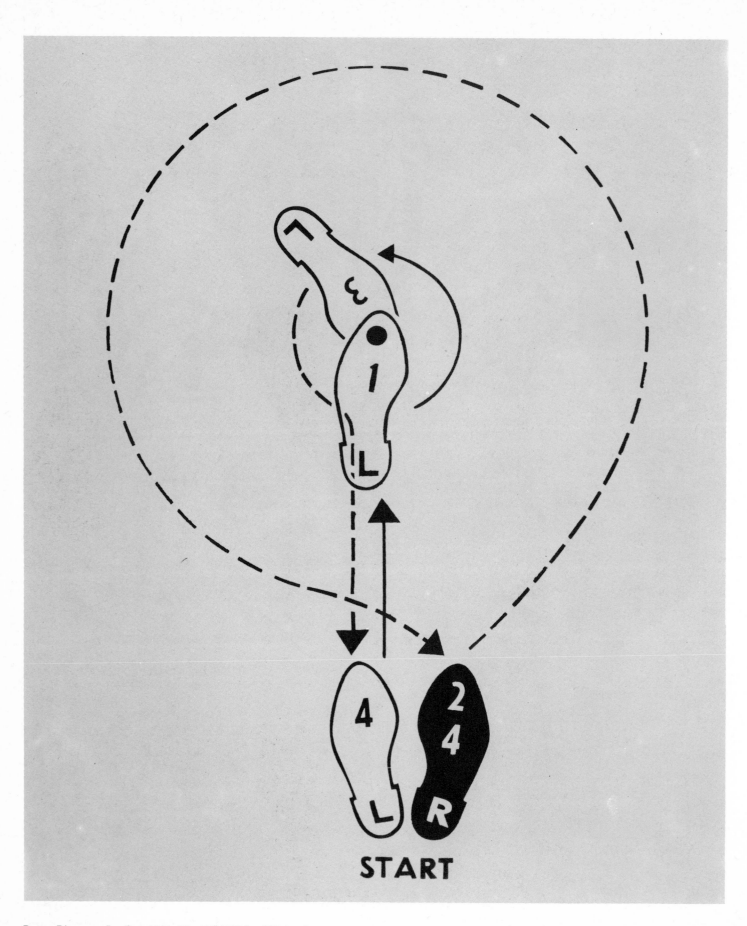

Dance Diagram—Fox Trot, 1961. 72 x 54" (182.9 x 138.4 cm)
Collection Fred Houghes, New York

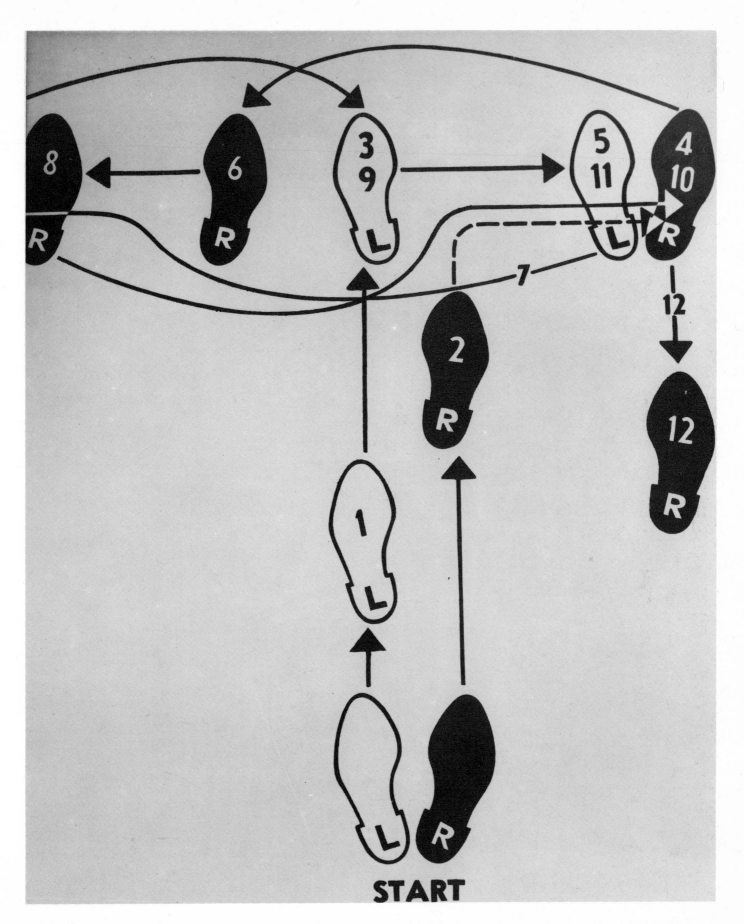

START

Dance Diagram—Tango, 1962. 72 x 54" (182.9 x 138.4 cm)
Collection Heiner Friedrich, Munich, Germany

27

Do It Yourself, 1962. 72 x 54½″ (182.9 x 138.4 cm)
Collection Kimiko and John Powers, Aspen, Colorado

28

Do It Yourself, 1962. 72 x 100" (182.9 x 254 cm)
Collection Dr. Karl Ströher, Darmstadt, Germany

Do It Yourself, 1962. 70 x 54" (177.8 x 138.4 cm)
Collection Florence Teiger, New Jersey

Do It Yourself, 1962. 54 x 72" (138.4 x 182.9 cm)
Collection Mr. and Mrs. Bagley Wright, Seattle, Washington

Do It Yourself, 1962. 24 x 18" (61 x 45.7 cm)
Collection Galerie Ileana Sonnabend, Paris

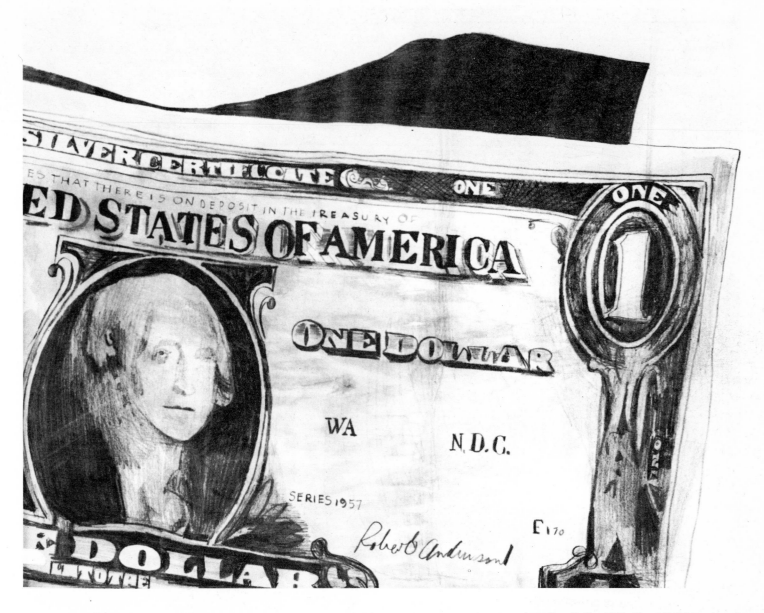

One Dollar, 1962. 18 x 24" (45.7 x 61 cm)
Collection Mr. and Mrs. Richard Sandifer, Kansas City, Missouri

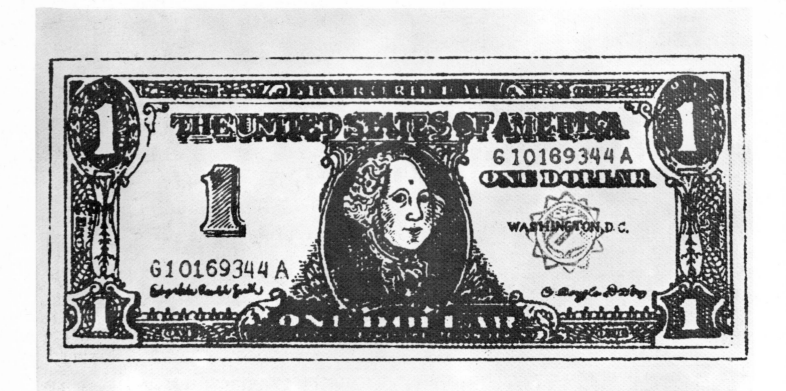

Printed Dollar #7, 1962. 5⅝ x 10" (14.3 x 25.4 cm)
Collection Mr. and Mrs. Burton Tremaine, Meriden, Connecticut

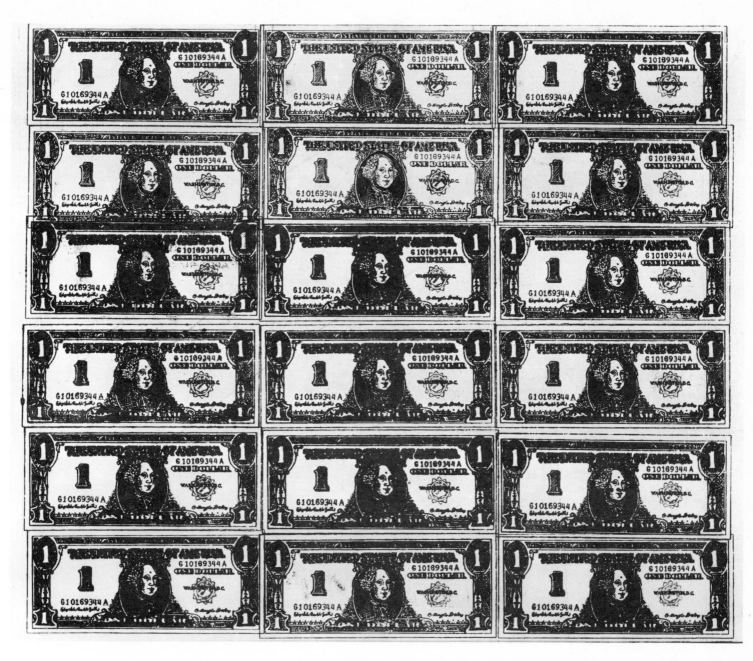

One Dollar Bills, 1962. 24 x 29¹⁵/₁₆" (61 x 76 cm)
Collection Dr. Karl Ströher, Darmstadt, Germany

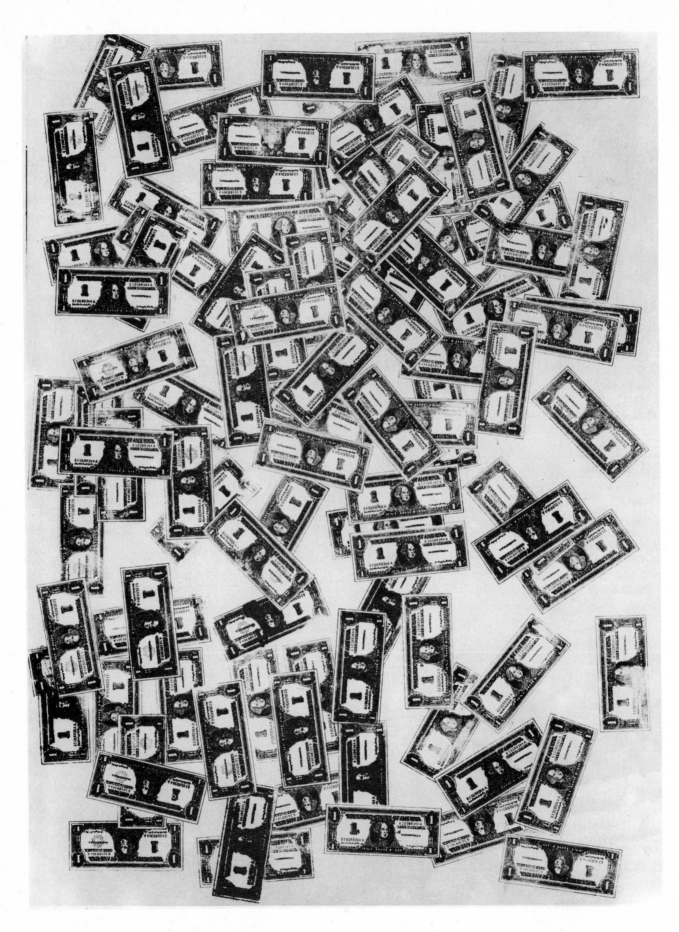

Dollar Bills, 1962. 54 x 72" (138.4 x 182.9 cm)
Collection Myron Orlofsky, South Salem, New York

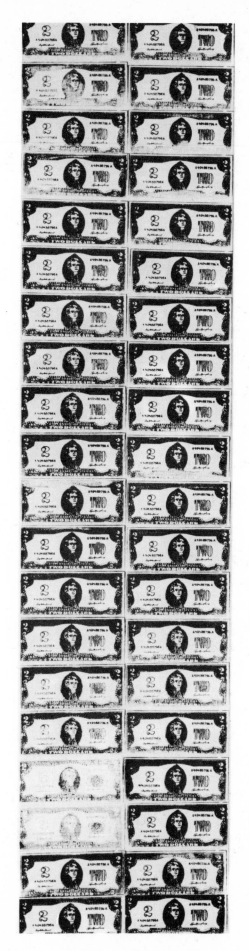

Two Dollar Bills, 1962. 83 x 19" (210.9 x 48.3 cm)
Collection William A. M. Burden & Co., New York

37

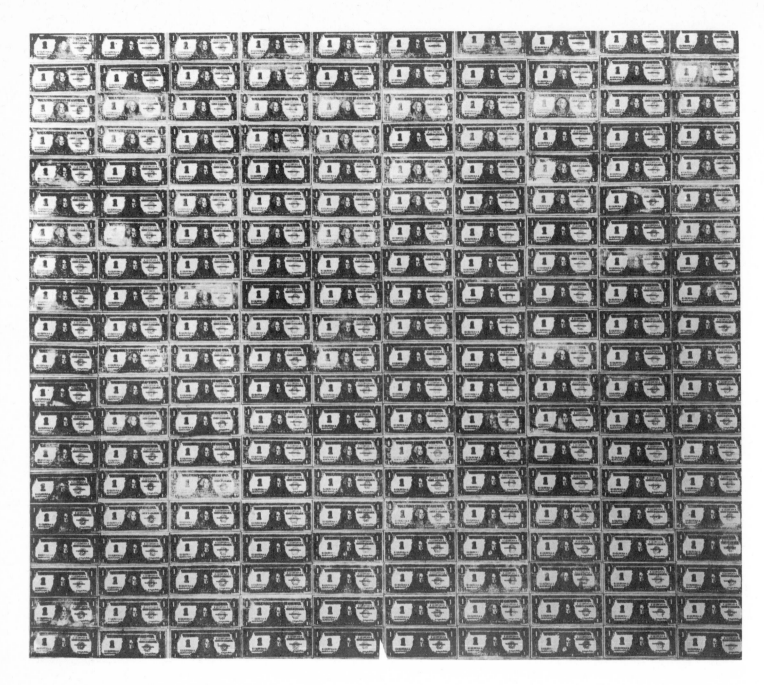

Dollar Bills, 1962. 82 x 92 (208.3 x 233.7 cm)
Collection Mr. and Mrs. Robert C. Scull, New York

Dollar Bills, 1962. 17¾ x 24″ (45 x 61 cm)
Collection Felice Wender, Minneapolis, Minnesota

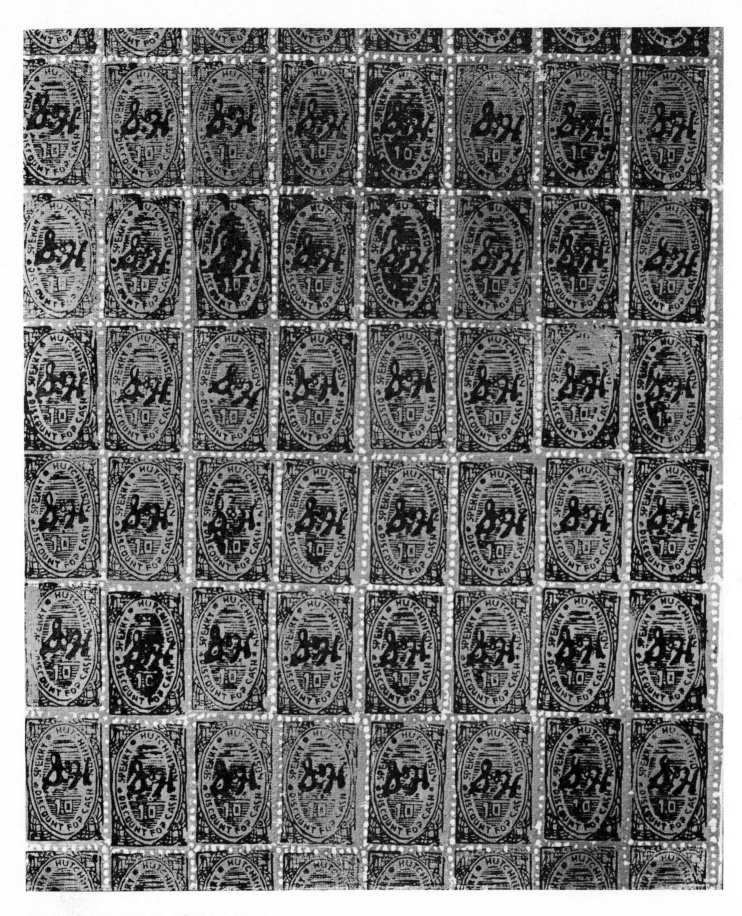

S&H Green Stamps, 1962. 20 x 16″ (50.8 x 40.6 cm)
Collection L. M. Asher Family, Los Angeles

Handle With Care — Glass — Thank You, 1962. 82 x 67" (208.3 x 170.2 cm)
Collection Dr. Karl Ströher, Darmstadt, Germany

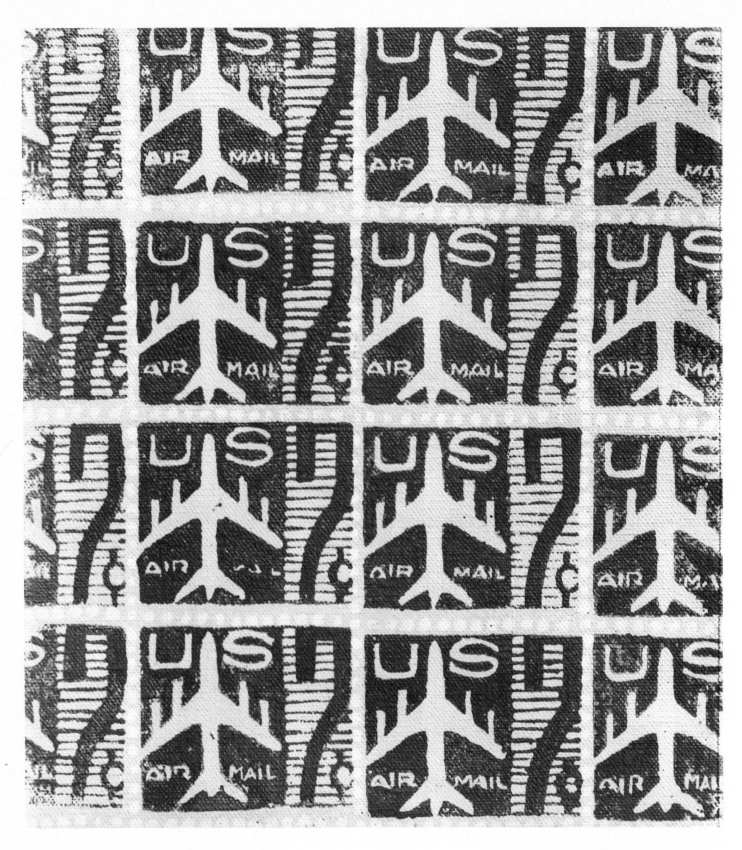

7¢ Airmail Stamp, 1962. 9¼ x 10¼" (23.5 x 26 cm)
Collection Mrs. P. N. Matisse, Santa Monica, California

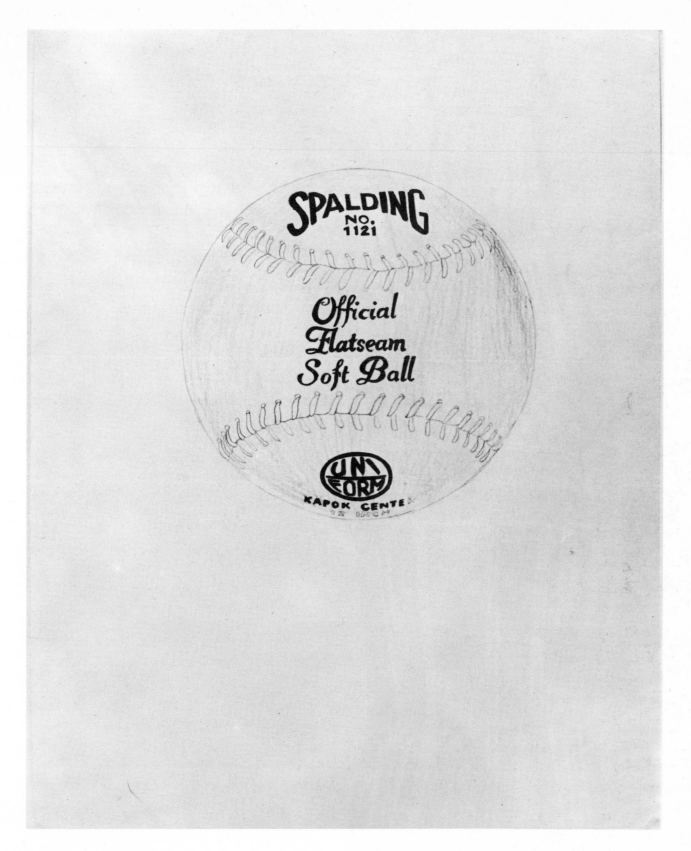

Spalding Soft Ball, 1962. 24 x 18" (61 x 45.7 cm)
Collection Galerie Ileana Sonnabend, Paris

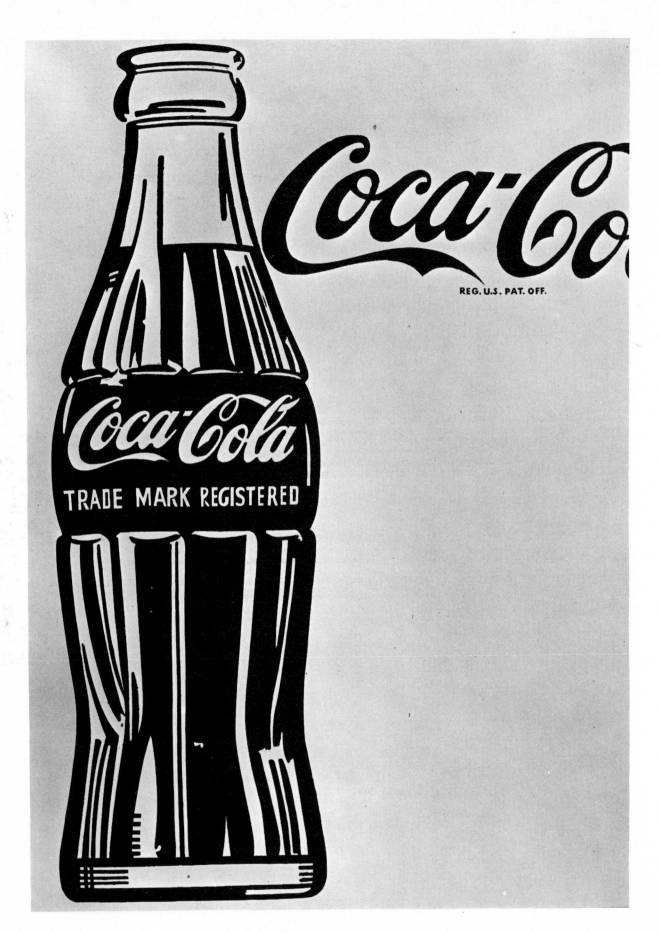

Coca-Cola, 1962. 72 x 54" (182.9 x 138.4 cm)
Collection Mr. and Mrs. Melvin Hirsh, Beverly Hills, California

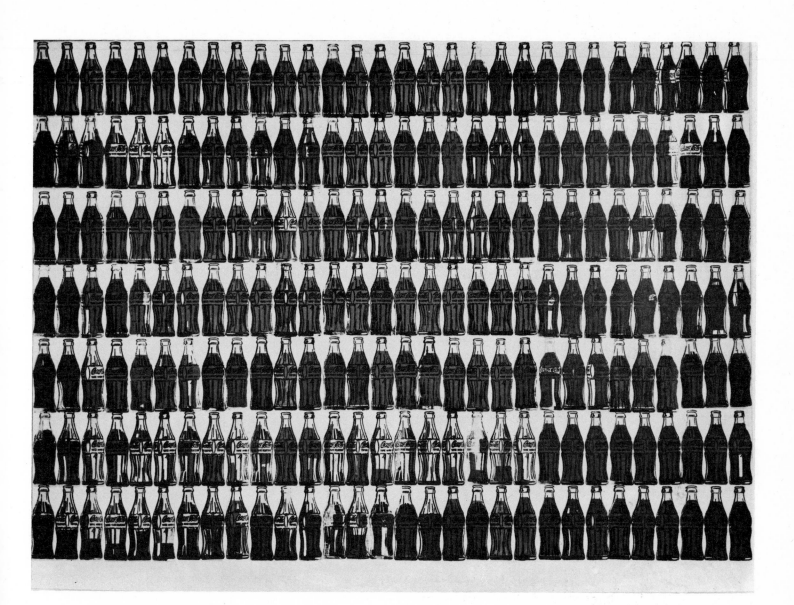

Coca-Cola Bottles, 1962. 82½ x 105" (209.6 x 266.7 cm)
Collection Harry N. Abrams Family, New York

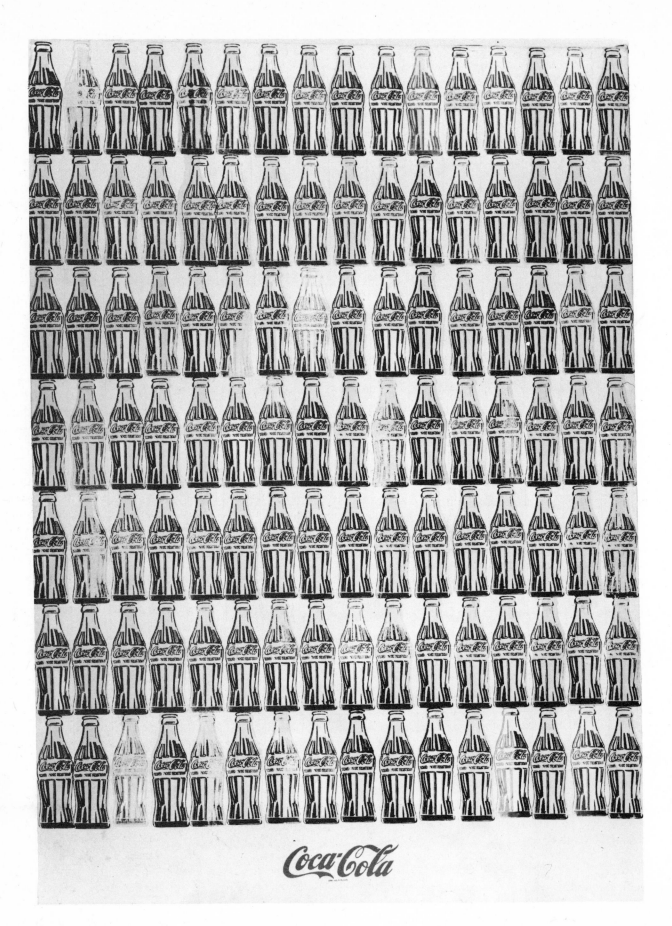

Green Coca-Cola Bottles, 1962. 83 x 57" (210.8 x 144.8 cm)
Collection Whitney Museum of American Art, New York

Andy Warhol: The Art

The most publicly celebrated figure to emerge from pop art is Andy Warhol. Claes Oldenburg and Roy Lichtenstein may well have received more serious consideration from the official art world, but to the American public-at-large Andy Warhol *is* pop. Not that Warhol is taken any less seriously by the art world; his paintings are sought after by collectors and museums and command prices as high as those of his colleagues. But the focus on Warhol has been more on Warhol the celebrity than Warhol the artist.

True, Warhol's attitude may have encouraged this reaction. He is notoriously evasive about his art and seemingly indifferent to interpretation. The same cannot be said of Oldenburg or Lichtenstein; for much of what they have to say about their work is intensely illuminating. But Warhol's super-cool attitude and ability to incite the wildest edge of publicity has undoubtedly influenced the reception of his art. He has not, of course, been entirely silent. An implicit sense of irony, even outright mockery, feeds through his few casually recorded remarks. But if Warhol misleads us the fault is more ours than his, for underneath the campy mask he so carefully presents to the world there is obviously a first-rate mind at work. Whether or not he casts himself in the role of anti-hero, feigns indifference or (for whatever reason) provokes our sense of disbelief is not the issue, for ultimately, judgment as to what is significant in art is pivotal to the work itself. Pop is a cultural phenomenon, and like any other style it must eventually stand or fall on its merit, as art. Within the pop style Warhol has produced an important body of work. The time has now arrived to selectively sort through his art and to examine the nature of his contribution.

Of the several artists who were to emerge as the leading proponents of pop art in the Sixties nearly all were professionally trained painters; many had years of serious endeavor behind them, even if in other styles. Some may have worked from time to time in jobs outside of their chosen career to support themselves, but their knowledge of art was extremely sophisticated. Warhol is possibly the only exception. Yet once he made the decision to switch from commercial art to painting, the rapidity of his transformation was startling.

From the beginning of his painting career (sometime toward the end of 1960) Warhol has employed a banal and common imagery. His ability to intuit his entry into the art world with an imagery that shortly afterward was to prove extremely critical within the development of American painting was the first token of his uncanny knack to incisively and speedily touch the heart of critical issues.

It is impossible, however, to discuss the origins and development of pop art—and especially the use of banal imagery so central to the style—without first remarking the influence of Jasper Johns and Robert Rauschenberg. Both painters unleashed into the art ambience various alternative proposals to abstract expressionism, chiefly by opening up painting (once again) to a greater range of imagistic content. Rauschenberg and Johns employed a type of imagery that evokes the ordinary, the commonplace of everyday life, and thus jointly freed banal imagery for use by a later generation of artists. Warhol was undoubtedly aware of Johns' and Rauschenberg's art (as were many other painters) but his direct use of comic-strip imagery as in *Dick Tracy* (1960) and *Nancy* and *Popeye* (both 1961) was an unexpected extension of their vocabulary—so much so that Roy Lichtenstein, on first seeing Warhol's comic-strip paintings at Leo Castelli's gallery at about the same time he brought in his own (in the spring of 1961), remarked on his amazement at the similarity of Warhol's work to his own.

Warhol's first works are clearly exploratory and derive as much from abstract expressionism as they connect to pop. Though the cartoon imagery and the style of drawing obviously refers to the original models, the paint is loosely applied and dribbles in the "approved" abstract expressionist manner. In *Del Monte Peach Halves* (c. 1960/61)—a harbinger of the forthcoming Campbell's soup cans—the fruit can is more or less centrally positioned, with the image and subdivided background very loosely painted. In contrast, *Nancy* appears to be a literal blow-up from a frame of the well-known cartoon. In short, these paintings veer between reworked images and absolute duplications.

The most decisive move apparent in Warhol's body of paintings that follows (from 1961 to 1962) is the rejection of paint handling. This decision again sharply connects his work to Lichtenstein's. It is astonishing that the two should simultaneously strike this notion, especially since they were the only artists to do so among the many involved with pop imagery at that time. But, while Lichtenstein persistently and unwaveringly narrowed down his style, Warhol at this time worked his way through many ideas with great rapidity, dropping each idea immediately once it was dealt with. If Lichtenstein proceeded with greater clarity and apparent purpose, it was for obvious reasons. He was a much more experienced painter than Warhol (his first one-man exhibition was held in New York in 1952); he had a greater theoretical grasp of his aims. Characteristically, once Lichtenstein narrows down a range of imagery suitable to his esthetic purpose he systematically plugs the gaps. However,

both artists during this period selected images which, though different, nevertheless reflected corresponding ideas. In addition they sometimes lifted their images from similar sources, especially newspaper or yellow-page phone book advertisements. For instance, Warhol's 1962 painting *Before and After* is subdivided into two side-by-side images that sequentially reveal the silhouetted head of a woman, identical except for the reshaping of her prominent aquiline nose to a pert retroussé accomplished by cosmetic surgery. Lichtenstein's *Like New* (painted about the same time) is a hinged diptych that also uses a sequential image. On the left panel is a piece of woven cloth with a large cigarette burn in the center; on the right is the same piece of cloth in impeccable condition after reweaving. Obvious, too, at this time is a shared vein of humor—both artists' imagery is often simultaneously funny and devastating. They relish thumbing a nose at the art world by choosing an outrageously sub-esthetic range of subject matter.

Warhol's body of painting clearly undergoes three principal stages of development: 1) he would select an image and rework it informally; 2) he then began handpainting selected images to simulate mass production; and 3) he finally deals with mass production directly through the use of various reproductive processes. The transition from one stage to another is not always clear, for there are occasional lapses.

Within the second category are the paintings derived from newspaper pages, match covers, dance-step diagrams, painting-by-number sets; multiple images of glass labels, money, S&H stamps; single and multiple images of airmail stamps and Coke bottles; and, most famous of all, single, multiple and serial images of Campbell's soup cans. With the exception of the Campbell's soup cans, which came last, the sequence and order of these works are difficult to establish[1]. Throughout this period Warhol made numerous drawings either related as preparatory to the many images enumerated above or as proposals that were never painted: a record cover, a baseball and others.

In these works there is a heavy amount of lettering, which he later discards. (Lichtenstein also gave it up, but he initially did a lot more with it than Warhol.) Warhol drops lettering entirely after the Campbell's soup cans, concentrating instead on the punch of his visual imagery. Also missing in much of this early work is the sense of brutality and morbidity pervasive to the later work. In short, in the earlier subject matter the possibility of the imagery being charged is there, but the temperature is low. The "charge" at this point is still below the surface. Nor is it a question of these works being painted by hand, though this is partially a factor; due simply to choice of imagery and inertness of handling, they lack the grotesqueness and sense of horror transmitted throughout the later work.

Within this group of paintings the highly varied *Do It Yourself* images are the most offbeat. Taken from hobby-shop color-keyed painting sets, these banal images are transformed by Warhol into strange paintings that are them-

selves supremely banal metaphors for paintings. Though the color is literal, its lyricism is sharply at odds with the banality of the image. The *Do It Yourself* paintings pose the question: can a painting be made that looks mechanical but is not? The numerous numbers (that in the hobby sets indicated which areas were to be painted which colors) are of mechanical origin, printed onto transfer paper and affixed to the canvas surface by the application of heat. They mark the first suggestion of Warhol's finding means to eliminate the use of the hand from his painting.

Some of the most important paintings from this second period, at least as far as Warhol's esthetic evolution is concerned, are the images of complete front or back pages from the New York *Mirror, Post* or *Daily News*. Newspapers inherently suggest the use of printing processes. They also deal with the ideas of mass production and reproductive processes, especially the photograph, which liberally appears in large scale on the front pages of these newspapers.

Implicit in these paintings are Warhol's later charged images of disasters and of public personalities who make news. But most important are the associations they contain of the manner in which the newspaper consistently touches the pulse of life. As a medium the newspaper is central to what Lawrence Alloway has described as the communications network of the urban environment. Once gathered, written, edited, composed, printed and distributed, news—like the paper it is printed on—becomes stale within a few hours of its production, and then is immediately disposable. What is topical one moment is dead the next, only to be replaced by the next headline or next piece of sensationalism, sandwiched between a constant barrage of messages to consume.

The newspaper image presents in a very forthright way the issue of duplication, which is never quite raised in the work of Lichtenstein, who deals only with the reproductive process itself through the use of Ben Day dots. With Warhol one senses the use of the chosen image as a whole, as an entity, especially in the later photographic images. The imagery that Warhol finally selects is in the range of charged, tough notions that in Rauschenberg's work become transformed by painterly handling. Warhol's imagery is transformed in much the same manner that Lichtenstein transforms the comic strips, but the crucial issue is that the transformation is not immediately apparent. More immediate to the viewer is that the painting looks as disposable as the original it is modeled from: something to be thrown away, or the cheapest kind of advertising, of no value except as a message to sell. This is exactly what infuriated Erle Loran as well as many others of the art audience. What these viewers failed to sufficiently consider was the power and ironic efficiency of the various concealed formal devices operating in the paintings: critical alteration of the contexts of the images, changes of scale, suppression of paint handling, compositional inertness, etc. But if Johns takes the American flag and with his formal innovations and painterly touch magically rehumanizes it, Warhol on

the other hand, almost by choice of imagery alone it seems, forces us to squarely face the existential edge of our existence.

The money, Coke, airmail and S&H stamps, glass label and Campbell's soup can paintings enforce the issue of multiplicity of the image itself, which as a motif is endlessly repeated. Two important formal innovations edge into these paintings. First, the actual as against the simulated use of an anonymous and mechanical technique, and second, the use of serial forms. Several of the money paintings were silk-screened, as were the modulated rows of images imprinted on the surface of the Whitney Museum's *Green Coca-Cola Bottles*. (However, though Warhol even much later never entirely removes hand touches from his paintings, it is not until he uses the blown-up photographic image taken from newspaper or other sources that he becomes crucially involved in photomechanical and silk-screen printing processes.) And with the Campbell's soup cans, which are the last of the hand-painted images, he shifts very decisively into the use of serial forms[2].

Central to serial imagery is redundancy. The traditional concept of the masterpiece as a consummate example of inspired skill that sets out to compress a peak of human endeavor into one painting is abandoned in preference for repetition and abundance. Serial forms also differ from the traditional concept of theme and variation. In the latter, the structure may be the same, but the composition is sufficiently varied so that each painting, though belonging to a set, can be recognized as unique. In serial imagery, uniqueness is not the issue; the structure and composition are sufficiently inert so that all the paintings, even though they can be differentiated, *appear* to be similar. Basically, it is a question of a shift in emphasis. Theme and variation are concerned with uniqueness and serial imagery is not. Serial forms are visually boring; there is very often a low threshold of change from painting to painting. But each painting is replete in itself and it can exist very fully alone. Obviously, when serial paintings are seen together within the context of a set, the serial structure is more apparent. Serial paintings or sculptures, however, are all equal in the sense of being without any hierarchy of rank, position or meaning. They also may be added to indefinitely, at any time. This, of course, depends upon the approach of each individual artist and the manner in which he sets up (or alters) the parameters of his particular system.

Including the Campbell's soup cans, Warhol's most serial paintings are those which thematically concentrate on a single image, for example, the various portraits as well as the Brillo and other boxes, the aluminum pillows, some of the disasters, and all the flowers. The power of these images derives from their seriality: that there are not only many more than a few in any given series, but that it seems to the viewer there are many more than can possibly be counted. This has partially to do with choice of imagery. Warhol invariably selects an image that pre-exists in endless multiples. Thus his series give the appearance of being boundless, never finished and without wholeness. Moreover, the larger the actual number of paintings in any one series, the greater the sense of inertia or input. Warhol's series, then (like the work of many other serial artists), speak of a continuum.

Some of Warhol's paintings seem to have affinities to the modular. This may well be true, especially for the S&H and airmail stamps, the multiple Coke bottles, the glass labels, some of the multiple Campbell's soup can images and the Marilyn Monroe paintings. However, the use of a modular structure is not central to these works, which are hard to distinguish in essence from the more serial ones. There is never any sense of wholeness or completion, or of a holistic or unitary quality, to any of his modulated forms, which invoke endlessness and appear to be a segment of something infinitely larger. Obviously Warhol's work is hard to compartmentalize, but there is no doubt that the use of modular forms has greater power in the hands of other artists.

Crucial to pop art is the ironic power of its banal imagery. But it would be a mistake to think that Oldenburg, Lichtenstein and Warhol, for instance, are attached to their material in the sense of praising it or liking it for itself. (They may like it for the purpose of their art, which is another matter altogether.) Unlike the English pop painters, who often express a romantic view of American culture, these artists are strictly neutral; they are neither for the material nor against it. Instead they use banal imagery ironically, and consequently detach themselves from emotional attitudes about their subject matter. Furthermore, this detachment does not mean they cannot be viewed in any measure as moralizers. Without doubt, a strong vein of tragic humor pulses through Oldenburg's sculpture and drawings. Lichtenstein's images of love are full of pathos, and at the same time, ironically, his lovers (and heroes) are fully exposed in their shallowness. Warhol's images are particularly savage and uncompromising. They appear in some curious way abandoned, as it were, to public gaze; and once there they demand quite persuasively that we face them, ourselves, and the 20th-century landscape we cohabit with them.

Warhol's large, sparse, black and white painting of a single Coke bottle is a brutally baleful icon. There is nothing delectable about this painting. The sensuousness of the original glass bottle (designed by Raymond Loewy Associates) with the dark brown liquid gleaming through the container is thoroughly negated in the painting. But Warhol has a very special capacity to select images, which, when presented in a painterly context, associationally press upon the nerve-ends of certain aspects of our daily existence. It is not that Coca-Cola is so bad or so good. As a sweet, carbonated drink it is essentially no better or worse than other brands that are marketed. But what is perturbing is the ferocity of the overall effort that goes into advertising, marketing and distributing something that is ultimately so trifling. Like so many other manufactured products, the packaging promises much, the advertising more, yet the product delivers little. Coca-Cola is prototypical of the

desperate urgency abounding in a free-enterprise, techno-logical society to bend and habituate the consumer to the producer's will, regardless of the intrinsic worth of the product. In fact, the more trivial the difference between the identical products made by different manufacturers, the shriller the advertising, the more ferocious the battle to gain and maintain a major share of the market. Unfortunately, there is more to it than this. Markets today are interna-tional, to be fought over in the same style as in America. Coca-Cola is symbolic of the new American industrial im-perialism in which technology, marketing techniques and culture become irretrievably and inseparably intermixed to spawn on new territory the same manic set of goals and values.

Similarly, Campbell's soup promises much and delivers just as little. The thirty-two different soups mass-marketed each have a different name redolent of the gustatory de-lights of many nations and traditional good cooking — Scotch Broth (A Hearty Soup), Consommé (Beef) Soup, Minestrone (Italian-Style Vegetable Soup), Cheddar Cheese Soup (Great As A Sauce Too!), Old-Fashioned Tomato Rice Soup, etc. So much diversity within multiplicity! Though the names and ingredients may be different, however, the soups are all equally tasteless and may as well have come out of the same vat. Campbell's canned soups — Warhol seems ironic-ally to assert — are like people; their names, sexes, ages, origins, tastes and passions may well be different, but an advanced consumer-oriented, technological society squeezes them all into the same vat.

It is difficult to ascertain exactly what combination of circumstances led Warhol to change his imagery and tech-nique so rapidly, radically and simultaneously toward the end of 1962 and in early 1963. Warhol's first New York exhibition in late 1962 included a very diverse range of paintings — Campbell's soup cans, Coca-Cola match covers, modular rows of Coke bottles, modular Martinson Coffee tins, at least one of the newspaper images (*129 Die*) and various portraits, in particular the modular heads of Troy Donahue, Elvis Presley and Marilyn Monroe. In this exhibi-tion, including at least one painting of rows of Coke bottles, all the portraits employ the silk-screen technique. The im-personal method of handpainting the images hitherto employed is subjected to a powerful transformation.

Rauschenberg and Warhol seem to have developed an interest in the silk-screen technique at about the same time (though Warhol may have anticipated Rauschenberg some-what, in the *Money* paintings of 1962). Rauschenberg's pur-pose was to find a means to alter the scale of the photographic material that he had formerly affixed to his paintings as elements of collage. Silk-screening allowed him to include the blown-up image as an integral element of the canvas surface. Warhol, on the other hand, uses the technique as a device to control the overall surface of the painting. Warhol first lays down a flat but often brilliant ground color and then unifies the surface and image by repetition of the module of the screen. The final image,

however, is very arbitrary and quite unlike the impersonal handling of the serial Campbell's soup cans, from which all trace of paint handling has been suppressed. In employ-ing the silk-screen technique, which is used in commercial art to give evenness of surface and crispness of outline, Warhol reverses the effect. In his hands the technique be-comes as arbitrary, unpredictible and random as the paint surface appears to be in an abstract expressionist painting.

In essence, silk-screen is a sophisticated stencil process. On the bottom of a box frame several inches deep and con-siderably larger than the image to be printed, a suitable porous material is attached (silk in the hand process and fine metal mesh in the mechanized process). The image can be affixed to the material by a variety of means, either by hand or photomechanically. Warhol uses the latter method. All areas other than those parts of the image to be printed are occluded and made impervious to the print medium, be it ink, oil paint or a water-soluble dye. The frame is then placed on top of and in close contact with the surface to be printed. The liquid printing medium is poured in at one end of the frame. It is then stroked across the image with a rubber squeegee and forced through the mesh to print on the surface of the material beneath. Though the silk-screen process is simple, many things can go wrong. For instance, if the medium is stroked across the image un-evenly, if the density of the medium varies, if the squeegee is worn or dirty, or if there is insufficient medium to com-plete a stroke, the image will not print evenly. Parts of the image will become occluded or the dirt will print tracks, etc. The sharpness of the image will also vary according to the pressure exerted on the squeegee, or the angle it is held at. Many of these deficiencies will often work their way into the mesh and, unless the screen is cleaned, will show up in subsequent images.

These normally accidental effects are often deliberately sought by Warhol. At other times, his images are printed more evenly. In many of the latter, especially some of the Marilyn Monroes, the nearly identical images are height-ened by touches of color applied with a brush. A compelling aspect of Warhol's silk-screen images is that the transforma-tion of the images is effected in the technique; thus it is embedded in the various processes.

The silk-screen process is capable of breeding a tremen-dous amount of paintings. Yet not only are Warhol's images very few; by the time the identical images are either printed many times on a single canvas, or alternatively printed on small single canvases and then assembled into one serial painting, the number of his paintings shrinks considerably. In fact, the overall body of his work is surprisingly small. Since a major part of the decisions in the silk-screen proc-ess are made outside the painting itself (even the screens for color can be mechanically prepared in advance) making the painting is then a question of screening the image or varying the color. These decisions can be communicated to an assistant. Perhaps this is one reason why Warhol doesn't count how many works he has made, or care. Those

he doesn't like he can throw or give away. It is not so much that he is uninterested in his own history (though that may well be a factor); his indifference arises partly because of the processes involved. It is always possible to make more, and what obviously interests Warhol is the decisions, not the acts of making.

Neither Lichtenstein's nor Warhol's painting (nor Johns' nor Rauschenberg's, for that matter) is involved in edge-tension in the same manner as the field painters (Stella, Noland, Kelly). Lichtenstein's method of organizing the painting has more to do with cubism, particularly his method of cropping the image. The actual borders of Warhol's paintings, on the other hand, are arbitrary and not at all critical. In fact, Warhol's paintings lack edge-tension. To him the edge is merely a convenient way to finish the painting. Like Lichtenstein, Warhol crops, but the final edge of the painting is determined by the repetition of the module of the screen, or the size of a single image contained on the screen. In Warhol's paintings of Elvis Presley, which reproduce the whole figure, the background is a flat silver. Either single, double or treble repeats of the figure are centered on the canvas. The top edge of the canvas cuts the head and the bottom edge cuts the feet. Because of the nature of the silk-screen process, which necessitates the unmounted canvas being placed in the press in order to be printed upon, the edges of these paintings are determined afterwards, though obviously their general location may be known in advance. Very often the single images printed on one canvas are united to form a larger unit of several canvases. In any event, the edge is always positioned as an outgrowth of the margins of the image on the screen. At times Warhol will add to a screened canvas another blank canvas of the same size painted the identical ground color—as for instance in some of the Liz Taylor paintings or the very large dun-colored *Race Riot*. But unlike photographs or movies, which localize space by delineating subject, surroundings, background, etc., Warhol's paintings present images in a surrounding space that is felt or perceived as a continuum. This is enhanced by the fact that his portraits are without a literal background. His heads or figures are positioned on a flat-painted surface.

What Warhol's painting lacks in edge-tension is compensated by other tensions he induces in his pictorial structure, notably that of slippage. This is introduced in various ways—by the under-inked directional vector of the squeegee, or the printed overlap of the margins of the screen, or a lack of taut registration when several colors are used. Many of the large *Flower* paintings involve this form of color slippage. In addition, Warhol deliberately ensures that the color areas are larger than the natural forms they are designed to denote. For example, the red of the lips in the Liz Taylor portraits is very much larger than the lips themselves.

A strong feeling of time is also induced by the silkscreen printing method. It arises from the apparent variation of light in the modulated or serialized images. In fact, there is no actual change of light. Warhol takes the same image, repeats it, and creates in the viewer a sense of seeing a whole series of light changes by varying the quantity of black from image to image. Thus the same image runs the gamut of blacks or greys, apparently indicating different times or amounts of daylight, when in fact the viewer is perceiving a single photo printed with a variety of screening effects. No other pop artist is involved in the ideas of time, sequence, duration, repetition, and seriality to the extent Warhol is. These aspects of formal innovation are what make his work unique.

In at least one painting, *Robert Rauschenberg* (1963), time is used by Warhol in a straightforwardly literal or narrative manner. The painting was made by screening old photographs of Rauschenberg, first as a child with his family, then as a growing boy, and finally as the artist Warhol knows. The time sequence of the images, which are repeated on the canvas in modulated rows, runs from top to bottom, the images at the bottom (of Rauschenberg the artist) being much larger in size. Apart from this painting, Warhol's use of the time element is generally more abstract. Warhol seems to realize that his work is less sentimental or journalistic—hence of greater impact—if the painting suggests time without actually using it.

Because of the oblique time-element that Warhol introduces into the paintings, each repetition of the same image seems to be unique rather than a duplicate of the others. Thus the internal variations and the slippage that arise as consequences of the printing techniques give life to what was originally a static image, in particular by making the viewer think that time is moving. This, of course, is enhanced in the serial paintings by the linear qualities of the sequence of the images from left to right and top to bottom. One reason why Warhol was readily able to drop words or written images is that his serial or modular images act in very much the same orderly sequence of parts that the structure of words evokes. The idea of movies, of course, is also inherent in the silk-screen paintings, the sequential presentation of images with slight changes first occurring in the money and Campbell's soup paintings, and particularly in the painting of tiered rows of Coke bottles that are in various stages of fullness or emptiness. Still other aspects of his painting lead toward movies—the silver backgrounds of many paintings, as well as the blank silver canvases often adjoining, which are like movie screens[3].

Warhol's instinct for color is not so much vulgar as theatrical. He often suffuses the whole surface of a canvas with a single color to gain an effect of what might be termed colored light. It is difficult to use any of the traditional categories in discussing Warhol's usage, which bends toward "non-art" color. His color lacks any sense of pigmentation. Like the silver surfaces of the Liz Taylor or Marlon Brando paintings, it is sometimes inert, always amorphous, and pervades the surface. Though often high-keyed, his colors are at times earthy, as in one of the *Race Riot* paintings, which is covered in a flat, sickly-looking, ocherish tinge

reminding the viewer of a worn, stained and decaying surface. In other paintings Warhol moves into what may best be described as a range of psychedelic coloration. For the most part his color is bodiless and flat and is invariably acted on by black, which gives it a shrill tension. Further, the color is often too high-keyed to be realistic, yet it fits into a naturalistic image. This heightens the unreality of the image, though the blacks he so often uses roughen the color and denude it of sweetness. However in a number of other works Warhol successfully counterpoises two or more brilliant hues without the use of black.

Warhol uses public pictures of people. With rare exception (e.g. Ethel Scull) he avoids candid snapshots that reveal private or idiosyncratic information about the persons concerned. His portraits are forthright, but of people wearing composed faces. The pictures are neither reworked nor touched up. What one finally must confront is the paradox that however correct its likeness, a picture never tells the truth. Photographs of faces are supposed to be revealing of more than the physical structure of the face. However they rarely reveal inner truths about the person concerned. That is why the *Jackie* paintings are so powerful (and touch us so deeply). Mrs. Kennedy may have been photographed during a terrible experience or ritual, but in the Warhol paintings she looks normal even in anguish. It is only in the car crashes, when people are caught imminently facing death, that they wear masks frozen in terror; otherwise Warhol's portraits transmit nothing of the inner psychic tensions of the persons portrayed. They are always dehumanized by never reflecting what they feel. Thus Warhol dehumanizes people and humanizes soup cans.

Warhol's use of context warps images, as well. Are we so sure that the individuals portrayed in the thirteen *Most Wanted Men* could not include a mayor? Or a police chief? Or simply a man who never in his life will be wanted by anyone for anything?

Within the *Disaster* series, the auto crashes with all their bloody, smashed and mangled bodies are finally made to seem real. If one evades looking too closely at the gory details of such a photograph in a newspaper, one is compelled, on the other hand, to look at them in a Warhol painting—if only because of the contradiction between what seems at one moment to be a very abstract painting and what at another suddenly becomes an image filled with the most horrible details. Or again, though no one is present, the ritualization of judicial execution in all of its morbidity is fully revealed in *Silver Disaster* by the "Silence" sign that lurks in the foreground.

The *Flowers* were first shown in 1964. They consist of many series of different sizes within two main series, one of which has green in the background, and the other, black and white. What is incredible about the best of the flower paintings (especially the very large ones) is that they present a distillation of much of the strength of Warhol's art— the flash of beauty that suddenly becomes tragic under the viewer's gaze. The garish and brilliantly colored flowers always gravitate toward the surrounding blackness and finally end up in a sea of morbidity. No matter how much one wishes these flowers to remain beautiful they perish under one's gaze, as if haunted by death.

Warhol is open to everything. And everything these days seems to consist of violence and death. Both are central to his art and his life. He doesn't censor, nor does he moralize —at least not directly in the work, though in a paradoxical manner by choice of material. When he presents his imagery he does so without any hierarchical or extra-symbolic devices. He can be related to the absurdist playwrights and writers, in vision if not in style. He does not share the underlying dramatic structure apparent in their work. He also has no surreal, metaphorical or symbolic edge. His work is literal throughout: those are Campbell's soup cans and nothing can be done to alter their existence; that is an atomic explosion, and there it is as an irrevocable fact of our existence; here is a car crash, and there is nothing that can be done to place it in another world. It is anonymous as the accident that can happen to anyone. The car crashes are as anonymous as the movie stars; they are portraits of death without even the ritual that attends the convicted killer executed in the electric chair. True, with *Jackie* and especially the painting of the funeral one views the liturgy, but one is well aware that this is no answer either.

It seems at first that Warhol's imagery is catholic, but this is not so; his choices are very deliberately limited. On the rare occasions when a painting fails it fails primarily because his sense of choice has let him down. But his sensitivity to exactly the right amount of charged imagery is singular.

Warhol's career as a painter or even a movie-maker may or may not be over. Only the future will answer this. One thing we are certain of. Whatever the ambition that motivated Warhol to become an artist, art itself—it seems—has had as much effect on Warhol as Warhol has had on art. Finally, like Duchamp, whom he so ardently admired, here is a man who now only speaks when he has something to say.

John Coplans

FOOTNOTES:

1. In addition, there exist photographs of a series of representations of automobiles, some of details (front, or wheels and fenders) and others of repetitive side views of the whole. These works were made as illustrations for a magazine article and should not be confused with Warhol's exhibited works.

2. For a more extended discussion of the usage of serial forms see John Coplans, *Serial Imagery* (exhibition catalogue, Pasadena Art Museum, 1968; book, the New York Graphic Society, 1968).

3. Though Warhol's interest in movies—to whatever degree—was very likely long-standing, apparently the crucial event that directed him into filmmaking was his 1963 exhibition of Liz Taylor and Elvis Presley paintings at the Ferus Gallery in Los Angeles. The attraction of Hollywood was too powerful to resist. Before making the journey for the opening of the exhibition Warhol obtained a hand movie camera and on arrival in Los Angeles with some of The Factory crew he began shooting *Tarzan*. The opening shots of this movie begin on the Los Angeles freeways and the subject is introduced by an approach shot of a Tarzana off-ramp sign.

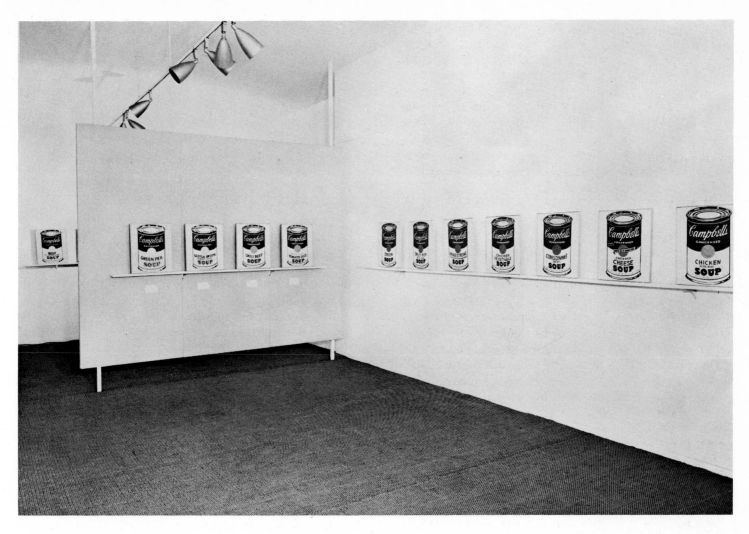

Installation photograph *Campbell's Soup Cans,* Ferus Gallery, Los Angeles, 1962.

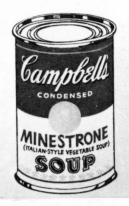 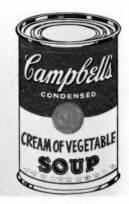 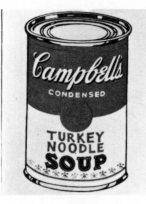 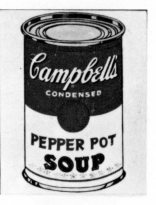

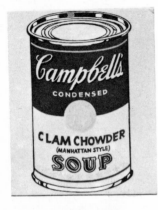 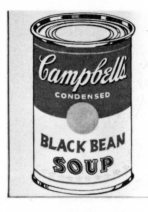 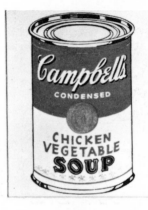 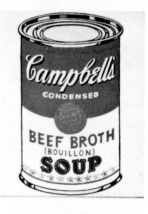

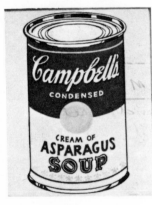 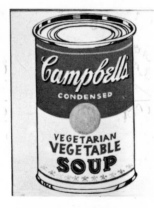 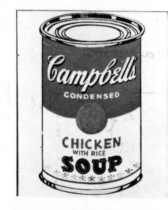 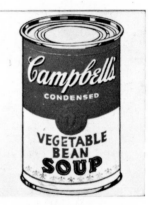

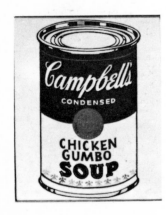 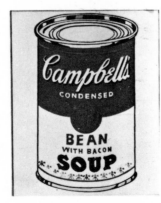 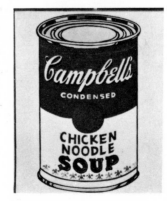 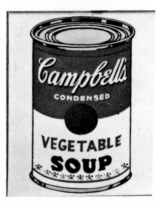

Campbell's Soup Can, 1961-62. 32 paintings, each 20 x 16" (50.8 x 40.7 cm)
Collection Irving Blum, Los Angeles

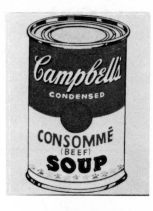 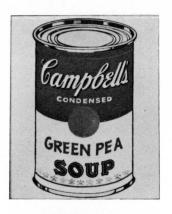 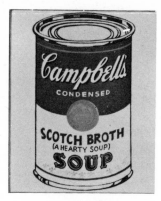 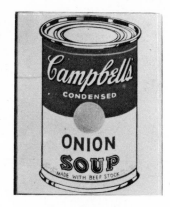

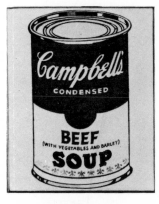 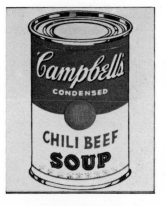 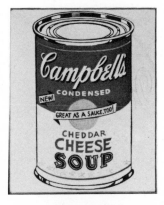 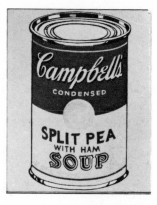

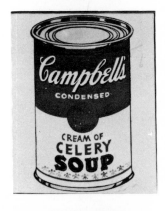 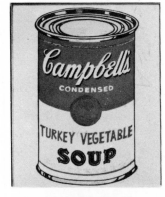 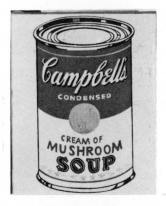 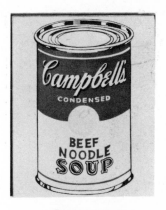

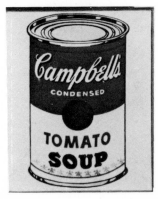 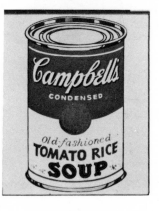 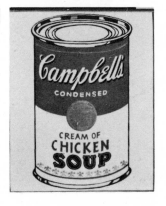 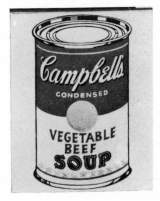

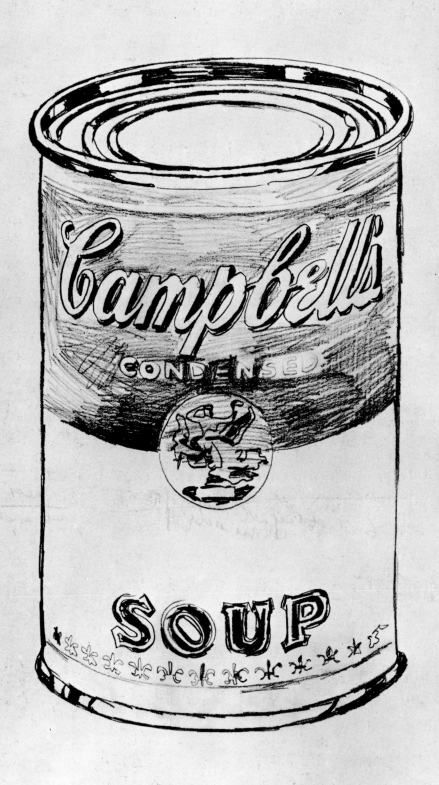

Campbell's Soup Can, 1962. 22⅜ x 17¾" (60 x 45 cm)
Collection Dr. Karl Ströher, Darmstadt, Germany

56

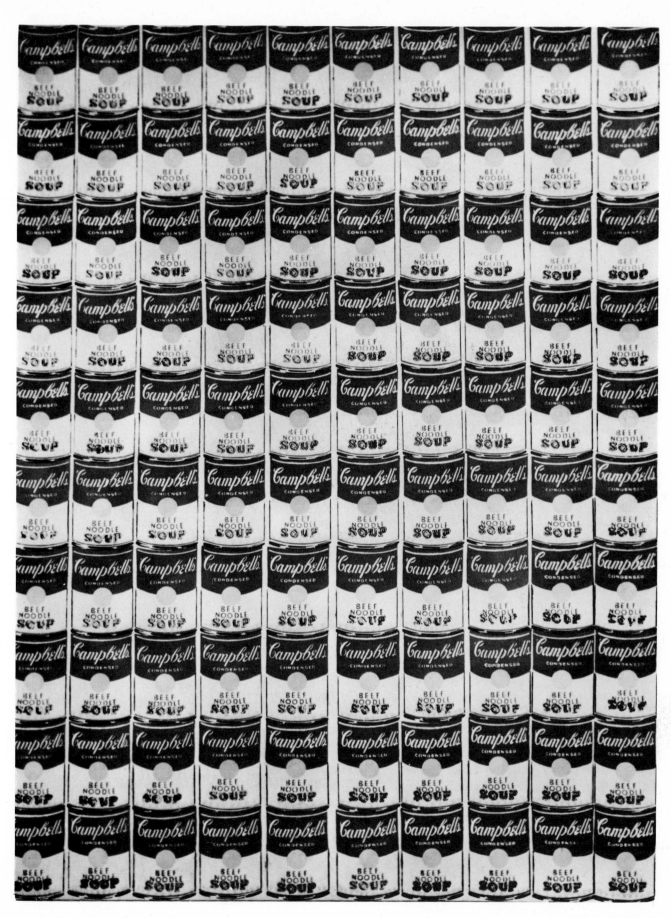

100 Soup Cans, 1962. 72 x 52" (182.9 x 132.1 cm)
Collection Dr. Karl Ströher, Darmstadt, Germany

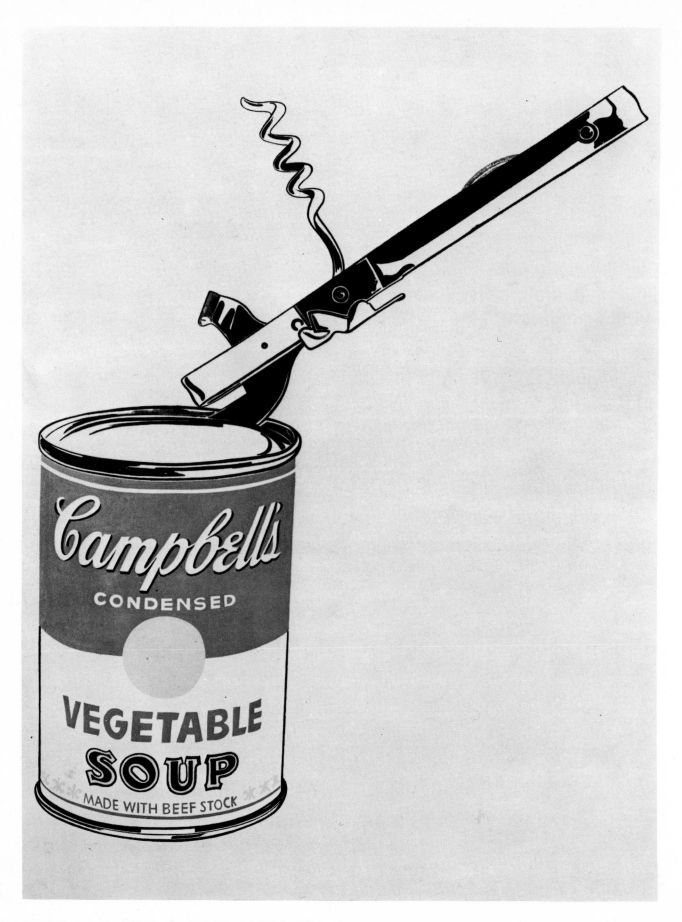

Campbell's Soup Can With Opener, 1962. 72 x 54" (182.9 x 138.4 cm)
Collection Mr. and Mrs. Burton Tremaine, Meriden, Connecticut

Group Soup Cans, 1962. 18 x 24" (45.7 x 61 cm)
Collection Galerie Ileana Sonnabend, Paris

Soup Cans, 1962. 23⅝ x 18" (60 x 45 cm)
Collection Mr. and Mrs. Peter M. Brant, New York

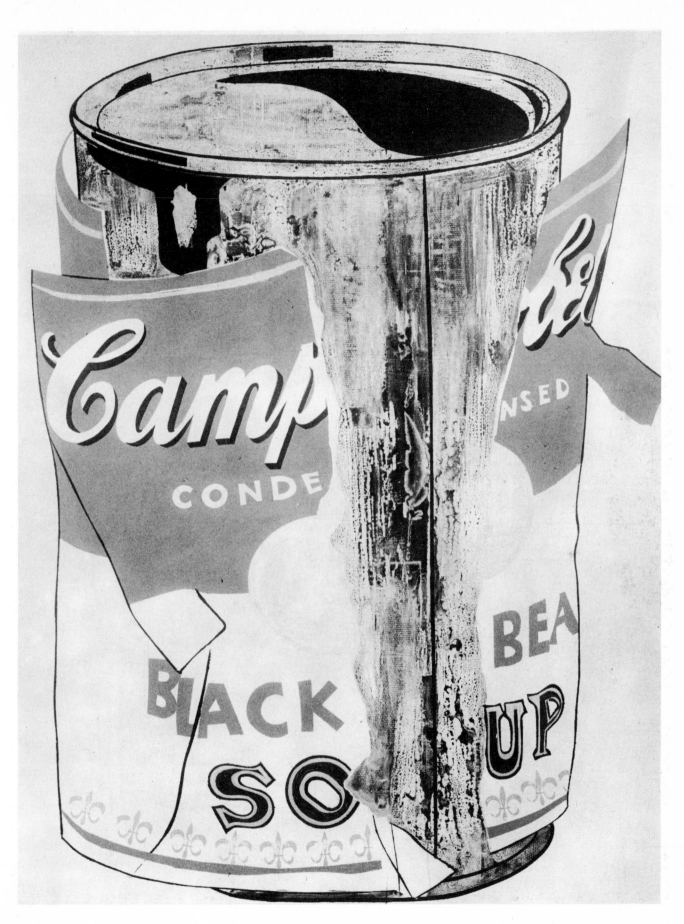

Torn Campbell's Soup Can, 1962. 72 x 63½″ (182.9 x 161.3 cm)
Collection Galerie Ileana Sonnabend, Paris

61

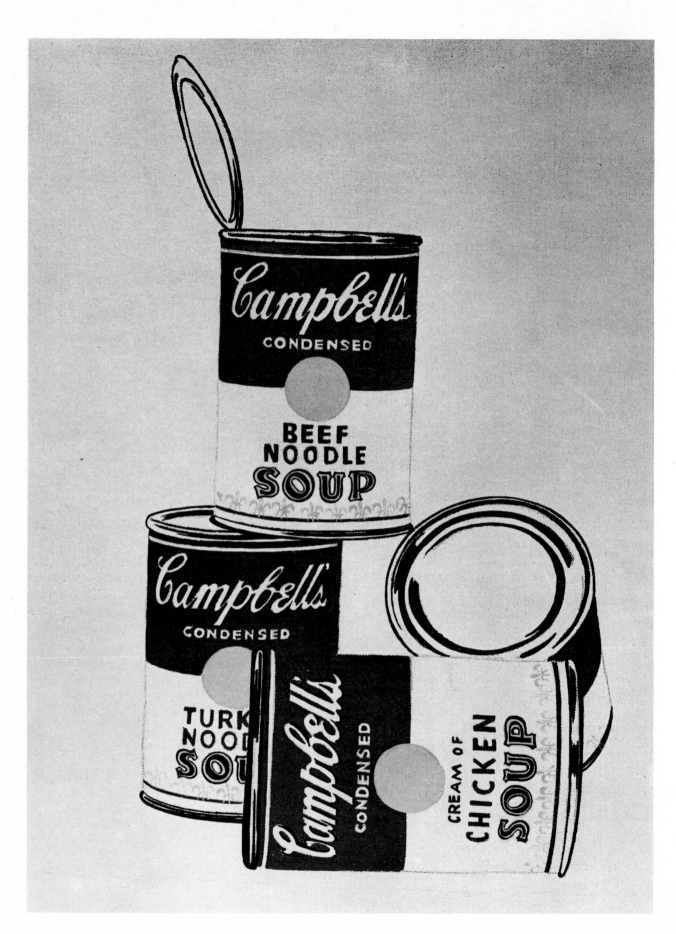

Four Campbell's Soup Cans, 1962. 20 x 16" (50.8 x 40.7 cm)
Collection Mr. and Mrs. Leo Castelli, New York

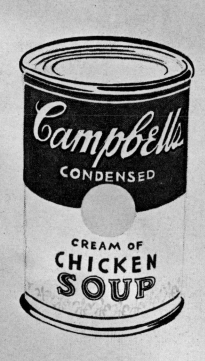

Campbell's Soup Can, 1962. 20 x 16" (50.8 x 40.7 cm)
Collection Galerie Buren, Stockholm, Sweden

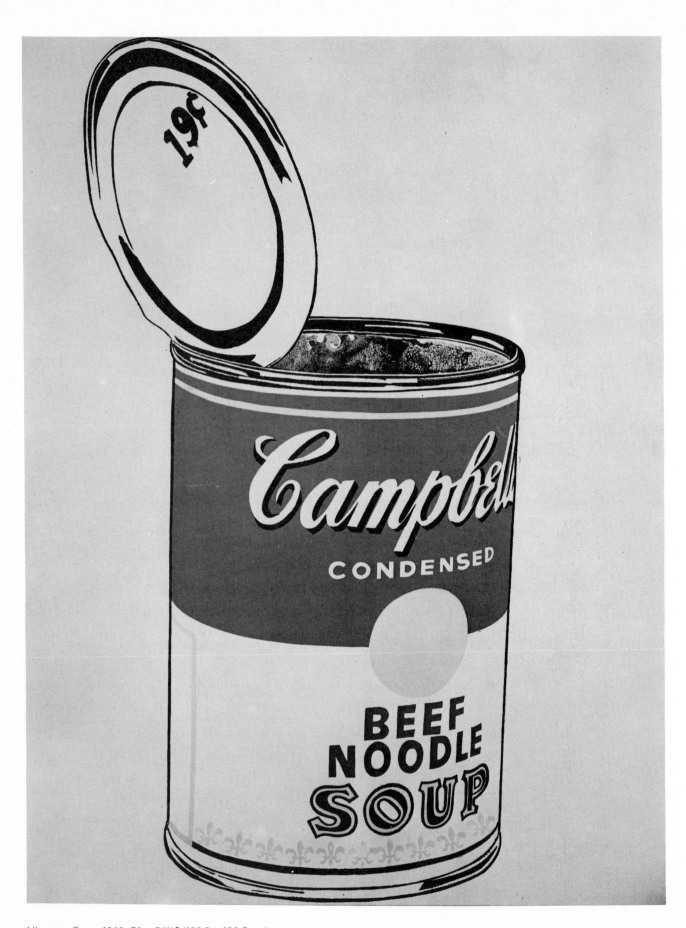

Nineteen Cents, 1960. 72 x 54½″ (182.9 x 138.5 cm)
Collection Mr. and Mrs. Robert A. Rowan, Pasadena

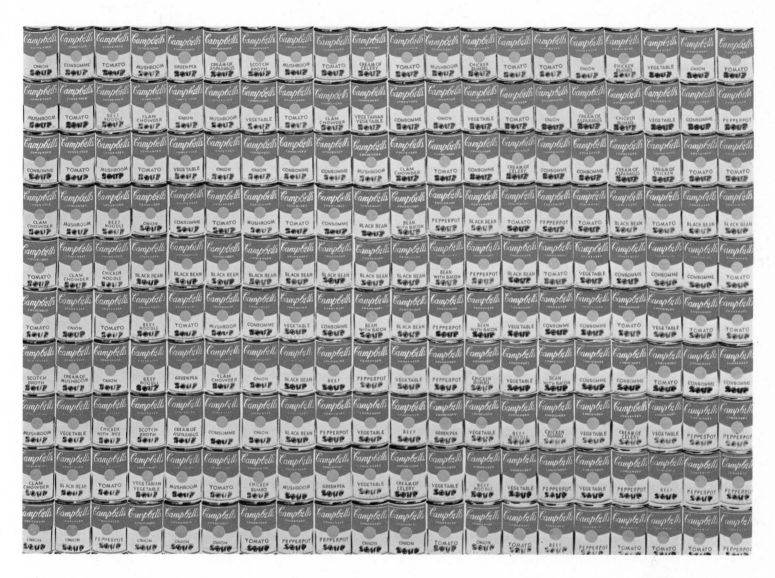

200 Soup Cans, 1962. 72 x 100" (182.9 x 254 cm)
Collection Kimiko and John Powers, Aspen, Colorado

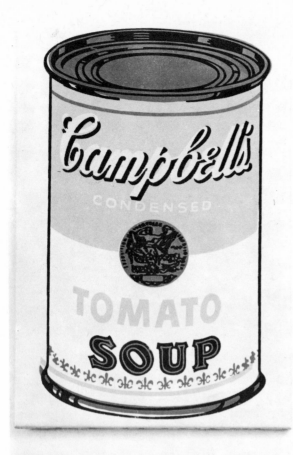

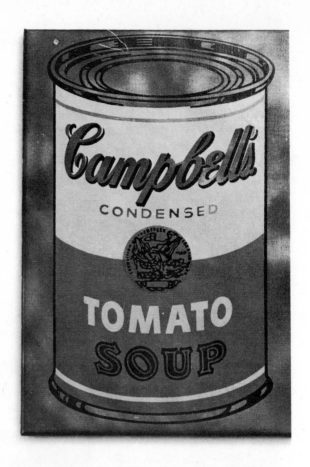

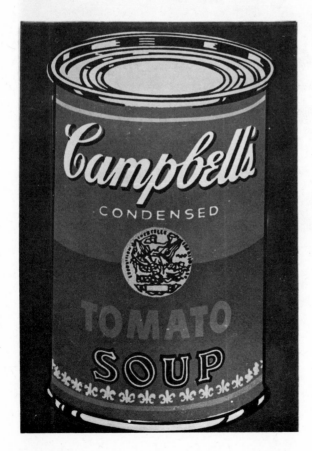

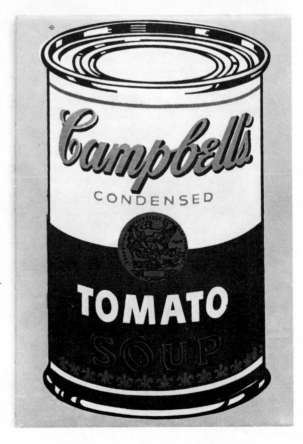

Campbell's Soup Cans, 1965. 4 paintings, each 36 x 24" (91.5 x 61 cm)
Collection Leo Castelli Gallery, New York (top left); Galerie Ileana Sonnabend, Paris (top right and bottom right);
The Museum of Modern Art, New York (bottom left)

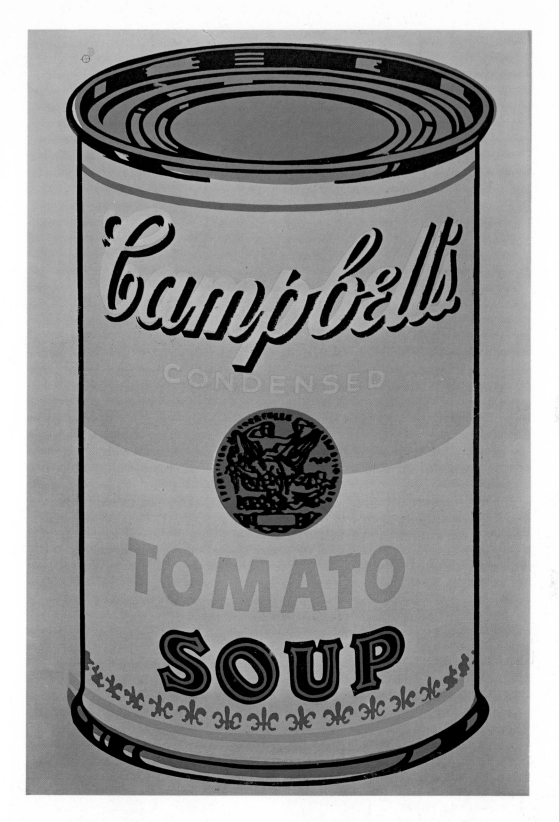

Campbell's Soup Can, 1965. 36 x 24″ (91.5 x 61 cm)
Collection Leo Castelli, New York

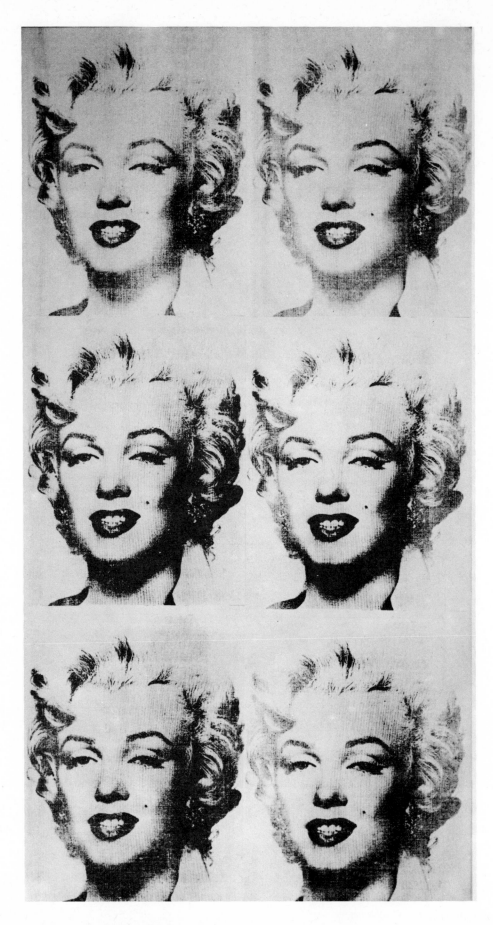

The Six Marilyns, (Marilyn Six-Pack), 1962. 43 × 22¼" (109.3 × 56.5 cm)
Collection Carter Burden, New York

68

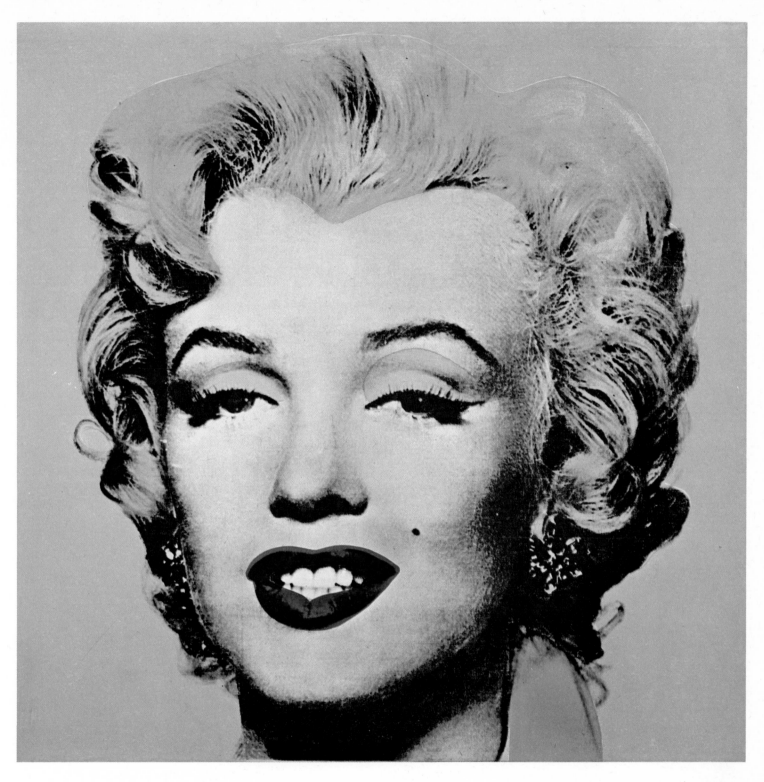

Marilyn Monroe, 1964. 40 x 40" (101.6 x 101.6 cm)
Collection Fred Mueller, New York

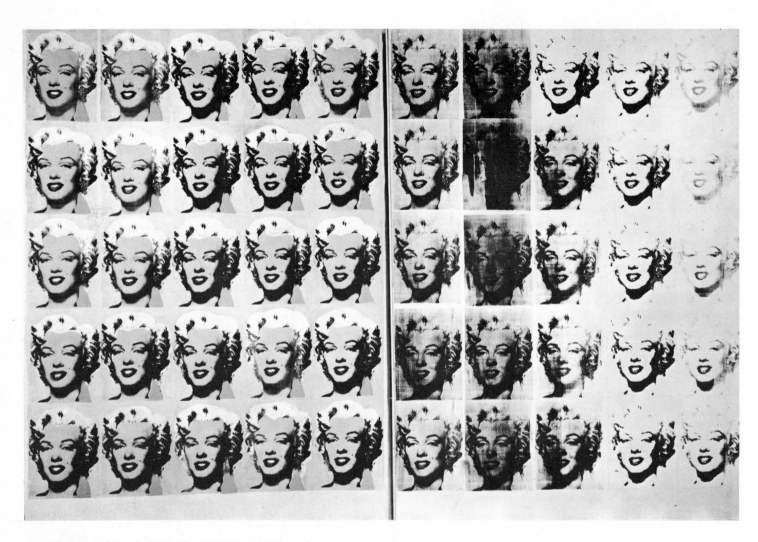

Marilyn Monroe Diptych, 1962. 82 x 114" (208.3 x 289.5 cm)
Collection Mr. and Mrs. Burton Tremaine, Meriden, Connecticut

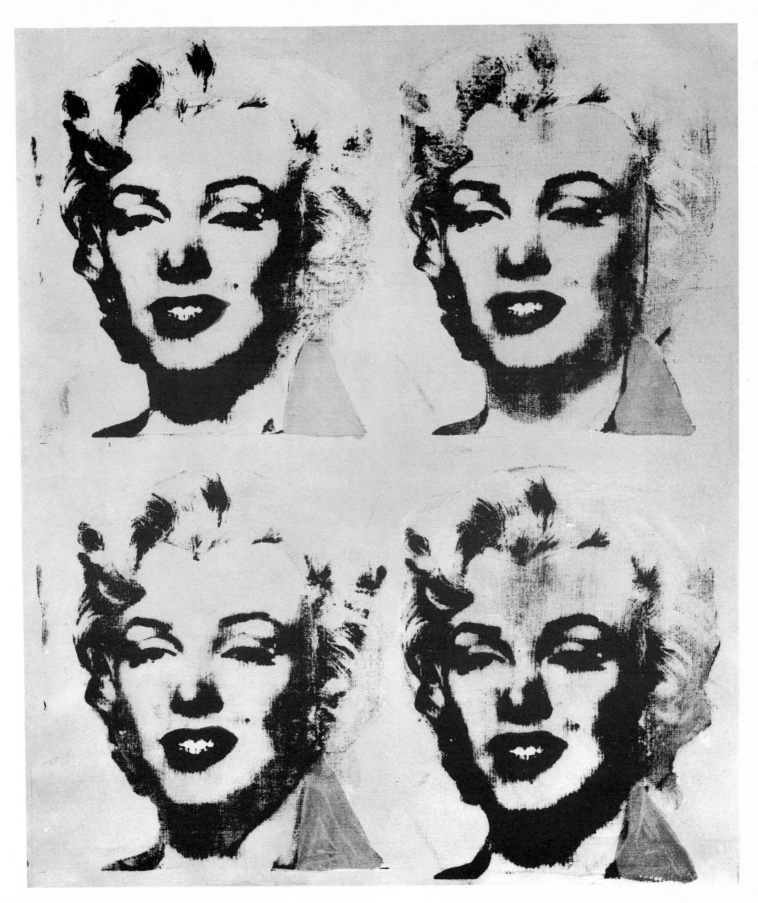

Marilyn Monroe. 1962. 40 x 32" (101.7 x 81.2 cm)
Collection Galerie Ileana Sonnabend, Paris

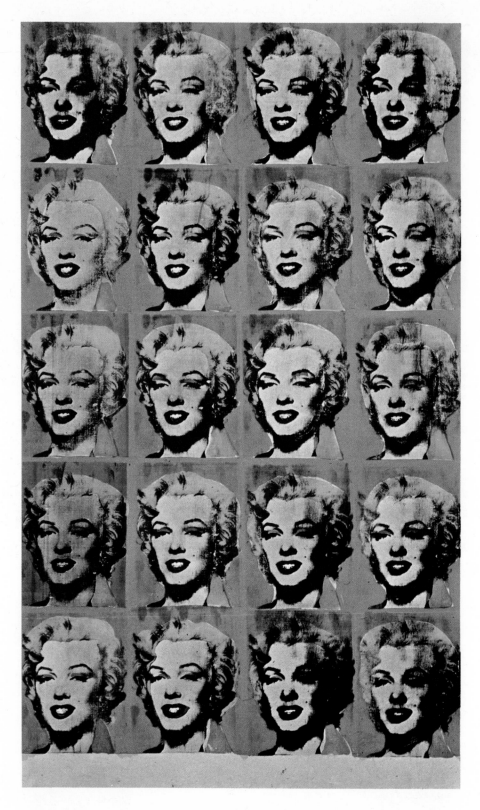

Marilyn Monroe, 1962. 81 x 66¾" (205.8 x 169.6 cm)
Collection René Montagu, Paris

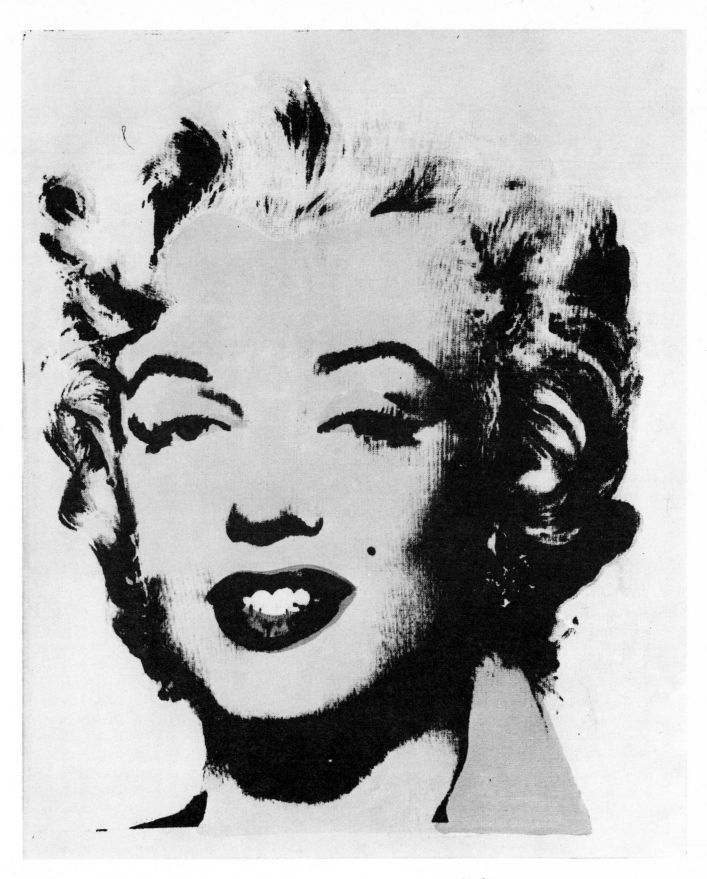

Marilyn Monroe, 1962. 20 x 16" (50.8 x 40.7 cm)
Collection Jasper Johns, New York

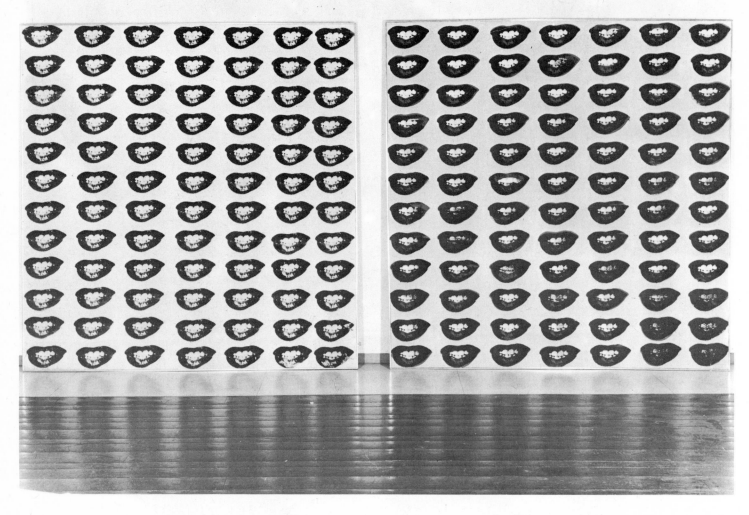

Marilyn Monroe's Lips, 1962. Left panel, 82½ x 82″ (209.6 x 208.3 cm), right panel, 82½ x 79½″ (209.6 x 202 cm)
Collection Joseph H. Hirshhorn, New York

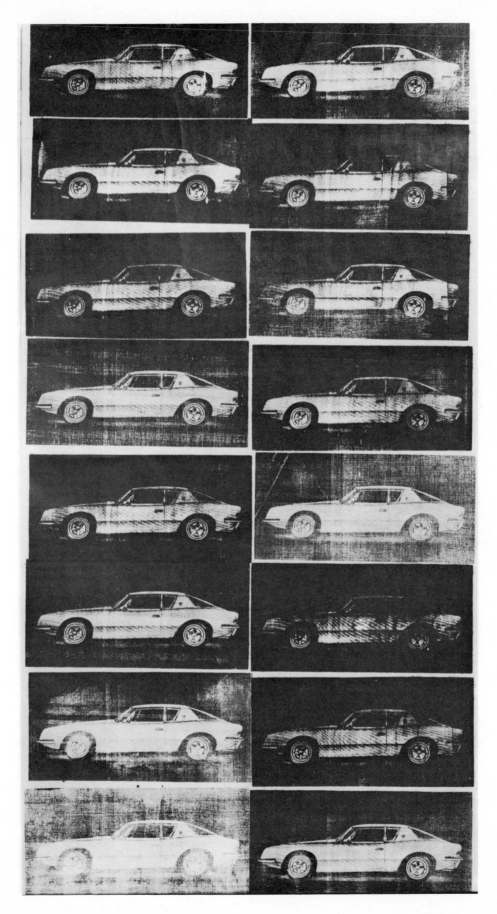

Cars. Collection the artist

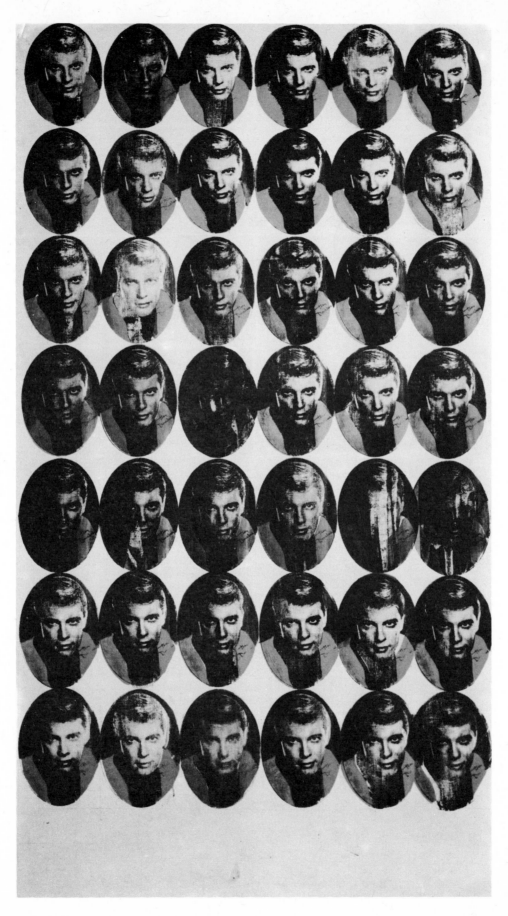

Troy Donahue, 1962. 43 x 84" (109.2 x 213.4 cm)
Private Collection

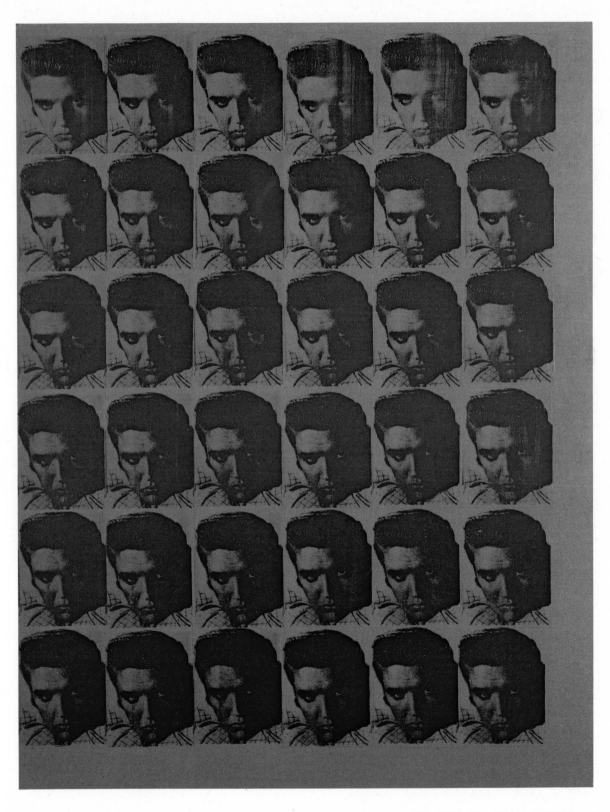

Elvis, 1962. 68 x 58" (172.7 x 147.3 cm)
Collection Galerie Bischofberger, Zurich, Switzerland

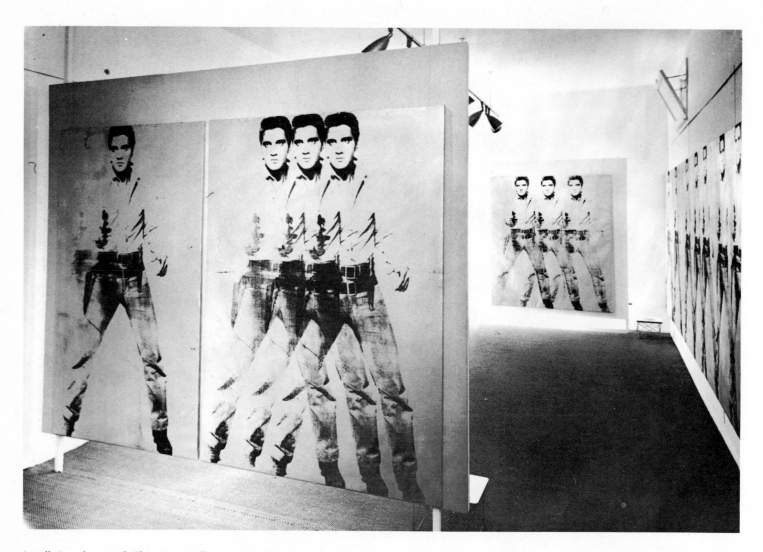

Installation photograph *Elvis,* Ferus Gallery, Los Angeles, 1963

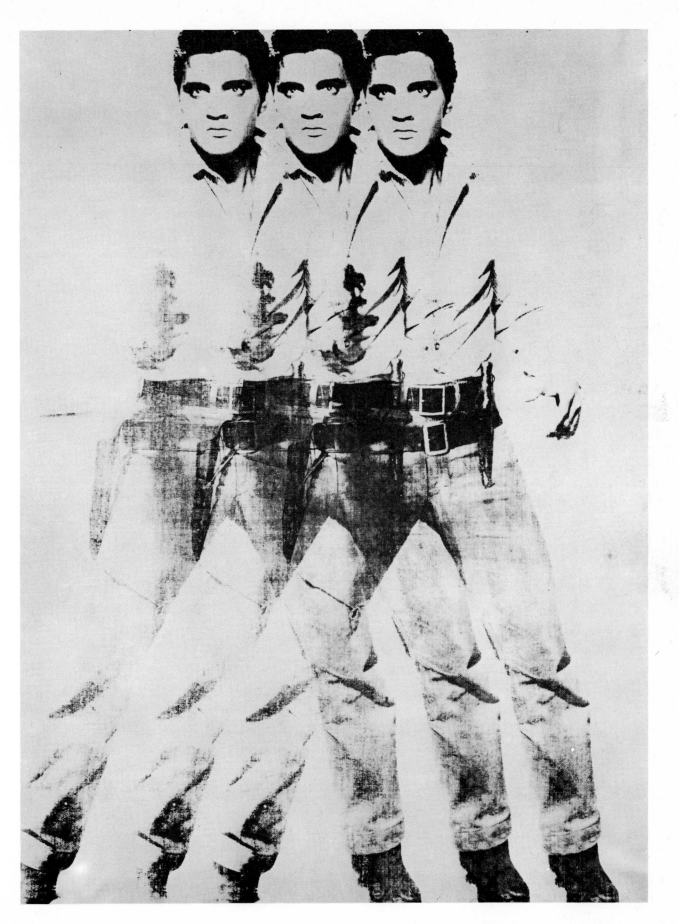

Elvis, 1964. 82 x 60" (208.3 x 152.4 cm)
Collection Leo Castelli Gallery, New York

79

Triple Elvis, 1962. 82 x 42" (208.3 x 106.7 cm)
Collection Harry N. Abrams Family, New York

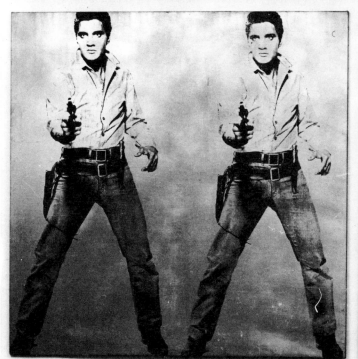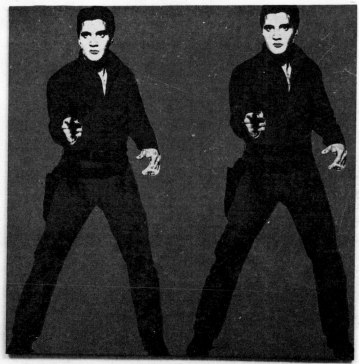

Elvis I and Elvis II, 1964. 2 panels, each 82 x 82" (208.3 x 208.3 cm)
Collection Art Gallery of Ontario, Toronto

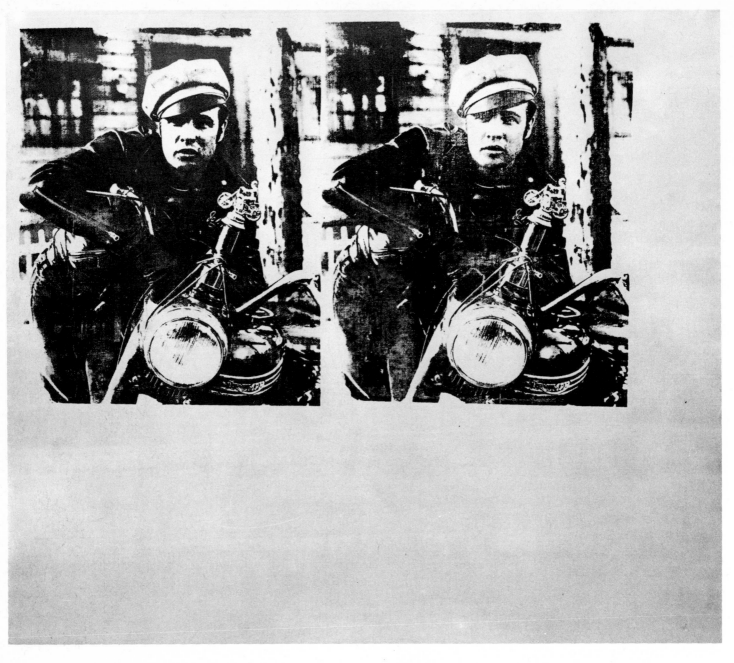

Silver Marlon Brando, 1963. 70 x 80" (177.8 x 203.2 cm)
Collection L. M. Asher Family, Los Angeles

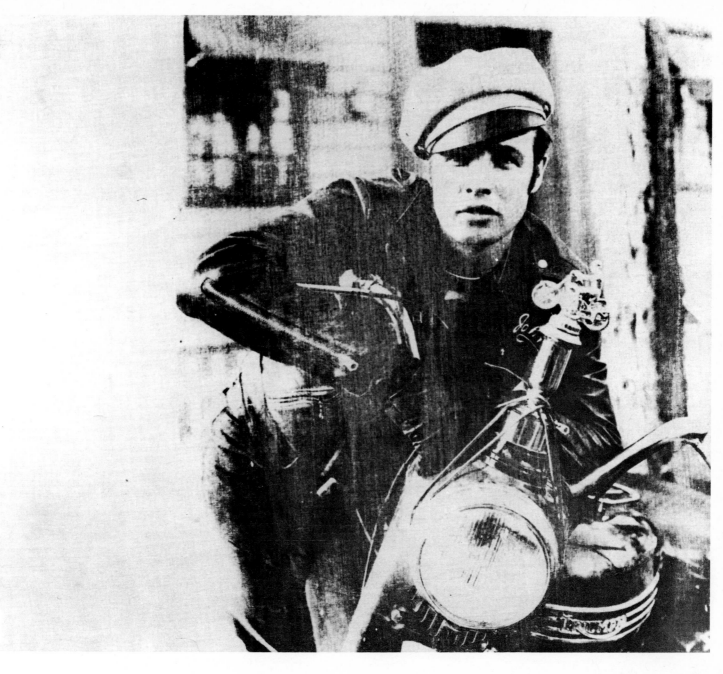

Marlon Brando, 1966. 41 x 47¼" (104 x 120 cm)
Collection Dr. and Mrs. A. F. Essellier, Zurich, Switzerland

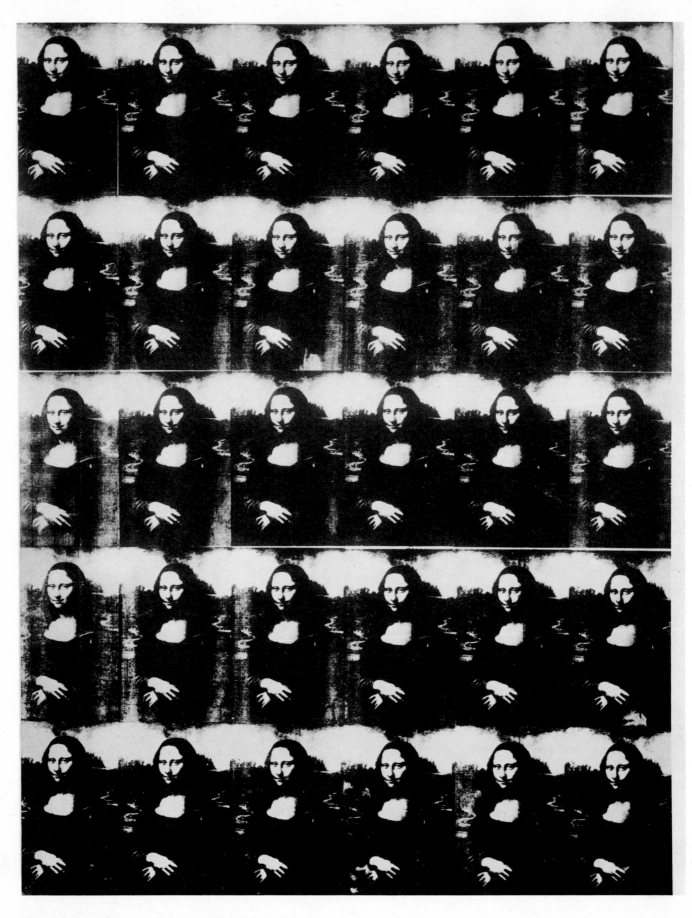

Thirty Are Better Than One, 1963. 110 x 82" (279.4 x 208.3 cm)
Collection Mr. and Mrs. Peter M. Brant, New York

84

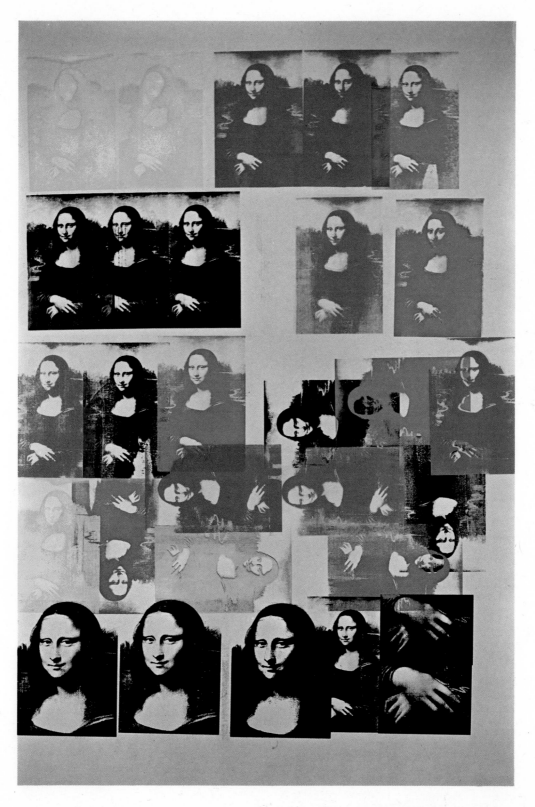

Mona Lisa, 1963. 128 x 82" (325.1 x 208.3 cm)
Collection Elinor Ward, New York

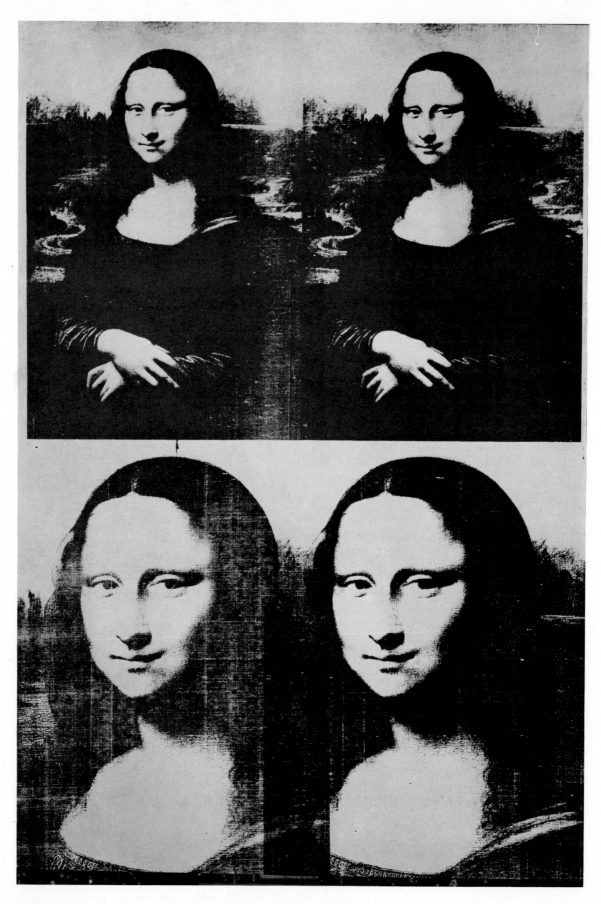

Mona Lisa, 1965. 44 x 29" (111.3 x 73.7 cm)
Collection The Metropolitan Museum of Art, New York, Gift of Henry Geldzahler, 1965

86

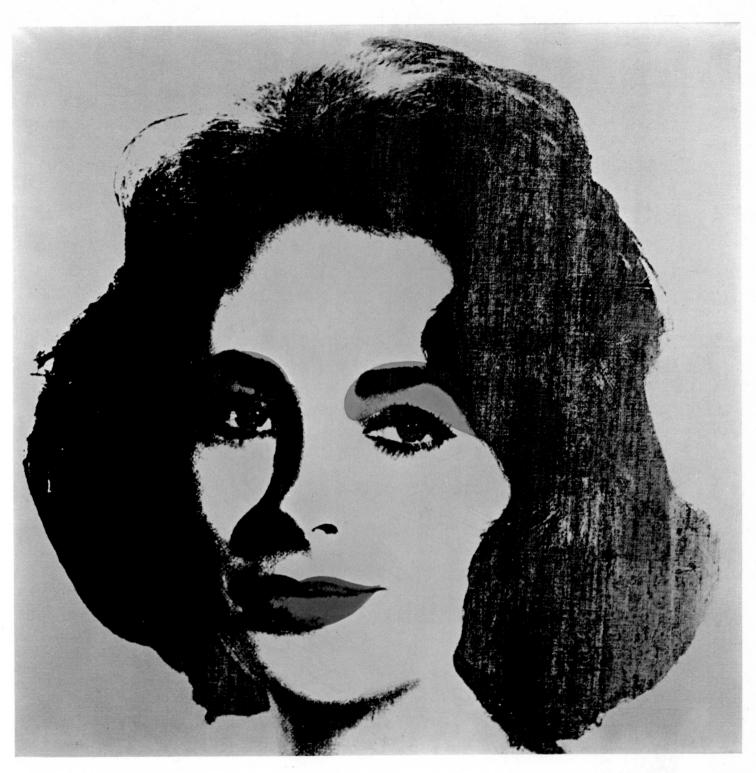

Liz, 1963. 40 x 40" (101.5 x 101.5 cm)
Collection Galleria Sperone, Turin, Italy

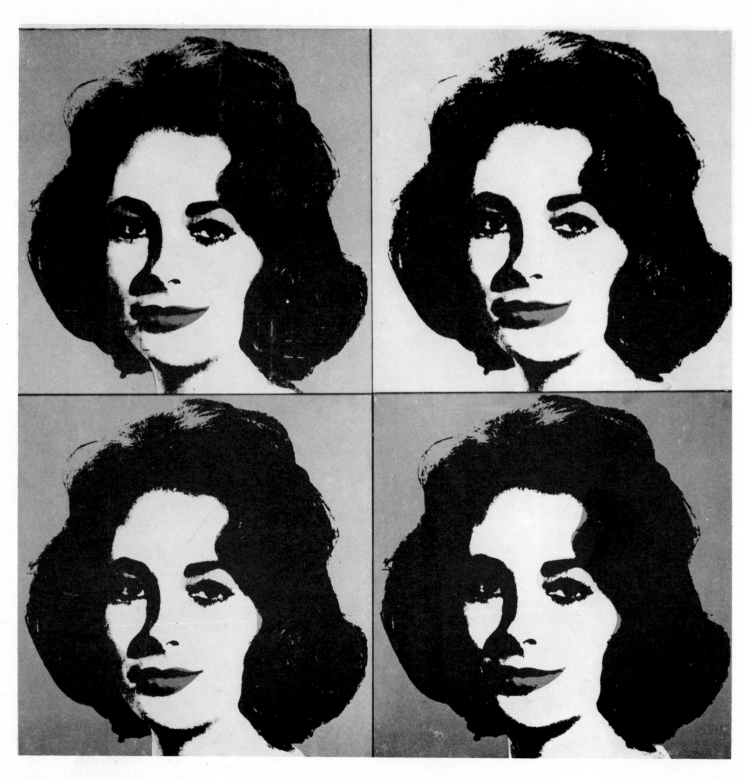

Liz, 1963. 4 paintings, each 40 x 40″ (101.6 x 101.6 cm)

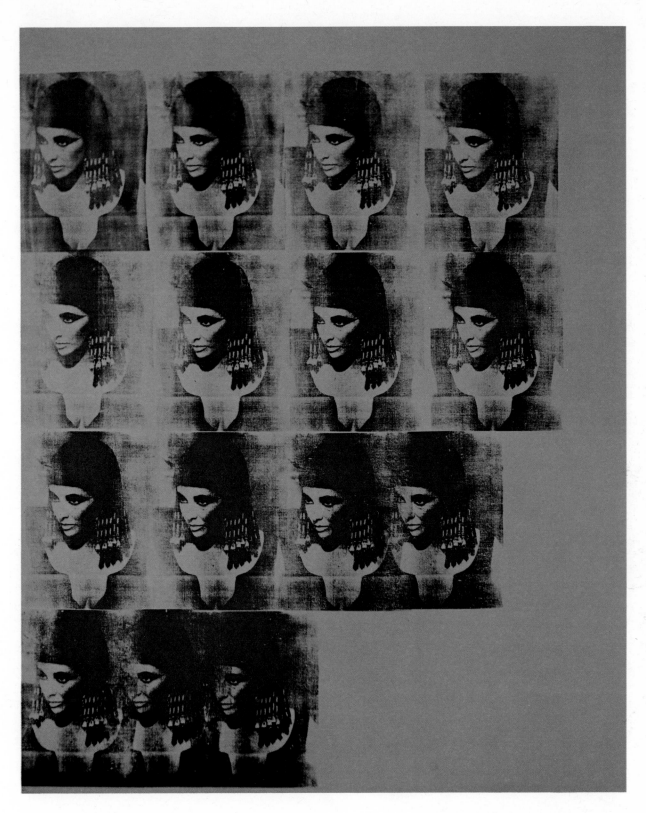

Liz as Cleopatra, 1962. 72 x 60" (182.9 x 152.4 cm)
Collection Dagny Janss, Malibu, California

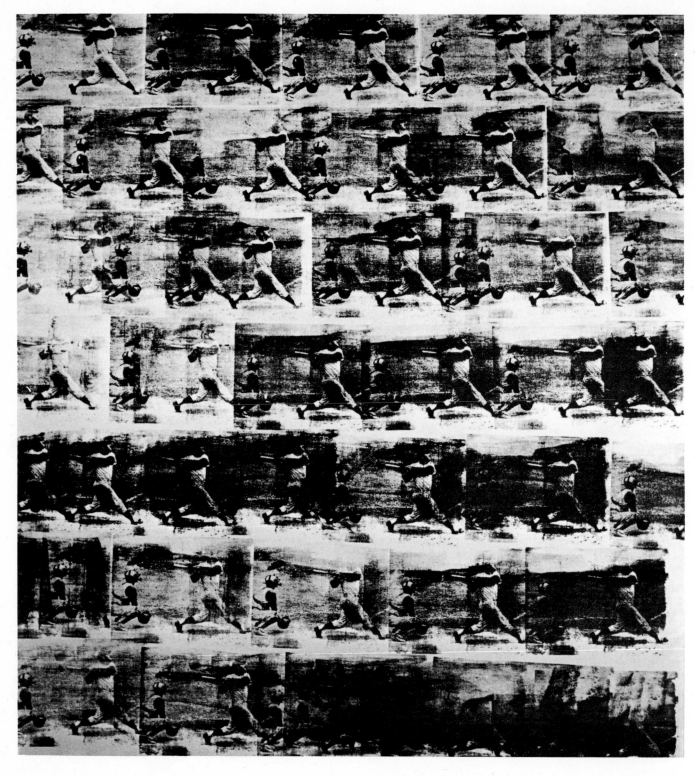

Baseball, 1962. 91½ x 82" (232.4 x 208.3 cm)
Collection William Rockhill Nelson Gallery Of Art—Atkins Museum of Fine Arts, Kansas City, Missouri

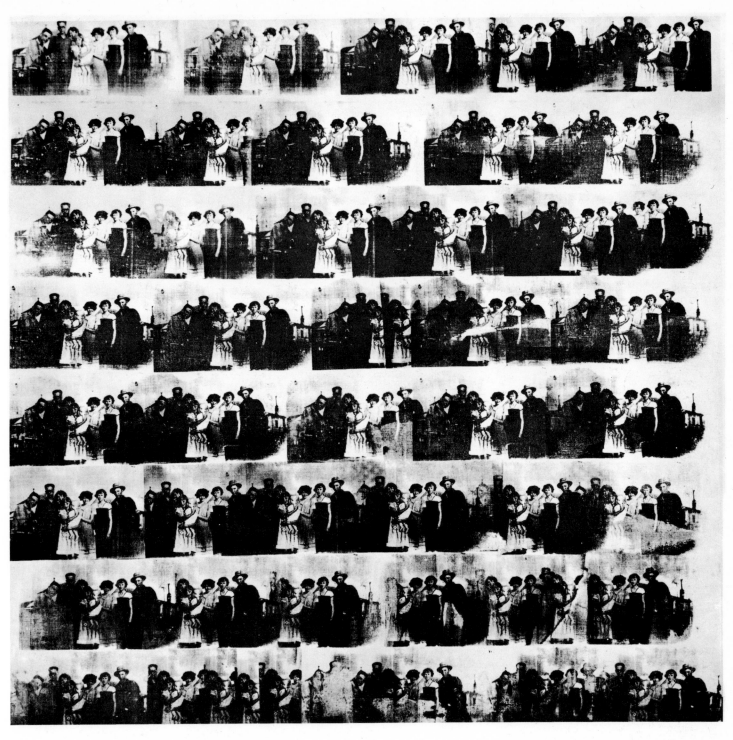

Let Us Now Praise Famous Men, 1962. 82 x 82″ (208.3 x 208.3 cm)
Collection Howard Adams, Washington, D. C.

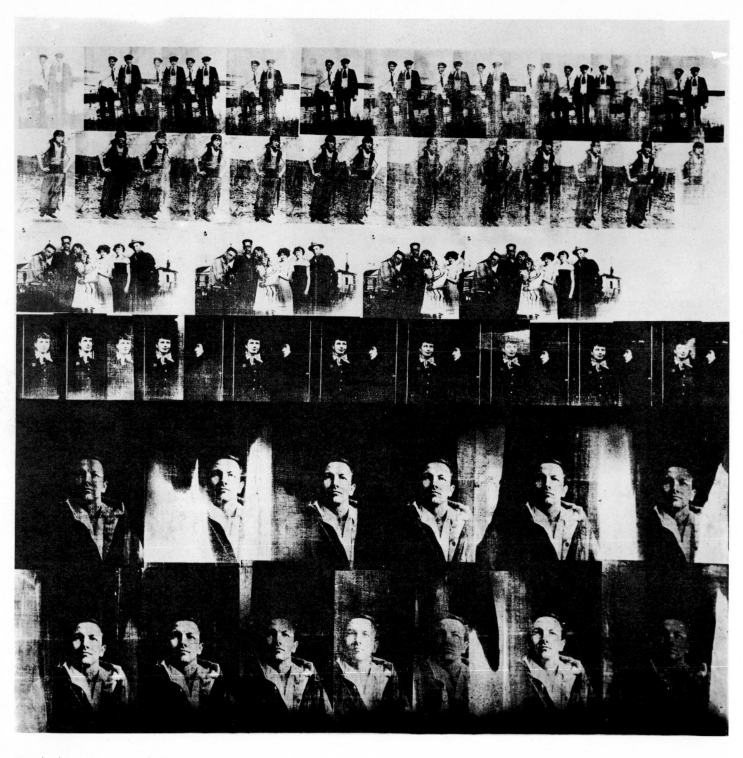

Rauschenberg, 1963. 82 x 82″ (208.3 x 208.3 cm)
Collection Harry N. Abrams Family, New York

92

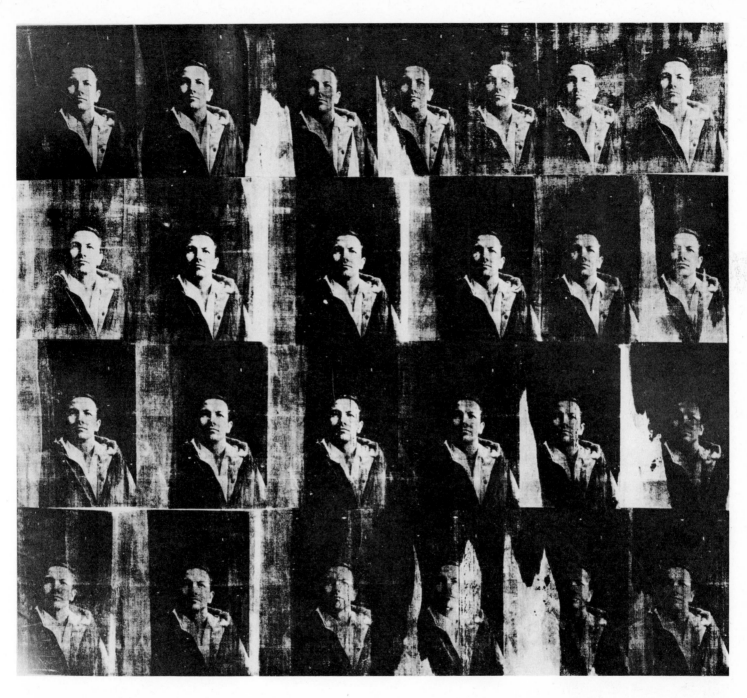

Texan, 1962. 82 x 82" (208.3 x 208.3 cm)
Collection Dr. Peter Ludwig, Wallraf-Richartz Museum, Cologne, Germany

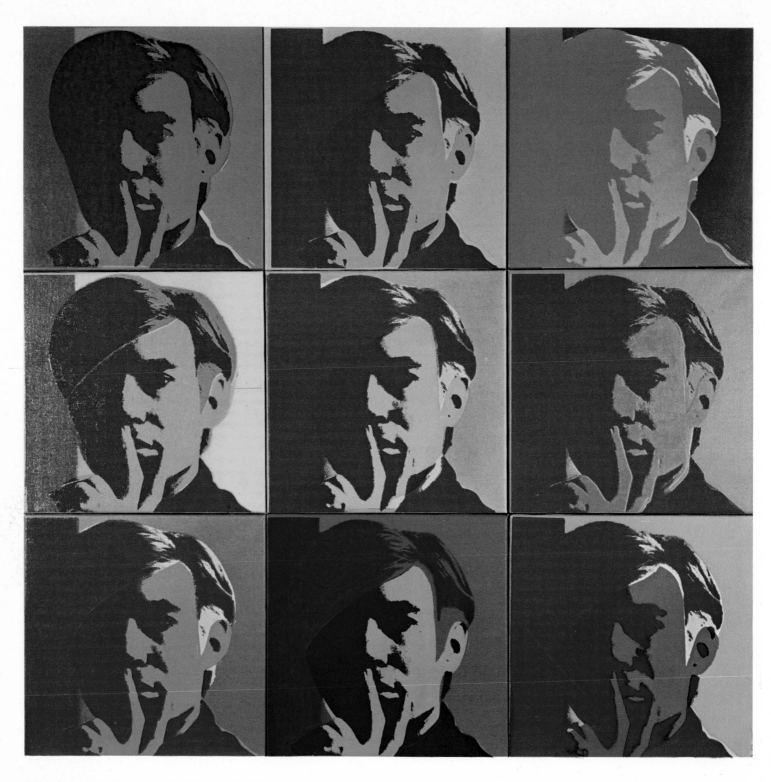

Self Portrait, 1966. 9 panels, each 22½ x 22½" (57.2 x 57.2 cm)
Collection David Whitney, New York

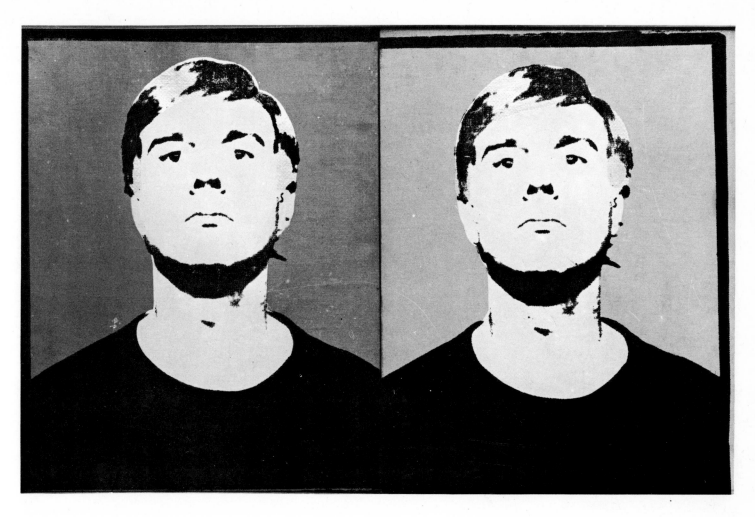

Self Portrait, 1964. 2 panels, each 20 x 16" (50.8 x 40.7 cm)
Collection Mr. and Mrs. Robert C. Scull, New York

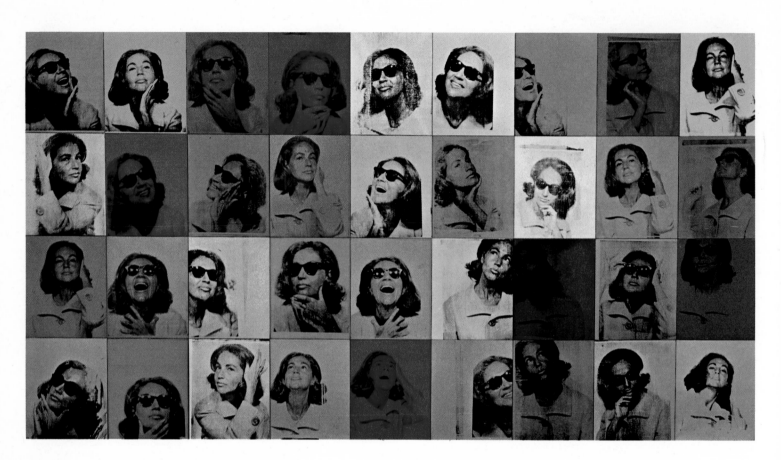

Ethel Scull 36 Times, 1963. 144 x 100" (365.8 x 254 cm)
Collection Mr. and Mrs. Robert C. Scull, New York

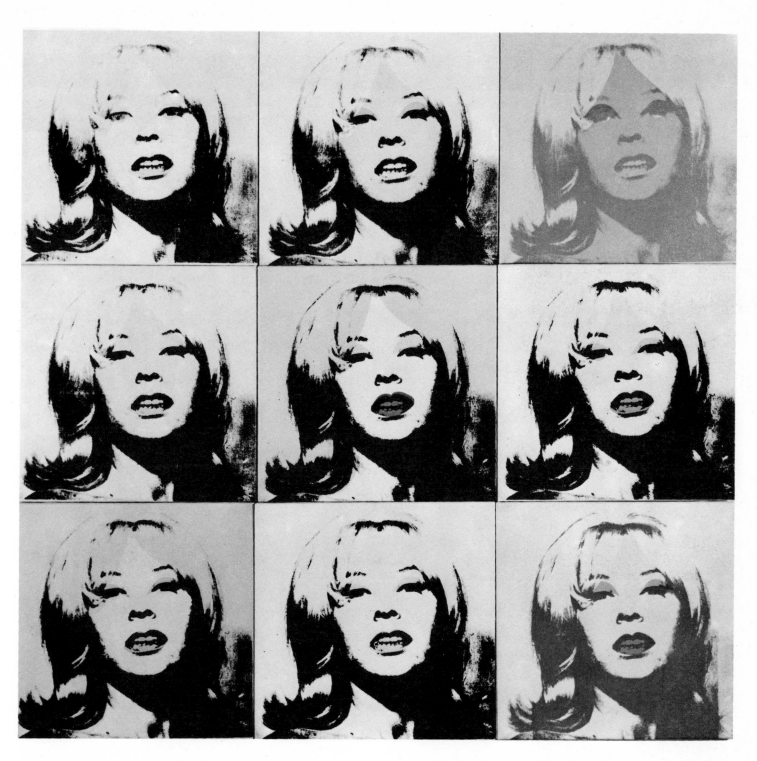

Portrait of Holly Solomon, 1966, 9 panels, 81 x 81" (205.8 x 205.8 cm)
Collection Mr. and Mrs. Horace H. Solomon, Englewood, New Jersey

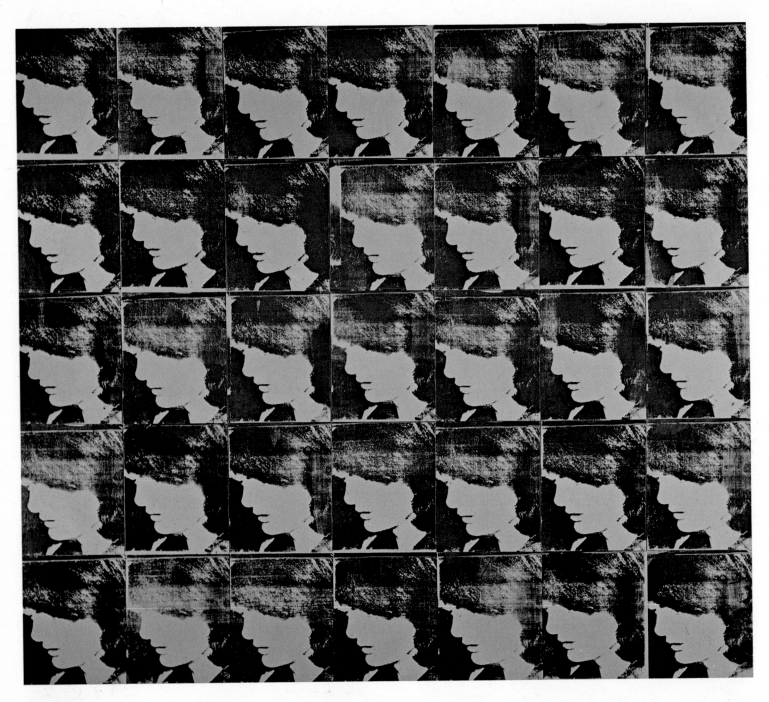

Jackie, 1965. 35 panels, each 20 x 16" (50.8 x 40.7 cm)
Collection Dr. Karl Ströher, Darmstadt, Germany

Jacqueline, 1964. 20 x 16″ (50.8 x 40.7 cm)
Collection Charles Wm. Bartholomew, Lakeville, Minnesota

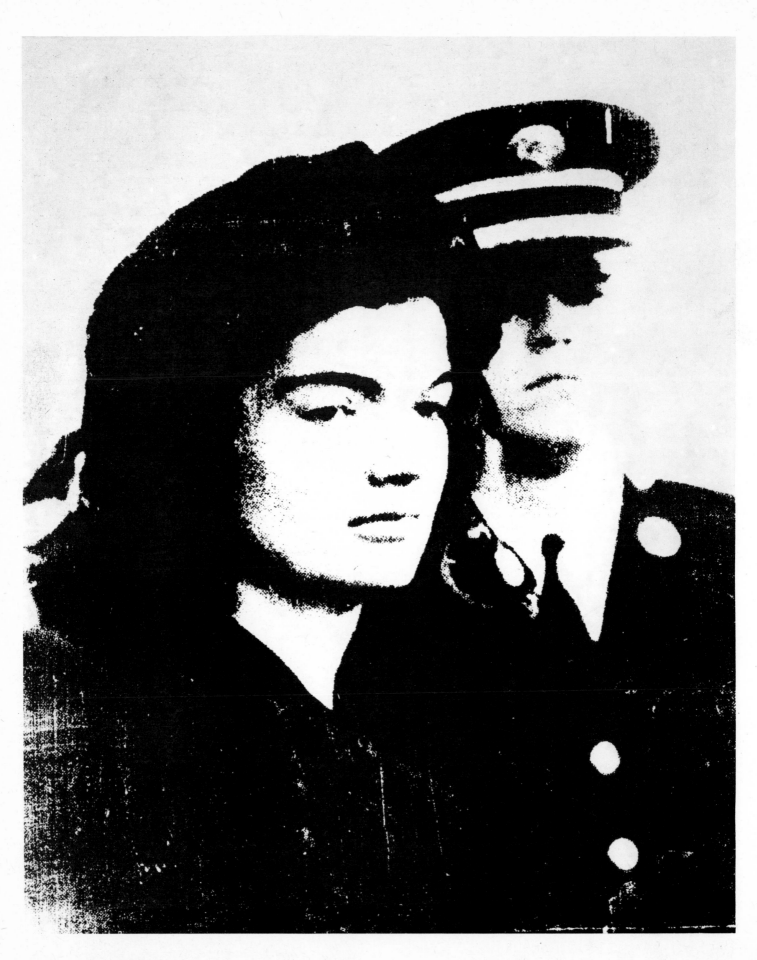

Jacqueline, 1964. 20 x 16" (50.8 x 40.7 cm)
Collection Dayton's Gallery 12, Minneapolis, Minnesota

100

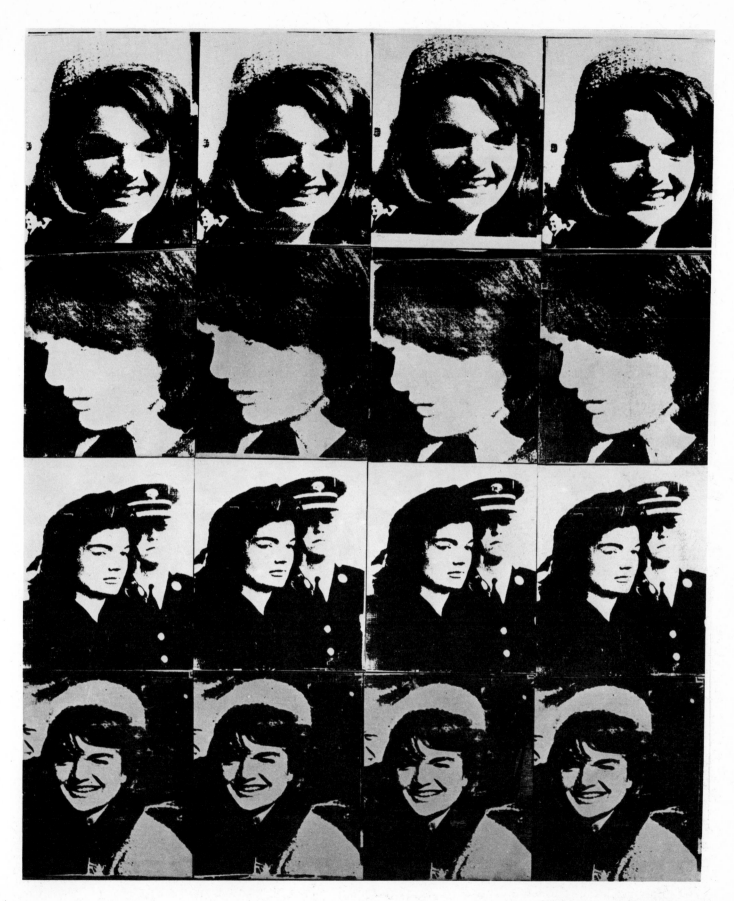

16 Jackies, 1964. 80 x 64" (203.2 x 162.6 cm)
Collection Walker Art Center, Minneapolis, Minnesota

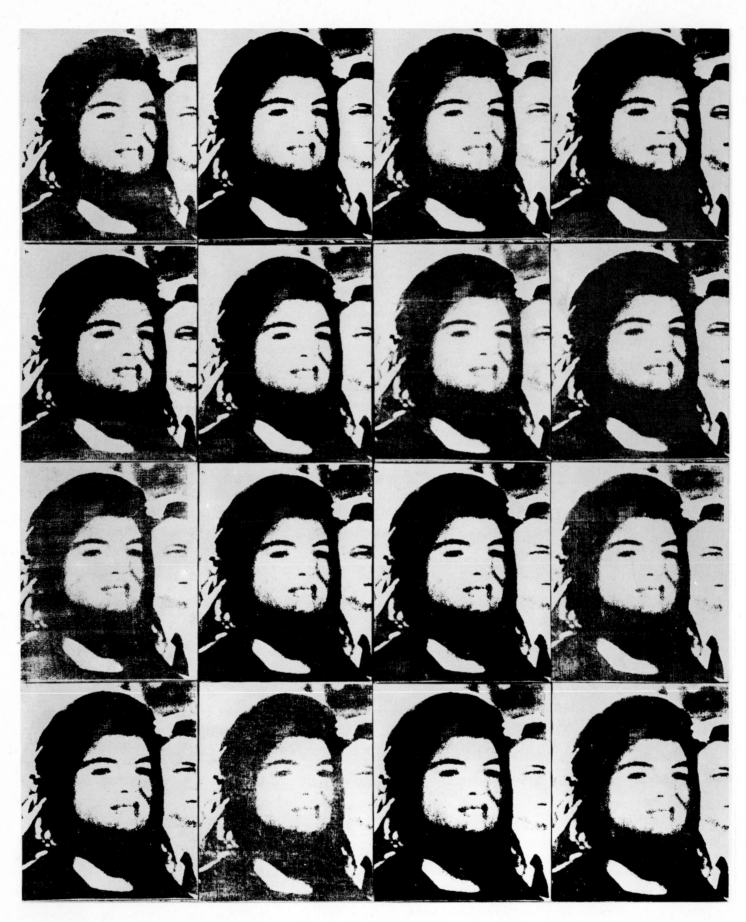

Jackie, 1965. 16 panels, 80 x 64″ (203.2 x 162.6 cm)
Collection Dunkelman Gallery, Toronto, Ontario

102

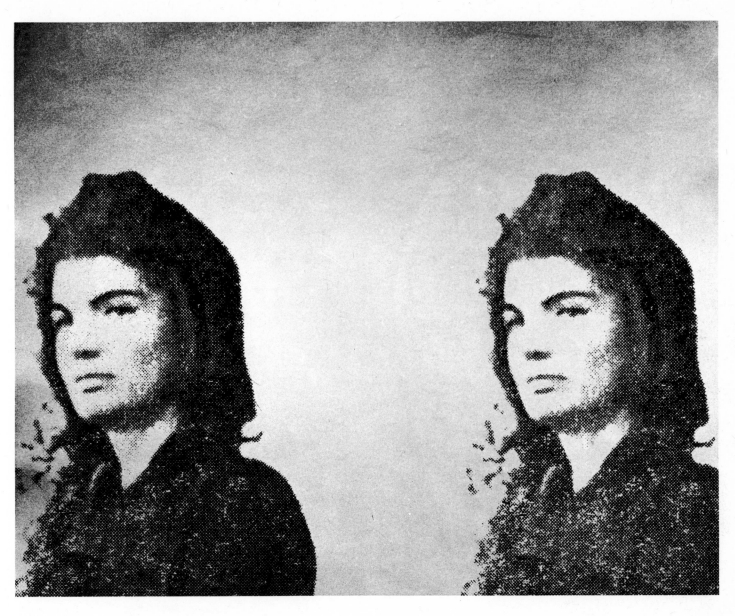

Two Jackies, 1966. 24 x 30″ (61 x 76.2 cm)

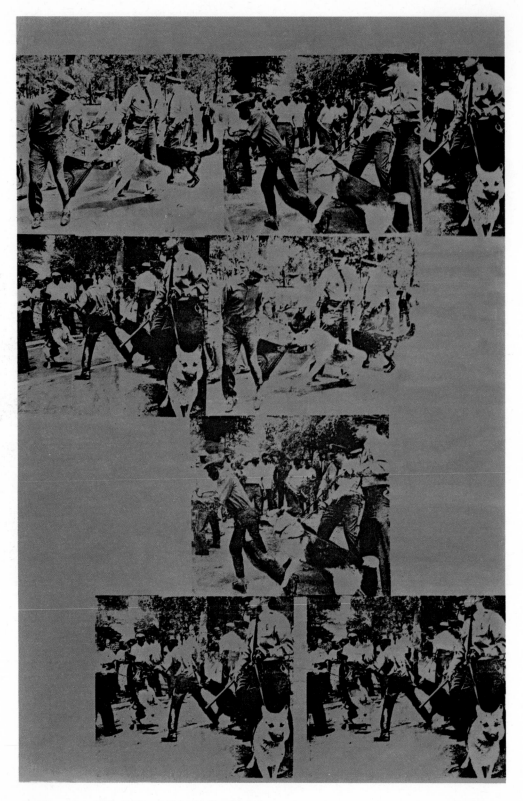

Red Race Riot, 1963. 131¼ x 83½″ (333.4 x 212 cm)

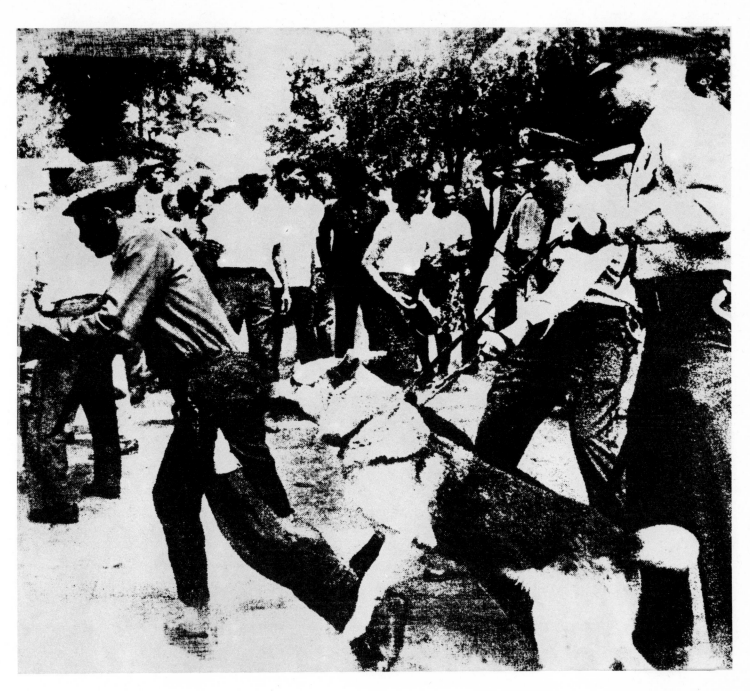

Race Riot, 1964. 30 x 33″ (76.2 x 83.8 cm)
Collection Leo Castelli Gallery, New York

Tunafish Disaster, 1963. 112¼ x 81⅞" (285 x 208 cm)
Collection Cy Twombly, Rome, Italy

Mrs. McCarthy and Mrs. Brown, 1963. 45¼ x 78¾" (115 x 200 cm)
Collection Galerie Apollinaire, Milan, Italy

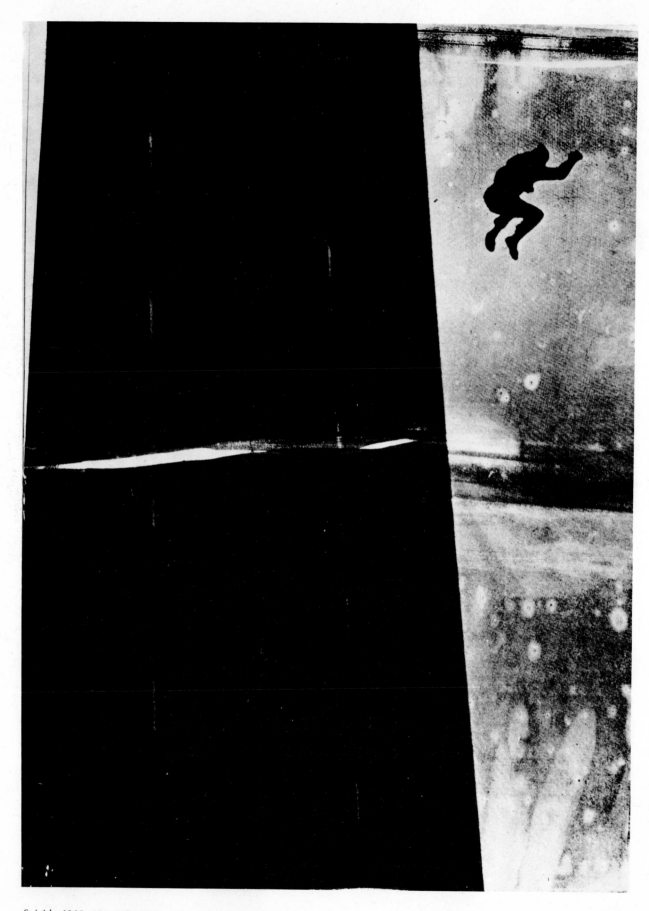

Suicide, 1962. 40 x 30" (101.7 x 76.2 cm)

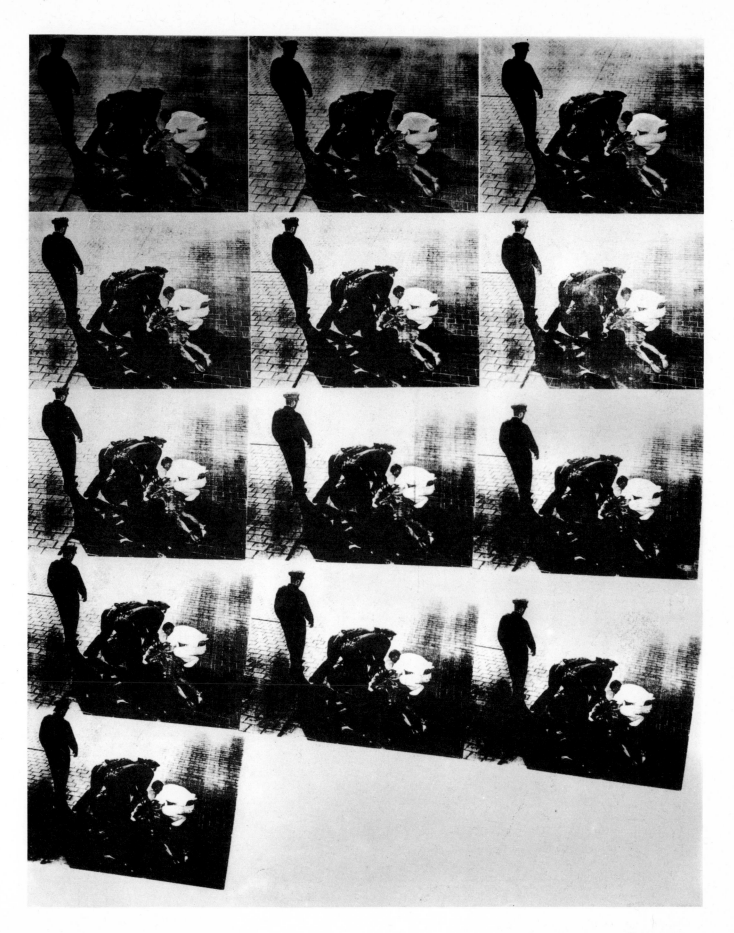

Bellevue, 1963. 106 x 78" (270 x 200 cm)
Collection Galleria Sperone, Turin, Italy

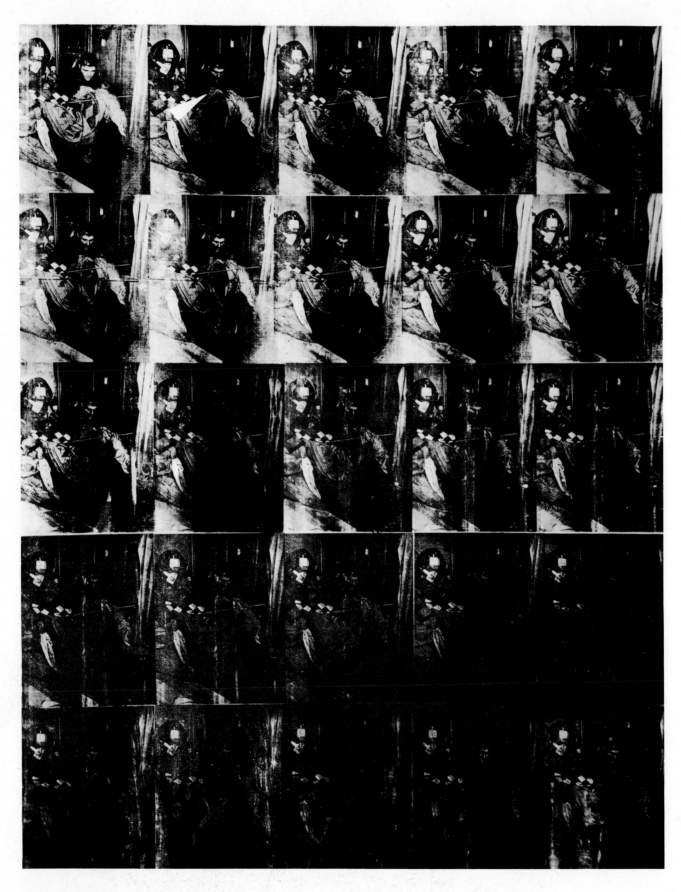

Disaster, 1963. 96 x 72" (243.9 x 182.9 cm)
Collection Los Angeles County Museum of Art, Los Angeles

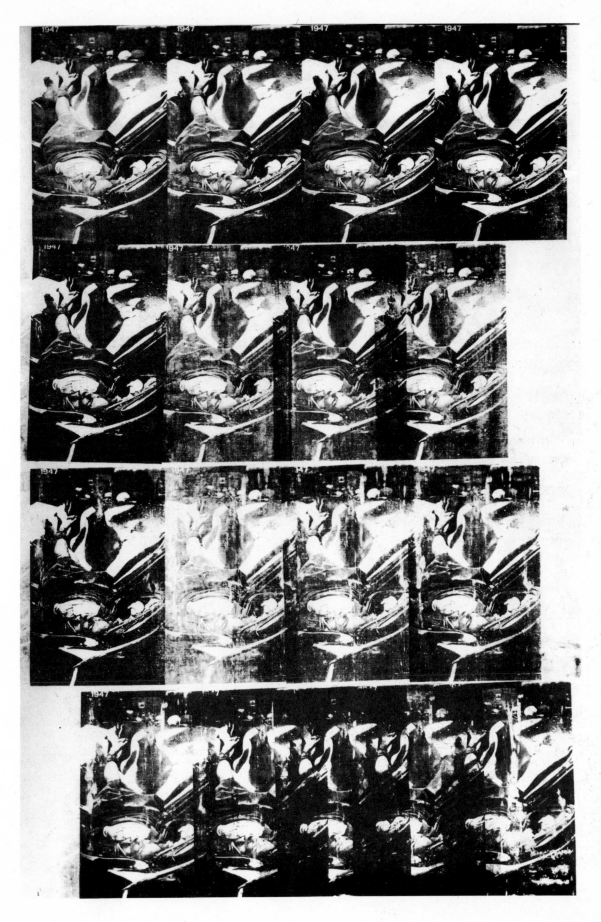

1947 White, 1963. 121¼ × 78″ (309 × 198 cm)
Collection Luciano Pomini Castellanza, Italy

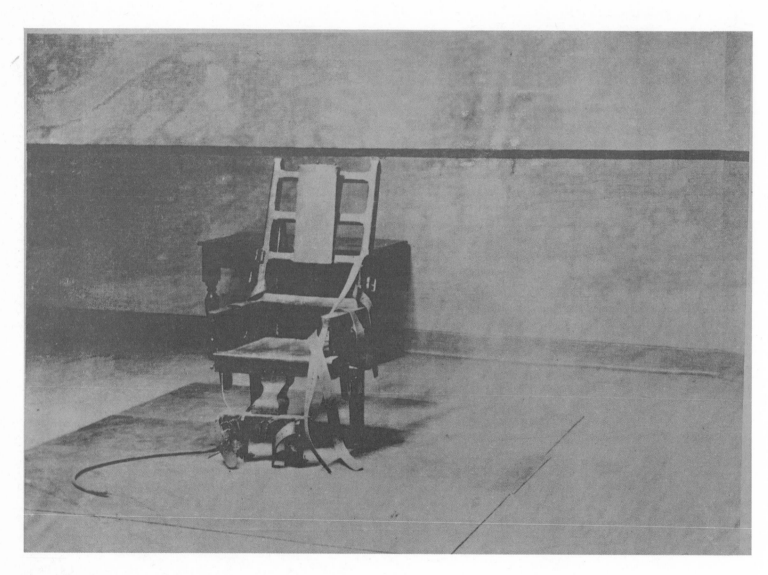

Electric Chair, 1967. 54 x 73" (137.2 x 185.5 cm)
Collection Mr. and Mrs. Peter M. Brant, New York

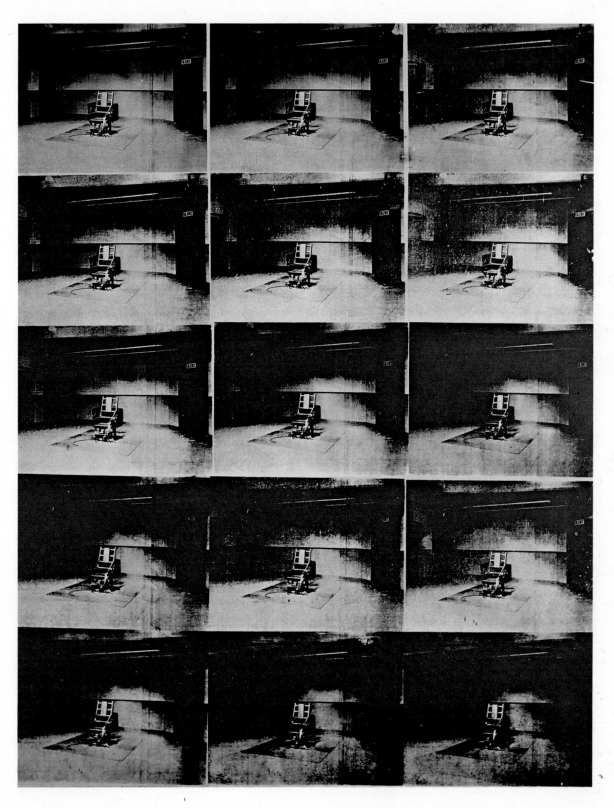

Lavender Disaster, 1964. 108 x 82" (274.3 x 208.3 cm)
Collection Mr. and Mrs. Robert A. Rowan, Pasadena

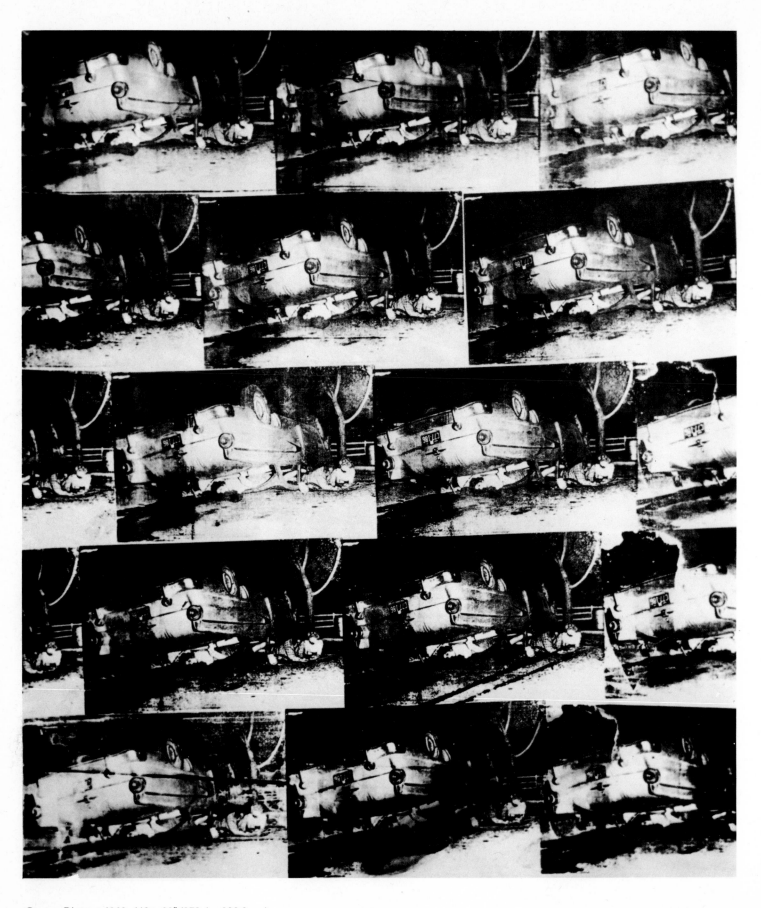

Orange Disaster, 1963. 110 x 82″ (279.4 x 208.3 cm)

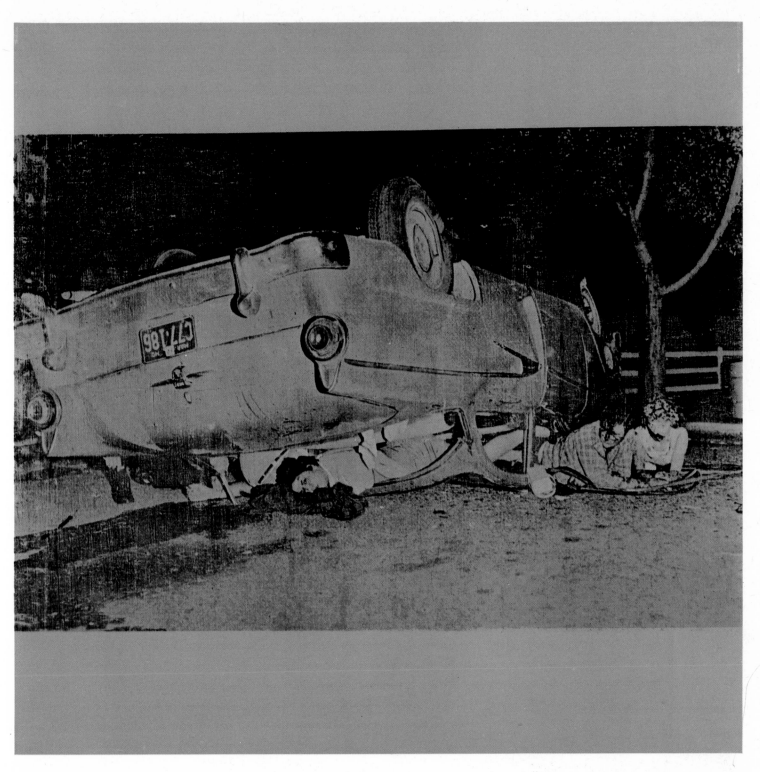

Orange Disaster, 1963. 30⅛ x 30⅛" (76.5 x 76.5 cm)
Collection Walter Hopps, Washington, D.C.

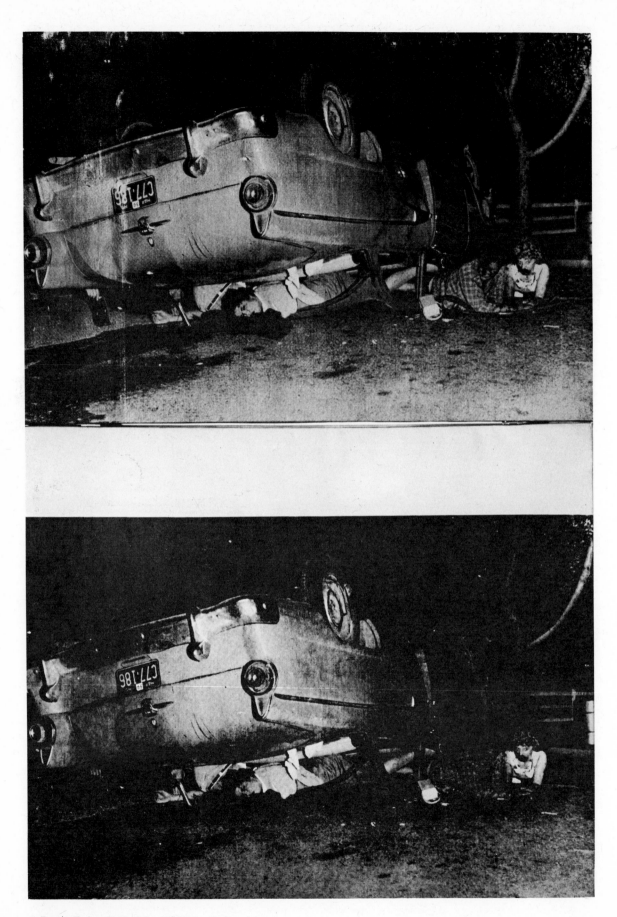

5 Deaths Twice, 1963. 50 x 30" (127 x 76.2 cm)
Collection Dr. R. Mattheys

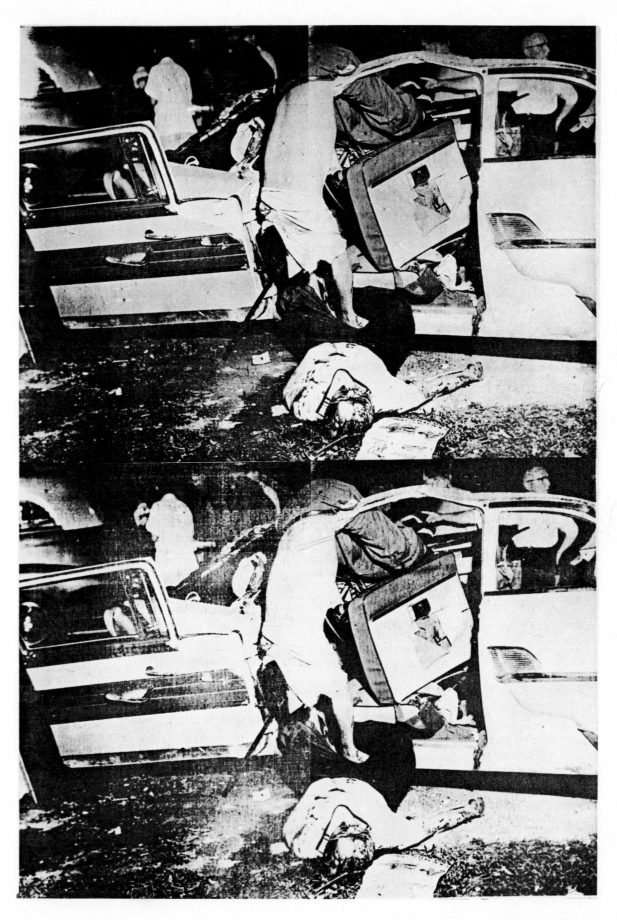

Saturday Disaster, 1964. 120 x 82" (304.8 x 208.3 cm)
Collection Rose Art Museum, Brandeis University, Waltham, Massachusetts

117

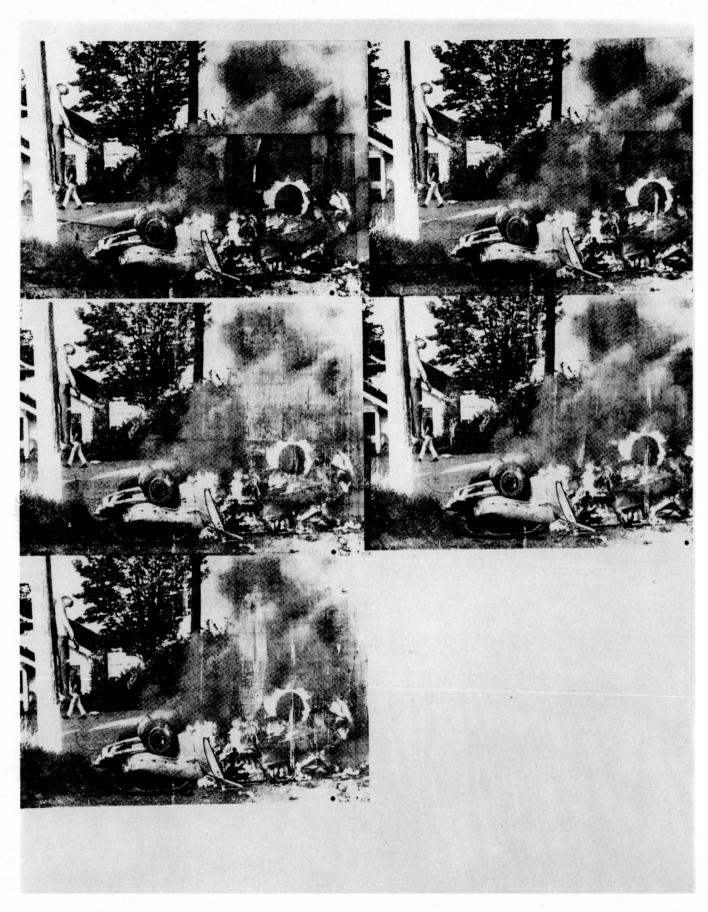

White Disaster, 1963. 106⅜ x 82¾" (270 x 210 cm)
Collection Dr. Karl Ströher, Darmstadt, Germany

118

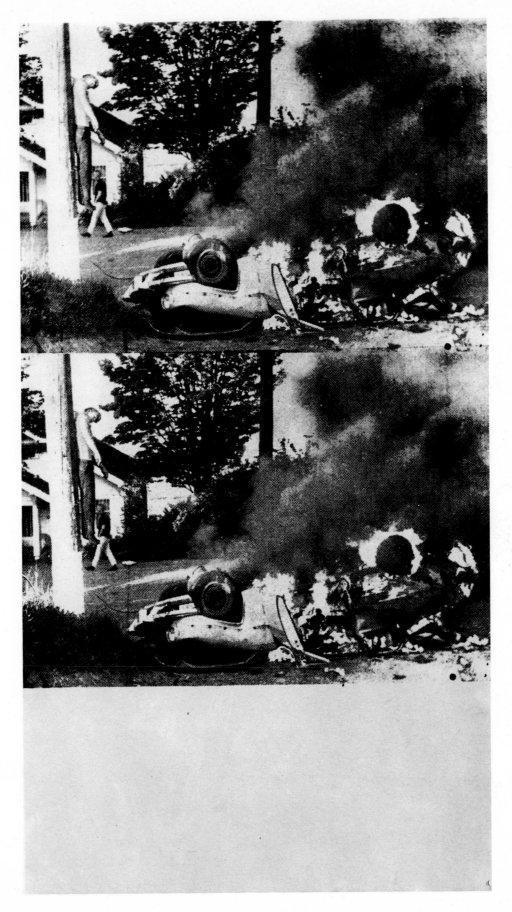

White Car Crash, 1963.
Collection Galerie Ileana Sonnabend, Paris

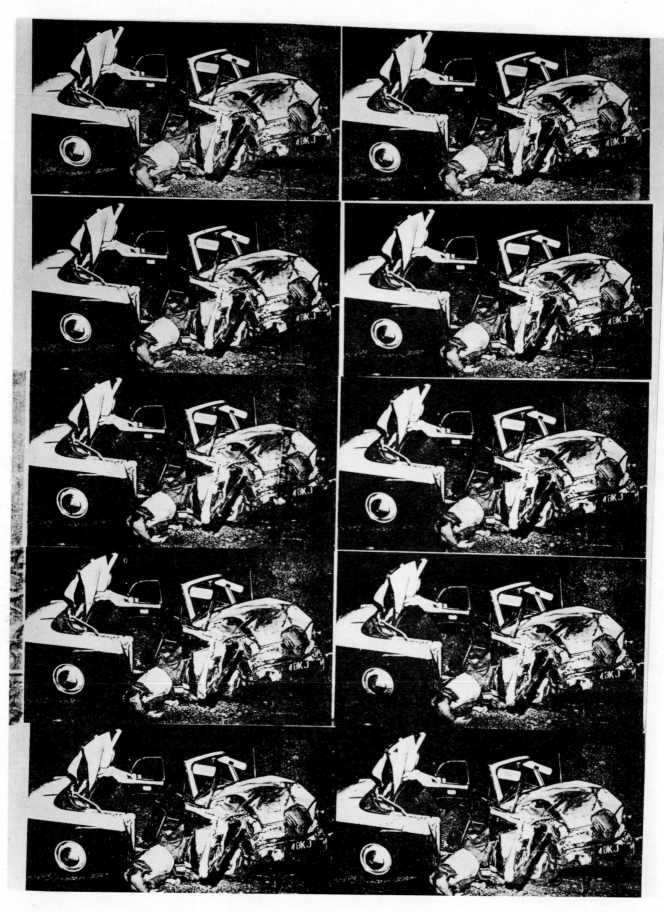

Green Disaster #2, 1963. 106 x 82" (269.2 x 208.3 cm)
Collection Dr. Karl Ströher, Darmstadt, Germany

120

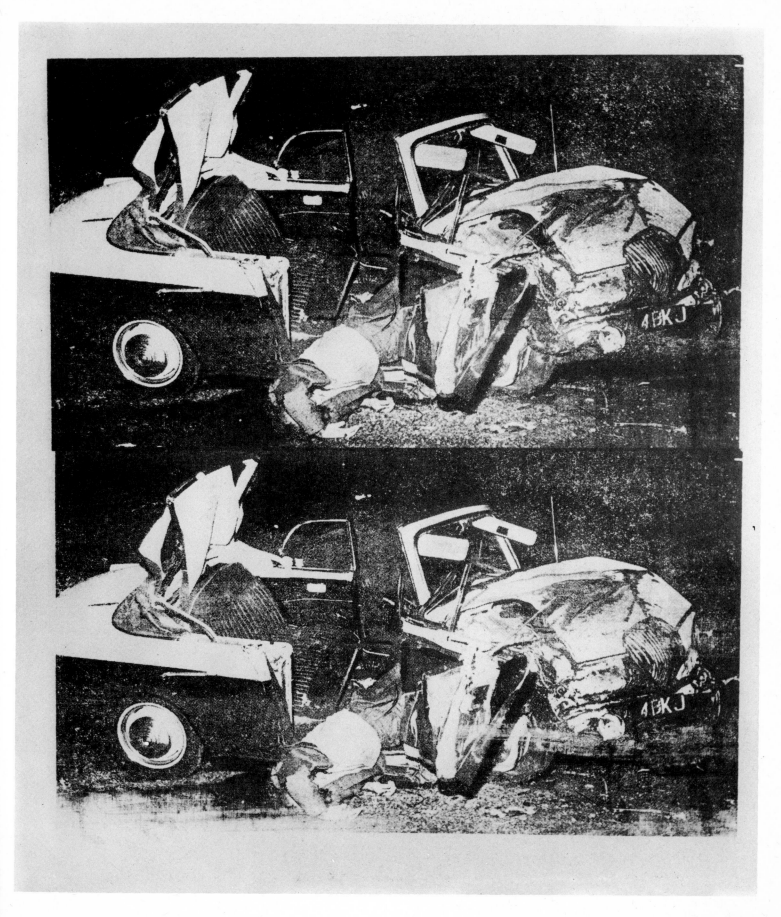

Car Crash, 1963.
Private Collection

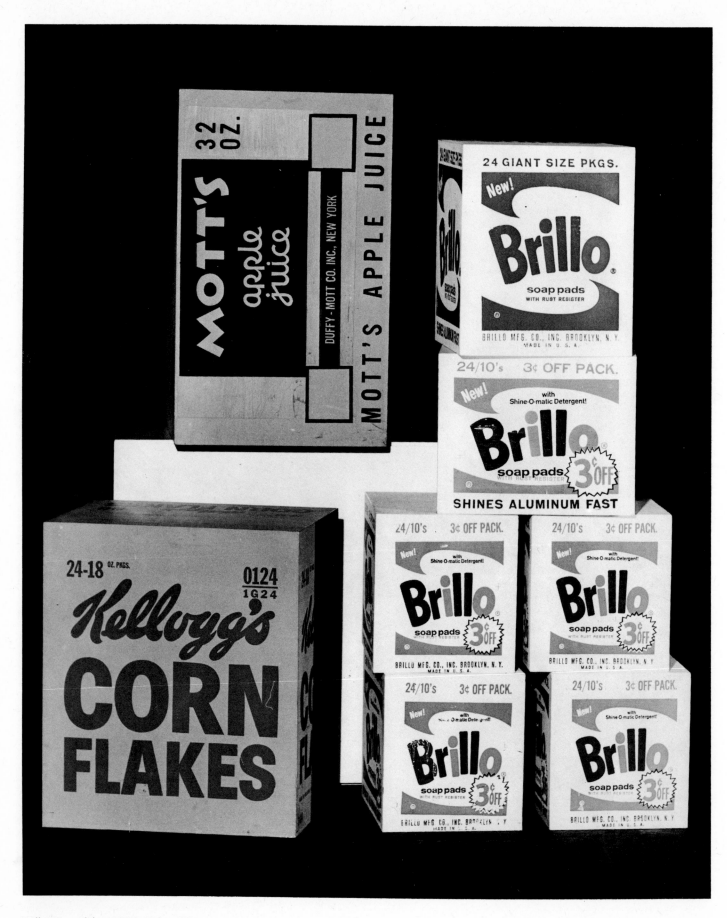

Brillo, Corn Flakes, Mott's Boxes, 1964.
Collection Dr. Karl Ströher, Darmstadt, Germany

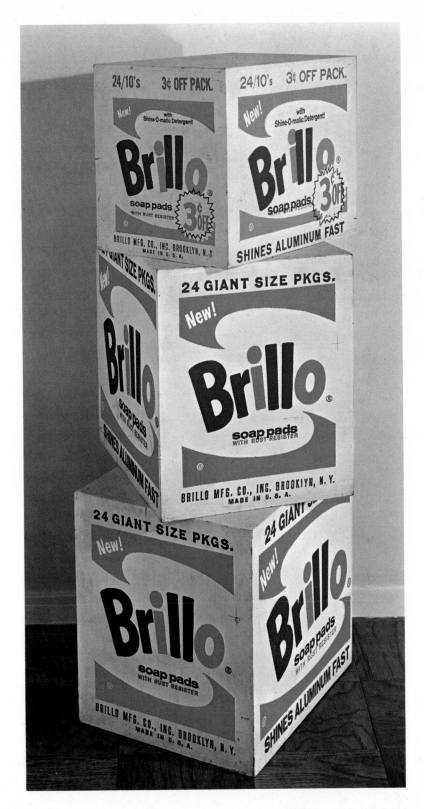

Brillo Boxes, 1964. 14 x 17 x 17 " (35.6 x 43.2 x 43.2 cm)
Collection Mr. and Mrs. Peter M. Brant, New York

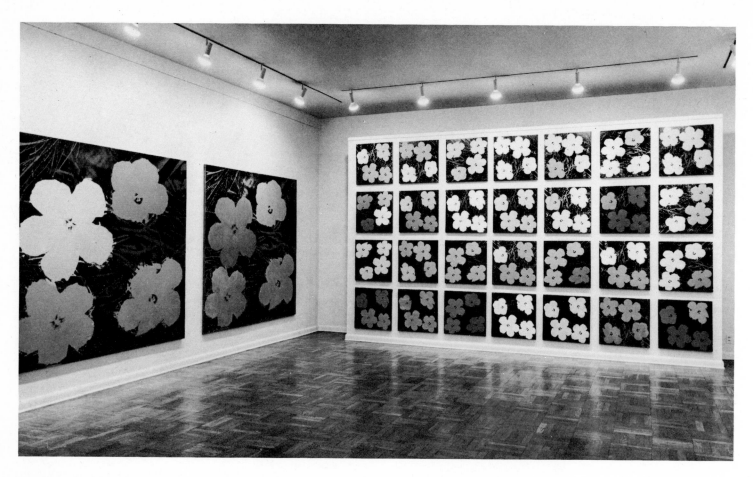

Installation Photograph *Flowers,* Leo Castelli Gallery, New York, 1964.

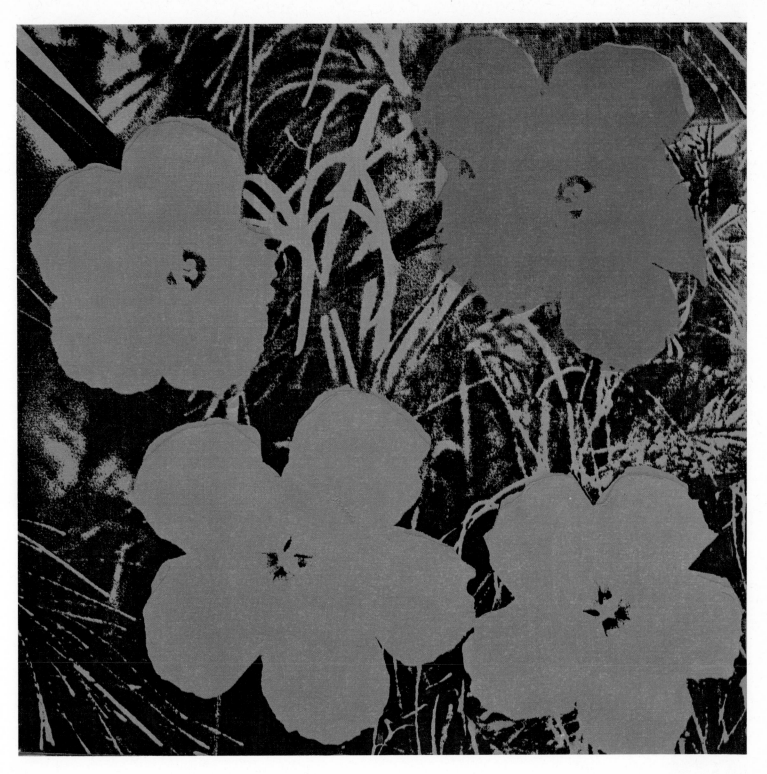

Flowers, 1964. 24 x 24″ (61 x 61 cm)
Collection Mr. and Mrs. Peter M. Brant, New York

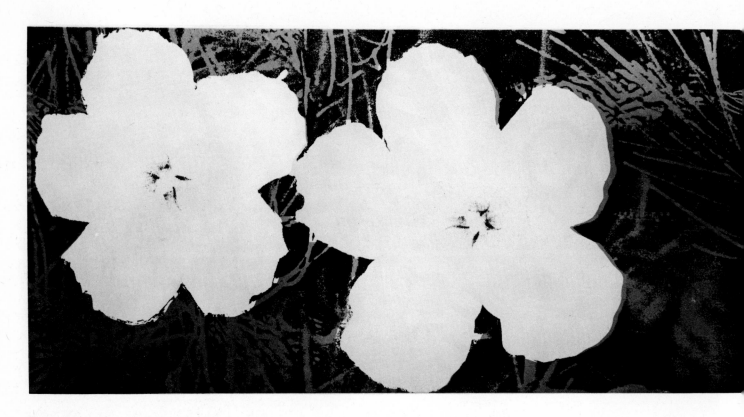

Flowers, 1964. 82 x 162" (208.3 x 411.5 cm)
Collection Mr. and Mrs. Robert C. Scull, New York

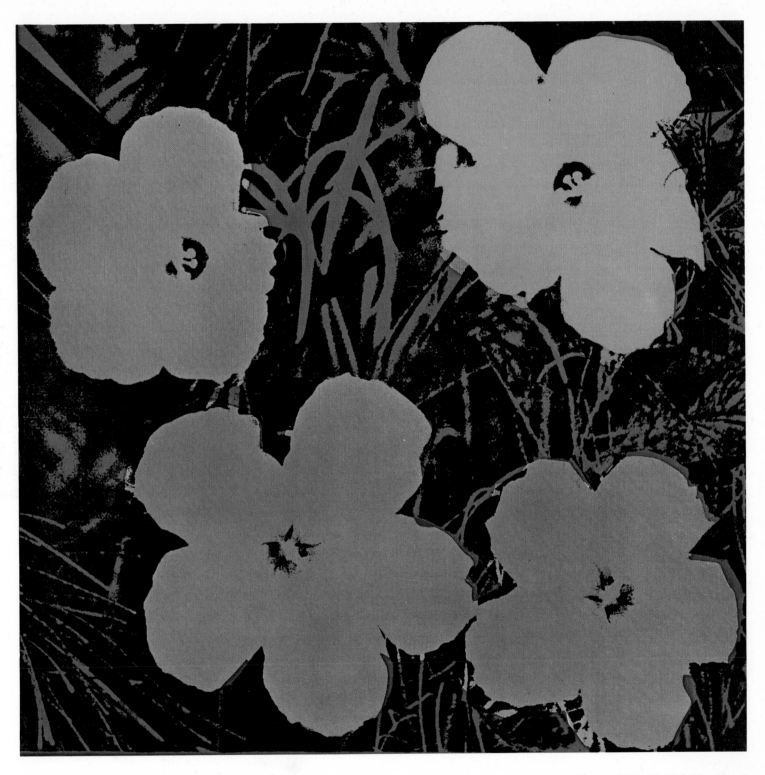

Flowers, 1964. 24 x 24″ (61 x 61 cm)
Collection Mr. and Mrs. Peter M. Brant, New York

127

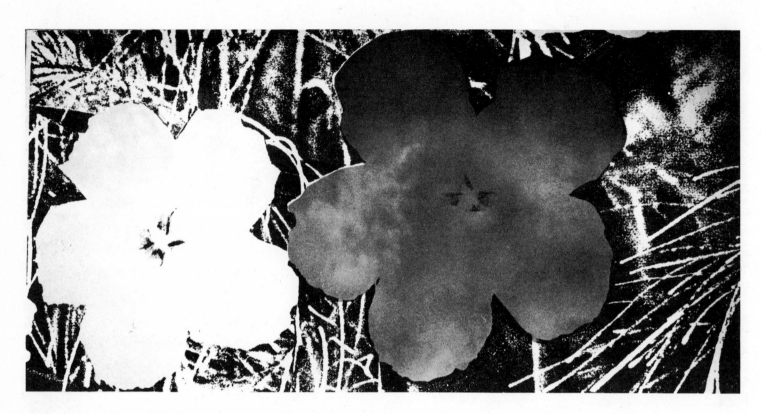

Flowers, 1964. 81⅛ x 160¾" (206.1 x 408.3 cm)
Collection Galerie Ileana Sonnabend, Paris

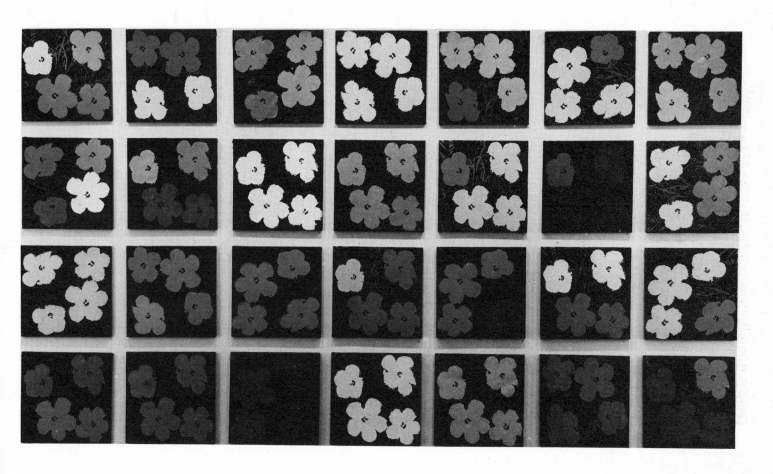

Installation photograph *Flowers,* Leo Castelli Gallery, New York, 1964

7 Portraits of Sidney Janis, 1967. 75 x 56" (190.5 x 142.2 cm)
Collection Mr. and Mrs. Sidney Janis (panel 1); Collection the artist (other 6 panels)

Watson Powell, Snr., (one panel of multiple portrait) 1964. 16 x 16″ (40.7 x 40.7 cm)
Collection American Republic Insurance Company, Houston, Texas

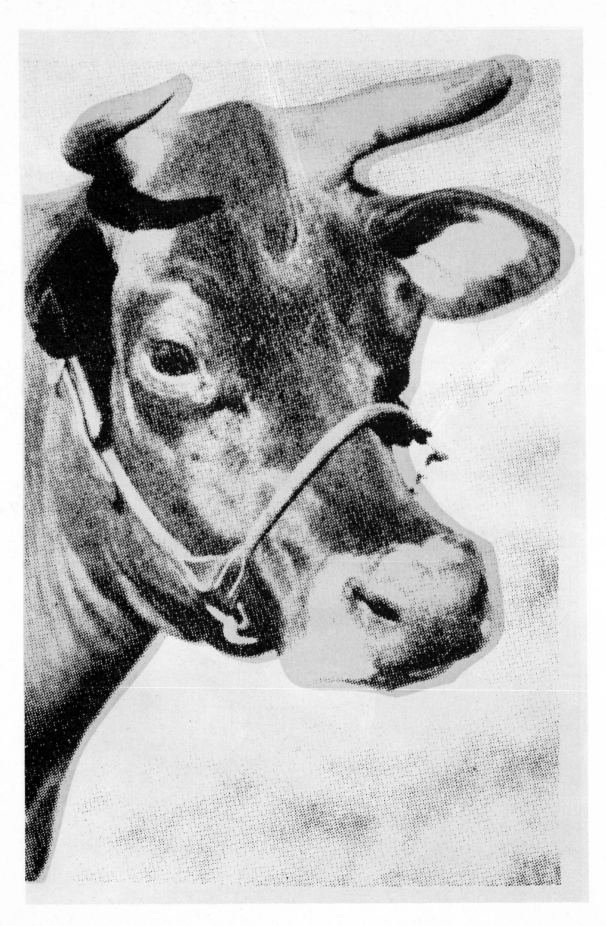

Cow Wallpaper, 1966. 44 x 30" (111.8 x 76.2 cm)

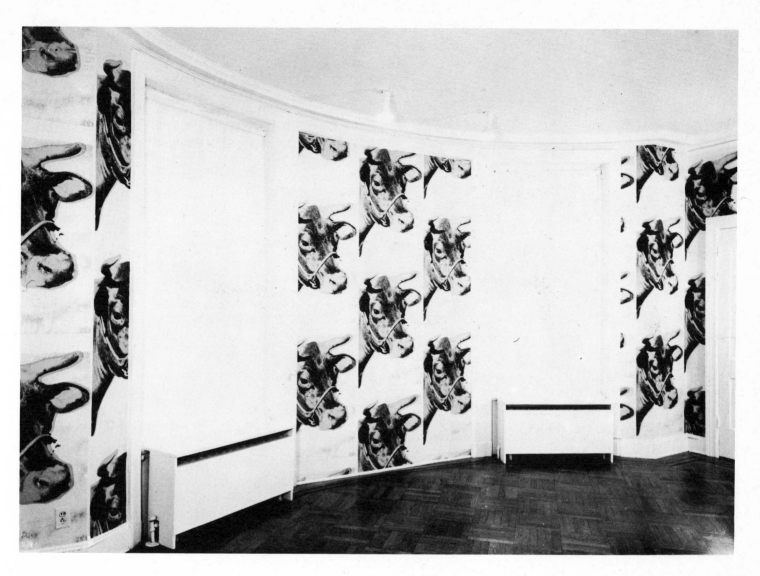

Installation photograph *Cow Wallpaper,* Leo Castelli Gallery, New York, 1966

Most Wanted Men — Salvatore V (profile), 1963. 48 x 39⅜" (122 x 100 cm)
Collection Isi Fiszman, Antwerp, Belgium

134

Most Wanted Men — Salvatore V (face), 1963. 48 x 39⅜″ (122 x 100 cm)
Collection Isi Fiszman, Antwerp, Belgium

135

Most Wanted Men—Redmond C, 1963. 48 x 39⅜" (122 x 100 cm)
Collection Galerie Ileana Sonnabend, Paris

Most Wanted Men—Ellis Ruiz B, 1963. 48 x 39⅜" (122 x 100 cm)
Collection Galerie Ileana Sonnabend, Paris

137

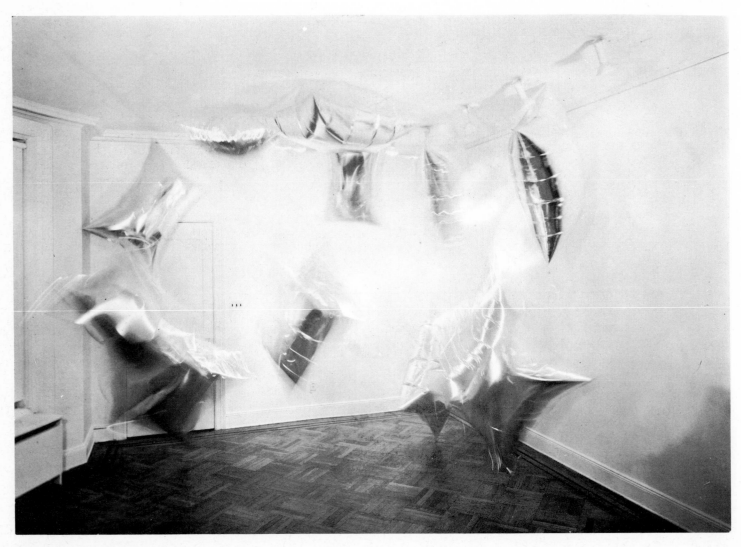

Installation photograph *Aluminum Clouds*, Leo Castelli Gallery, New York, 1966

Notes after Reseeing the Movies of Andy Warhol

On reseeing the movies of Andy Warhol, in bulk, old and new—a task which involves a good number of working days—the first thing that strikes one is the uniqueness of the world presented in them, and the monumental thoroughness with which it is presented; a uniqueness in the sense that there is no other artist in cinema similar either in subject, form, or technical procedures. Warhol went into his work with such an intensity, concentration and obsession that one whole area of experience—the people, the visual ideas, the ways of doing it—was so totally covered that there is practically nothing left for anybody else to do in that area.

We have other similar instances in contemporary cinema: Stan Brakhage, Gregory Markopoulos and Jean-Luc Godard went about their work the same thorough way: there is nothing much left for any other film artist to do in the areas they passed through. Huge areas of form and content have been covered in all four mentioned cases, with all the formal questions, technical procedures, solutions explored. In Brakhage we have one area of content, form and technical procedure explored; in Markopoulos another; in Godard still another; in Warhol again another. Neither the content, nor form, nor style, nor technology is the same in any of the four cases. Each artist came and revealed a different vision of the world.

Sometime in 1965, Stan Brakhage came to New York. On his mountain, in Colorado, nine thousand feet high, he had heard about Warhol and *Sleep*. He sat down at the Film-Makers' Cooperative and he said: "Enough is enough. I want to see the Warhols and find out what's the noise all about." So he sat and looked through reel after reel of *Sleep*. I think he even said he looked through all of it. I was working by the table, and Stan stood there, suddenly, in the middle of the room, and he started raging, in his booming mountain voice. He told us that we were taken in, that we were fools for sure. Plus, he said, he was leaving New York. Something to that effect. Sitney was there too, I think, and perhaps Kelman. I walked ten times across the room, listening to Stan's rage. Something shot through my mind: "How did you project the film, 16 frames per second or 24 frames per second?" I asked. "Twenty-four," said Stan. "Please, Stan," I said, "do us a favor. I know it's hard for you, but please sit down again and look at *Eat* and *Sleep*

at 16 frames per second, because that's how they were intended to be." Which Stan bravely did, honoring us, and for which I honor him. We went across the street, to Belmore, for some coffee and for some wound-licking, and we left Stan alone to watch the films. When we came back, much later, we found Stan walking back and forth, all shook up, and he hardly had any words. Suddenly, he said, when viewed at 16 frames per second, suddenly an entirely new vision of the world stood clear before his eyes. Here was an artist, he said, who was taking a completely opposite aesthetic direction from his, and was achieving as great and as clear a transformation of reality, as drastic and total a new way of seeing reality, as he, Stan, did in his own work. Stan left the room, without any more words, and had a long walk. I have never seen him before, nor ever since, as shaken up by another aesthetic world as he was that day after watching the movies of Andy Warhol.

A very simple, a very simple displacement indeed. From 24 frames to 16 frames per second. But that's the story of all of Warhol's art: it's always so unbelievably simple a thing that makes it work. One little thing rightly chosen shifts the whole to a totally new angle, becomes the key to the essence of the work. To see that one simple but unique angle, that one unique formal idea (or concept), has been the Warhol talent alone, a talent that runs out over the boundaries of his art and spills into the areas of life in general. It's commonplace knowledge by now, from *Vogue* to *The New York Times*: it is the unique eye of Warhol to discover, to single out the right faces. A face that Andy Warhol singles out will eventually reach the covers of *Look*, of *Life* or *Vogue*. The same goes for shapes, objects and ideas. If one could call the cinema of Brakhage a cinema of retinal impacts, or simply a cinema of impacts—then one could call a great part of Warhol's cinema a cinema of presences. One of the special gifts and marks of Warhol's cinema has been this ability of distinguishing, of finding, of seeing the cinematically and conceptually photogenic.

"But it's so easy to make movies, you can just shoot and every picture comes out right."—Andy Warhol[1].

Only the next decade will begin to gain some perspective on the cinema of Andy Warhol. As I sat, now, reseeing all his movies again, I was again getting involved in them from the beginning and in a new way. One of the problems of preparing a Warhol filmography, for instance, is that the original presentations of his films have been so much like the films themselves. For example, at the original show, the different reels of the film entitled **** were projected in double superimpositions (one reel on top of the other). Today, on the shelf, what's left of it is a pile of individual 30-minute reels with no information of any kind as to how to look at them. One can look at them any way one wants. I viewed them as separate 30-minute films; one reel—one film. *More Milk, Evette*, during the premiere screening was projected as a double-screen movie—there was another movie, I don't remember which (and no use

asking Andy, his mind is blank on such matters), projected beside *Evette* on the same screen. A number of other Warhol movies were shown sometimes in single projections, sometimes in double projections, sometimes in superimpositions; sometimes two 30-minute reels were projected one after the other, running for 60 minutes; at other times the same two reels were projected side by side at the same time, running for 30 minutes. At the end of 1964 and throughout the year 1965, immediately after the Expanded Cinema Festival (at the Cinemathèque), Warhol went through a period of projection experiments, experiments which culminated in the Velvet Underground series at the Dom, and *The Chelsea Girls*. During such experimental projections the projectionist could do practically anything he wanted—with Andy standing behind him, of course. The projections at The Factory were always very casual, that is, with people milling around, walking in front of the screen, the music going on at the back. The chance aspects of *The Chelsea Girls,* the overlappings of reels in sound and image, drove some reviewers to desperation: they never knew if they were seeing the same film as their colleagues. In short: the aesthetics that went into the making of the films spilled out into the presentations of the films, into the theater. This uncompromisingness and thoroughness of the cinema of Andy Warhol is carried thus to its ultimate purity (or call it extreme) in every area, whichever area of his cinema we happen to touch.

This thoroughness of the cinema of Andy Warhol sometimes provokes curious paradoxes. For instance: as huge and monumental as the achievement and body of the cinema of Andy Warhol is, one could also entertain an argument—and it's a quite popular argument in certain circles—that Andy Warhol doesn't exist at all in practicality. Andy Warhol is a concept, an idea, a myth, a Madison Avenue concoction, a product of the advertising agents.

"The problem is that he had almost nothing to say, and therefore substituted camp and, at best, put-on. He was and is, however, a cunning self-publicist, and there are always some unweary critics around ready to find significance in amateurish improvisation."—Hollis Alpert[2].

Warhol is like America: America is only an idea, after all, they say. They say, even New York is not America. The early Warhol is all LaMonte Young, or Jackson McLow, or Paik. The later Warhol (I'm speaking about Warhol's cinema) is either Ronald Tavel or Chuck Wein; still later it's maybe Viva, or maybe Paul Morrissey, who knows. And the mystery of it all remains how it all holds together! Again, it's like the United States: the idea, the concept, they say. That is, the essentials ("the Revolution") come from Warhol, and the particulars, the materials, the people come from everywhere and they are molded and held together by the central spirit, Andy Warhol—Andy Warhol who has become almost the symbol of the noncommittal, of *laissez-faire,* of coolness, of passivity, of *tabula rasa*—almost the Nothingness Himself.

"In many ways inaction is preferable to unintelligent action, for it has at least the merit of not creating further sanskaras and complications. The movement from unintelligent action to intelligent action (i.e. from binding karma to unbinding karma) is often through inaction. This is characteristic of the stage where unintelligent action has stopped because of critical doubt, but intelligent action has not yet begun because no adequate momentum has arisen. This special type of inaction which plays its part in progress on the Path should in no way be confused with ordinary inaction which springs from inertia or fear of life."—Meher Baba, *Discourses*[3].

I have watched Andy Warhol at work, and I have seen certain ideas grow and come into existence; and I have seen some ideas grow and change and never reach realization because something somewhere didn't click: the approach, the angle, the shape, the set-up didn't exactly work out. So I know well that nothing or little that Warhol does during those "passive," "careless" and "casual" shooting or painting sessions is really that careless or that passive. His aesthetic senses are behind it all, always awake, letting it all happen. But when everything is "just happening" and when everybody thinks that "things are happening by themselves"—there he stands, like he isn't even there, and with an unnoticeable, single, simple switch from 24 to 16 mental or formal "frames"—with one single conceptual switch he transposes the "uncontrolled" realism into an aesthetic reality that is Warhol's and nobody else's. Those "16 from 24" switches are very unnoticeable—it may be a shrug, it may be a word, it may be a deadpan, it may be a touch or a swing of the camera—they may be very slight but they are always there, and nobody sees them—neither their meaning nor even their very existence—but the Artist himself; and that's exactly where the origin of the myth of the Permissive Andy comes from, from the fact that he is the Total Artist and sees what no one else really sees.

"Why is *The Chelsea Girls* art? Well, first of all, it was made by an artist, and, second, that would come out as art."—Andy Warhol[4].

"Marcel Duchamp reduced the creative act to choice and we may consider this its irreducible personal requirement. Choice sets the limits of the system, regardless of how much or how little manual evidence is carried by the painting."—Lawrence Alloway[5].

This controlled, and I stress, totally controlled cinema—insist on this view of Warhol as an artist, I insist that instead of total permissiveness he has been exerting a total control—because of this inversion, the ying and yang of permissiveness-control, the film division of The Factory attracted to itself all the sad, disappointed, frustrated, unfulfilled, perverted, outcast, unreleased, eccentric, egocentric, etc., etc., talents and personalities. A whole generation of the Underground Stars produced by Jack Smith, Ron Rice and Ken Jacobs were there, on the brink of Waiting to Be Used. And there he was, Saint Andy, letting them all into his orbit, into his quarters. Effortlessly and painlessly he moved them and coordinated them and used the energies and forces that were pouring in, balancing them, clashing them—a most subtle maneuvering of the most ex-

treme temperaments and personalities in town, a maneuvering that culminated, on one hand, in *The Chelsea Girls,* and on the other in the Velvet Underground light projections. The Dom series of the Velvet Underground, with projections, were the most energy-charged performances I have ever seen anywhere. The film-maker here became a conductor, having at his fingertips not only all the different creative components—like sound controls, a rock band, slide projectors, movie projectors, lighting—but also all the extreme personalities of each of the operators of each piece of the equipment. He was structuring with temperaments, egos and personalities! Warhol maneuvered it all into sound, image and light symphonies of tremendous emotional and mental pitch (Exploding Inevitables was the other name) which reached to the very heart of the New Generation. And he, the conductor, always stood there, in the balcony, at the left corner, next to the projector, somewhere in the shadow, totally unnoticeable, but following every second and every detail of it, structure-wise, that is.

"The Plastic Inevitables (Velvet Underground; Warhol and Company) performances at the Dom during the month of April provided the most violent, loudest, most dynamic exploration platform for the intermedia art. The strength of Plastic Inevitables, and where they differ from all the other intermedia shows and groups, is that they are dominated by the Ego. Warhol, this equivocal, passive magnet, has attracted to himself the most egocentric personalities and artists. The auditorium, every aspect of it—singers, light throwers, strobe operators, dancers—at all times are screaming with an almost screeching, piercing personality pain. I say pain; it could also be called desperation. In any case, it is the last stand of the Ego, before it either breaks down or goes to the other side. Plastic Inevitables: theirs remains the most dramatic expression of the contemporary generation—the place where its needs and desperations are most dramatically split open. At the Plastic Inevitables it is all Here and Now and the Future."[6]

The exhausted and tired academic art squeezes all and any content into worked-out, accepted, likeable forms. They are no longer aesthetic forms: they are molds. They give the illusion of strength, security and harmony. There is this aspect of new art: a feeling of things placed on the verge of out-of-balance. It's like Taylor Mead. I saw him the other day at The Factory. He was complaining about a film he was doing with somebody, how he was cut and edited to pieces. "Wynn said he'll keep in *only the essential parts* of my scenes, where *the thing happens.* Nothing will be left," he said, "only the controlled." Because what his scene was really about—and Andy understands this and permits it—can be revealed only by means of *duration.* Yes, the duration, that's the word. There are certain ideas, feelings, certain contents which are structured in time. The literal meanings you can spell out through climaxes, through the scenes "where the thing happens." That's why Godard's films are so literal. But the real meaning, the one that is beyond the literal meaning, can be caught only through structuring in time. That applies equally to feelings and

thoughts. One of the essential misunderstandings about art and thought has been the belief that thought is opposed to aesthetic activity, to art. And particularly that thought has no place in cinema, which is images, man, images! But the modern scientists tell us that the thoughts are governed by the same structural processes as art, that is, by pace, rhythm, duration; the durations and repetitions of thoughts and feelings and actions. Much of philosophical and mystical writing attracts us not because of the ideas but because of the rhythms and pacings, the structures of thoughts, the meditative and contemplative structures of those writings. The literal meanings are of secondary importance. Most of the criticism of Andy Warhol films (apart from the "poor technique") rests on the fact that his movies seem to be lacking any literal meanings, any ideas, any scenes in which "things happen."

"With us, people can be whatever they are, and we record it on film. If a scene is just a scene, with a lot of ideas that have nothing to do with the people, you don't need to make a movie, you could just type it."—Paul Morrissey[7].

When you go beyond the literal ideas, beyond the sensory shocks, when you begin to deal with more essential movements of thought and spirit, when you try to register more subtle human qualities—and the cinema of Andy Warhol has always been concerned with man—you begin to structure in time.

"These other Yankees don't know that I'm from the South, so they don't bother me, but the South has a feeling toward the human person that the North doesn't have."—Andy Warhol[8].

"I still care about people but it would be so much easier not to care. It's too hard to care...I don't want to get too involved in other people's lives...I don't want to get too close...I don't like to touch things...that's why my work is so distant from myself..."—Andy Warhol[9].

"With film you just turn on the camera and photograph something. I leave the camera running until it runs out of film because that way I can catch people being themselves. It's better to act naturally than to set up a scene and act like soneone else. You get a better picture of people being themselves instead of trying to act like they're themselves."—Andy Warhol[10].

We have one more of those curious paradoxes with which Warhol's work abounds. There is this popular notion that Warhol is *the* commercial artist of the Underground. That notion is promoted by both the wider public and by the aestheticians of the avant-garde. The paradox is that the cinema of Andy Warhol, more than any other cinema, is undermining the accepted notions of the American entertainment and commercial film. The cinema of Brakhage or the cinema of Markopoulos or the cinema of Michael Snow has nothing to do with the entertainment film. They are clearly working in another, non-narrative, non-entertainment area, as in a classical way and meaning we say all poetry is in a different area. But the cinema of Warhol, *The Chelsea Girls, The Nude Restaurant, The Imitation of Christ,* is part of the narrative cinema, is within the field of cinema that is

called "movies," it deals with "people," is part of it. Is part of it, but is of a totally different ilk. That's why the movies of Andy Warhol cannot be ignored by the commercial exhibitors. At the same time, once they are in, and they are In, they are undermining, or rather transforming, or still more precisely, *transporting* the entertainment, the narrative film to an entirely different plane of experience. From the plane of purely sensational, emotional and kinesthetic entertainment, the film is transported to a plane that is outside the suspense, outside the plot, outside the climaxes—to a plane where we find *Tom Jones,* and *Moby Dick,* and Joyce, and also Dreyer, Dovzhenko, and Bresson. That is, it becomes an entertainment of a more subtle, more eternal kind, where we are not hypnotized into something but where we sort of study, watch, contemplate, listen—not so much for the "big actions" but for the small words, intonations, colors of voices, colors of words, projections of the voices; the content that is in the quality and movements of the voices and expressions (in the Hitchcock or Nichols movies the voices are purposeful, theatrical monotones)—a content of a much more complex, finer and rarer kind is revealed through them. And these faces and these words and these movements are not *bridges* for something else, for some other actions, no: they are themselves the *actions.* So that when you watch *The Imitation of Christ,* when you watch this protagonist who does practically nothing, who says very little—when you watch him from this new, transported plane of the New Art (all minimal art exists on this transported plane)—you discover gradually that the occupation of watching him and listening to him is more intellectually fruitful, more engaging, and more entertaining than watching most of the contemporary "action" and "entertainment" or serious "art" movies. A protagonist emerges with a unique richness of character. All the mystical and romantic seekers of Truth and God have left their marks in this character. Patrick is the hero of the end of the 20th century. Every little word, sound, hesitation, silence, movement reflects it totally and completely. Not that Warhol *made* him act that way, to be that way: he chose him perfectly and flawlessly and allowed him to be himself within the context, and chose him for those qualities and in that place.

"'I'm so mad at Andy,' she said. 'He just *puts* you out there and makes you do everything.'"—Ingrid Superstar[11].

"I have Andy now to think ahead and make the decisions. I just do what he tells me to do."—Viva[12].

And this is one of the achievements of Warhol's work, as one discovers when one reviews it again today: this total exploration of these unseen, imperceptible aspects of changing reality, of using his art and the technology of cinema to register them; to structure with those subtle human qualities and changing, emerging, new realities which escape even the wizards of the Cinéma Vérité.

"What Warhol does not permit is that his machine and technique become the stars of the film. In most so-called 'documentary camera style' features being screened these days, the supremely slick results and absolutely astonishing feats of technical wizardry defeat whatever hope of evoking reality the film's creators may have had in mind. Their standards, in which all things are perfect, may be said to establish a visual fantasy. Warhol's technique establishes visual reality, in which nothing is perfect. But it is real, and his films are all the better for it."—Dennis J. Cipnic[13].

—And do not think for a moment, dear reader, that the actions, the choices of the artist, *why* he chooses this or that procedure at that particular moment in history, are meaningless, or do not express man fully! Do not ask him to explain it all to you, why he did it that way, and please do not say, when you find that he can't answer, that his silence means that he *didn't* know what he was doing. No, every moment of his life, his whole past grew and grew and mounted and led to this moment of unconscious choice. What I'm saying is that the protagonist and the feeling and the content of *The Imitation of Christ* is pure Warhol.

"Warhol himself, I suspect after talking with him, doesn't know where he's really at, what he's really stumbled into."—Richard Whitehall[14].

What amazes one, when one resees Warhol movies, the entire bulk of his film work, is the amount, the vastness of the gallery of the people, of different dreams, faces and temperaments that his films are filled with. Andy Warhol is the Victor Hugo of cinema. Or maybe Dostoyevski, a little bit sicker, that is. And then, again and again this preoccupation, or should I say obsession, with the phenomenal reality, with the concrete reality around him, as he's trying to grasp it and record it again and again, and each time it escapes him. As if the deeper you dig into the human aspects, the more you swing into the material aspects—one deepens the other.

"All my films are artificial, but then everything is sort of artificial. I don't know where the artificial stops and the real begins."—Andy Warhol[15].

"'I've been thinking about it,' conceded Warhol. 'I'm trying to decide whether I should pretend to be real or fake it. I had always thought everyone was kidding. But now I know they're not.' He looked worried. 'I'm not sure if I should pretend that things are real or that they're fake. You see,' said Warhol, craning his head absently, 'to pretend something real, I'd have to fake it. Then people would think I'm doing it real.'"[16].

"'Well, I guess people thought we were silly and we weren't. Now maybe we'll have to fake a little and be serious. But then,' Warhol said, going on like a litany, 'that would be faking seriousness which is sort of faking. But we were serious before so now we might have to fake a little just to make ourselves look serious.'"[17].

The reality seems to be constantly slipping away from under the feet, so he turns to another way of doing it, coming to it from another angle—again and again—with such untiring persistence and obsession that it borders on both the titanic and the insane. Yes, only in a factory, it could be done only by a factory, and not by a human effort. No, the face, held for no matter how long on the screen, no, it doesn't reveal it *all;* nor do the endless conversations

reveal or register it *all,* they do not reveal the existence totally. So he zooms in and out and swings the camera and runs it wild, at the Dom, and in the studio, trying to catch IT through the medium itself, through the materials and chances of his medium, indirectly, sneakily, from the sides—putting blind snares to catch the truth, the reality, the existence—and that doesn't do it either. So he goes to two screens, to three screens, to superimpositions, and strobes, and music—or he just leaves the camera by itself—maybe it will do it when nobody sees it, looking at IT by itself, as the eye of a newborn baby—maybe it's there, IT, but we don't know how to see it again—yes, how to see it or look at the world as if you have never seen it? So he places the camera there and it watches life—it stares at life, like a baby, and it's difficult to stand it, that naked look, so you become conscious of it, you begin to reveal yourself to the child, you show to the child what you'd never reveal to even the closest of your friends, those certain secret emotions, certain secret subtle fragile curious motions of the soul.

"...Experiencing things and objects as things and objects is the outcome of holding certain attitudes, and to hold and apply these requires a constant effort."—Sinclair[18].

The other day, I was looking through some old English texts. Then I dug out *La Chanson de Roland,* and *Vogelweide.* Oh, the beauty of the Old French, and the High German, and the Old English! Why is it so that languages seem to become slicker with time? They seem to lose those raw edges, that earth quality. Or is it only an illusion, all those mysterious spaces, those unknowns and those in-betweens? Anyway, I thought, whatever the case, the language of the Warhol sound movies (I am talking about the language of cinema) and the language of much of the Underground in general, beginning with 1960 or thereabouts, when compared with the Hollywood film or the European art film, has all the qualities of the Old English, of the Old French, of the High German. It has those raw edges, those mysterious areas where the imagination can roam, where we can erect our own under-textures and under-structures—those mysterious blanks, spaces, muddled noises which can be interpreted two, three, four, ten different ways—that crackling sound—that unpolishedness which at some point becomes pregnant with personal meanings. Like LaMonte Young's music into which, while listening, you can project one million of your own melodies. That's about the most significant difference between the language of the New Cinema (the Underground) and the film language of the Old Cinema. The only thing is that usually *Old* refers to the origins, to the sources—but in cinema, until now, *Old* meant everything that had become so polished, had reached such a degree of functionality, specialization and practicality that it had lost all mystery and all origins. The only parallel between the Old English and a similar notion of cinema would be to speak about Lumière. And that's where the early cinema of Andy Warhol went: to the cinema of Lumière. He did it very instinctively, but with that act he rehabilitated the meaning of *Old*

in cinema, he pushed it all the way back to the true origins. At the same time, he became the first modern film artist who went back to the origins for a readjustment of his art, for the refocusing of the medium.

"Andy Warhol is taking cinema back to its origins, to the days of Lumière, for a rejuvenation and a cleansing. In his work, he has abandoned all the 'cinematic' form and subject adornments that cinema had gathered around itself until now. He has focused his lens on the plainest images possible in the plainest manner possible. With his artist's intuition as his only guide, he records, almost obsessively, man's daily activities, the things he sees around him.

"A strange thing occurs. The world becomes transposed, intensified, electrified. We see it sharper than before. Not in dramatic, rearranged contexts and meanings, not in the service of something else (even Cinéma Vérité did not escape this subjugation of the objective reality to ideas) but as pure as it is in itself: eating as eating, sleeping as sleeping, haircut as haircut.

"We watch a Warhol movie with no hurry. The first thing he does is he stops us from running. His camera rarely moves. It stays fixed on the subject like there was nothing more beautiful and no thing more important than that subject. It stays there longer than we are used to. Long enough for us to begin to free ourselves from all that we thought about haircutting or eating or the Empire State Building; or, for that matter, about cinema. We begin to realize that we have never, really, seen haircutting, or eating. We have cut our hair, we have eaten but we have never really seen those actions. The whole reality around us becomes differently interesting, and we feel like we have to begin filming everything anew. A new way of looking at things and the screen is given through the personal vision of Andy Warhol; a new angle, a new insight—a shift necessitated, no doubt, by the inner changes that are taking place in man."[19]

"In effect, then, Warhol insists on *our* personal commitment, to ourselves, rather than his (the observer can no longer be as passive toward art as he has been for the last four hundred years or so), by giving so little and demanding so much. (How do you fill the time in which you are supposed to be looking at the picture?) ...Like it or not, it appears that we are being expected to alter our accustomed patterns of perceptual rate, our attention span, and our notions of fitness."—Alan Solomon[20].

The viewer is, thus, confronted with his own blank mind. Here is cinema that doesn't manipulate him, doesn't use *force* on him: he himself, the viewer, has to search, to ask questions, sometimes unconsciously, other times consciously, and still other times by throwing objects at the screen. The *serious* art and the *good* entertainment are supposed to shake *you* up. Here, however, is an art which asks that *it* be shaken up; by *you,* filled up with ideas, by you! An art that is a *tabula rasa.* A cinema that leaves the viewer standing alone, in front of it, like looking into the mirror. Didn't we always say that art mirrors reality? So here it really is! Before, it was always true that man mir-

rored art. Now we straighten things out. We liberate man from art's slavery…Isn't the mirror empty and silvery too, like Warhol's face, like the silver of his hair, like the silver of Warhol's Silver Flotations, the silver of The Factory walls, the silver of his paintings?

"To do this once is forgivable. It is a kind of dadaesque joke mocking art—and hell I'm all for it. People and artists do tend to take themselves too seriously at times. If one has enough money for selling Brillo boxes at $200 apiece to waste on six hours of raw stock and developing (such as in the movie *Sleep*) to create a mammoth joke—well man go ahead. But to do it again and again and then ask people to sit through it is pushing things a bit too far. A joke's a joke, but I for one would be embarrassed to play the same boring joke on people more than once."—Peter Goldman[21].

During the early years of the decade, the early period of Warhol's film work, whenever I went to a university, lecturing, I used to take one of Andy's films, usually *Eat*. And always the same thing used to happen. The film starts rolling, the audience sits quietly, for a minute or two. The catcalls and crack remarks begin. In the fourth or fifth minute, however, they begin to realize that I have no intention of stopping the film, and the reports from the back lines reach the front lines, that the reel is *big* (45 minutes). The most unsettling, however, is the fact that no amount of noise or cracks seems to do any harm to the film! Its nonchalant, obstinate and don't-give-a-damn imperturbability on the screen seems to reject or absorb anything you can throw at it. It almost grows stronger with every whistle. So the students begin to leave the auditorium. After ten minutes or so the impatient ones leave or give up, others resign, and the rest of the show proceeds quietly. Later, from the discussions, it becomes clear that there is always a period—to some five minutes, to others fifteen, to some still longer—a period of *jumping the reality gap*, or what we could also call the period of aesthetic weightlessness; a period of adjusting to the aesthetic weightlessness, to the different gravitational pull. From there on you are floating through your mind, from there on the movie—*Sleep, Eat, Haircut,* and exactly the same applies to the later sound movies, say *The Imitation of Christ*—from there on everything becomes very rich. You are watching now from a new angle, every detail reveals a new meaning, the proportions and perspectives change—you begin to notice not only the hundred-mile movements but also one-inch movements; not only a crashing blow on the head is an action, a touch of a butterfly wing is also an action. A whole new world opens because of this shifted angle of vision, of seeing, a world in which there is as much action, suspense, tension, adventure, and entertainment as on the former plane—and more!

"When we speak of fashions in thought, we are treating philosophy lightly. There is disparagement in the phrases, 'a fashionable problem,' 'a fashionable term.' Yet it is the most natural and appropriate thing in the world for a new problem or a new terminology to have a vogue that crowds out everything else for a little while. A word that everyone snaps up, or a question that has everybody excited, probably carries a generative idea—the germ of a complete reorientation in metaphysics, or at least the 'Open Sesame' of some new positive science. The sudden vogue of such a key-idea is due to the fact that all sensitive and active minds turn at once to exploiting it; we try it in every connection, for every purpose, experiment with possible stretches of its strict meaning, with generalizations and derivations. When we become familiar with the new idea our expectations do not outrun its actual uses quite so far, and then its unbalanced popularity is over. We settle down to the problems that it has really generated, and these become the characteristic issues of our time."—Susanne Langer[22].

One could say that the cinema of Jean-Luc Godard is the cinema of applied propaganda. His is an ingenuous and total usage of all the means of cinema, the vocabulary, the syntax, for the purpose of putting across certain literal ideas. As a result, the medium is misused, and the ideas themselves distorted, as all propaganda is.

The cinema of Brakhage is the cinema of the truth of the eye, of seeing. The preoccupation with the processes of seeing in its own turn revolutionized the means of registering the seeing, it expanded the medium through which man expresses or retains his visual memories and ideas.

The cinema of the Cinéma Vérité authors is the use of the film medium for the purpose of "catching life as it is," "catching truth as it is." By putting a special stress on life and truth "as is," they made it feel self-conscious; the truth became singled out, undressed, stripteased, and thus out of the proper truth context. The truth became a fiction, a fantasy.

The cinema of Andy Warhol is also about the truth and life as is, or, rather, men as they are. It is a cinema or a passion to record the people and their feelings as they are—but without any stress on it, without any illusions, without any sales talk about truth and life as is—in other words, doing it but remaining silent, letting the thing itself speak for itself. Everybody, all the Cinéma Vérité film-makers are trying to catch the truth in order to show it to *others;* Warhol is doing it as a private passion. The truth caught in Warhol movies remains in the shadow, under the palm trees, no light is being thrown into its face, and it's visible only to those who themselves put in effort to see it, who light their own lamps, so to speak. The very humble and transitory look of his films seems to pay respect to the truth's privacy.

Again, it was Stan Brakhage who, on his last visit to New York—as he has done on every other of his previous visits—was lamenting the transitory aspects of his art. He slumped into the chair with his long legs on the floor, helpless, almost defeated, talking about the cathedrals and frescoes, and wondering which of his films, if any, will remain in the year 2200, when some of the originals already are fading and crumbling today. There was Jerry

Joffen, we remembered, six years ago, who worked, had influence, including influence on Warhol at some early stage—and where is his work today? It all went with the wind, only the memories left. The ephemerality of Warhol's screenings, all the chance elements of them, and the changing states and shapes and lengths and even the titles of his films—Warhol seems to have incorporated all the transitoriness of things into his very aesthetics, looking at his own work nonchalantly, and cool, very cool, no dramatics, no lifted voice about it. And that's why it seems to me that his cinema is really about the transistoriness of the medium and the transitory state of all things. About the transitoriness of all existence and all art.

I bumped into Andy the other day. We spoke about this and that, and about my own film diaries. He spoke about how much he wanted to do the same: to record everything that he saw, everything that happened around him. "But it's impossible," he said, "it's impossible! I tried, but it's impossible. It's impossible to carry with you a movie camera, a tape recorder, and a still camera at the same time. I wish I could do it."

So he is still at it! Still trying to catch it all—by all possible means. It's an obsession unto death!

"We're going to start making serious movies," said Andy.

Jonas Mekas

FOOTNOTES:

1. Andy Warhol, quoted by Gretchen Berg in an interview, *L.A. Free Press,* March 17, 1967.
2. Hollis Alpert in *Saturday Review,* quoted in the advertisements of the film, *Coming Apart.*
3. Meher Baba, *Discourses,* p. 113.
4. Andy Warhol in an interview with Gerard Malanga, *Arts Magazine,* Vol. 41, No. 4, 1967.
5. Lawrence Alloway, *Systemic Painting,* The Solomon R. Guggenheim Museum catalogue, 1966.
6. Jonas Mekas, *Village Voice,* May 26, 1966.
7. Paul Morrissey, quoted in an article by Neal Weaver, *After Dark,* January 1969.
8. Andy Warhol in an interview with Gerard Malanga, *Arts Magazine,* Vol. 41, No. 4, 1967.
9. Andy Warhol, quoted by Gretchen Berg in an interview, *L.A. Free Press,* March 17, 1967.
10. Andy Warhol, quoted by Gene Youngblood, *L.A. Free Press,* February 16, 1968.
11. Ingrid Superstar, quoted in *The Realist,* August 1966.
12. Viva, quoted by Barbara L. Goldsmith, *New York* magazine.
13. Dennis J. Cipnic, *Infinity,* September 1969.
14. Richard Whitehall, *L.A. Free Press,* April 28, 1967.
15. Andy Warhol, quoted by Gene Youngblood, *Los Angeles Herald-Examiner.*
16. Andy Warhol, quoted by Leticia Kent, *Village Voice,* September 12, 1968.
17. Ibid.
18. Sinclair, *Conditions of Knowing,* quoted in the Stable Gallery program note (Warhol show).
19. Jonas Mekas, excerpt from text of sixth independent Film Award, in *Film Culture,* No. 33, 1964.
20. Alan Solomon, Boston Institute of Contemporary Art catalogue (Warhol show, 1967).
21. Peter Goldman, *Village Voice,* August 27, 1964.
22. Susanne Langer, *Philosophy in a New Key.*

The Filmography of Andy Warhol

Introduction

There are all kinds of problems in preparing an Andy Warhol filmography. I have done my best, within the short time I had to prepare this filmography, to give at least a start to it. I resaw most of the films, I checked and rechecked certain facts with the early assistant of Andy Warhol, Gerard Malanga, and with the present assistant, Paul Morrissey. Andy is very weak on dates and names. In many cases my own private diaries and the archives of the Film-Makers' Cinemathèque proved to be more reliable than the human memory. There will be, in the future editions of this Filmography, a few changes in the order of production of some of the films. Some of the dates are only approximate. A number of films are not listed because nobody could agree on either their whereabouts or their very existence. The people at The Factory Film Library (if I may dare call it by that name) are totally disorganized, bless them. This Filmography, therefore, should be considered as a first draft.

— Jonas Mekas, January 1970

Baby Jane Holzer and Gerard Malanga in *Kiss*, 1963.

Kiss
16mm. 50 min. B&W. Silent. 16FPS.
With Naomi Levine and Ed Sanders; Naomi Levine and Rufus Collins; Naomi Levine and Gerard Malanga. All filmed August 1963.
With Baby Jane Holzer and John Palmer; Baby Jane Holzer and Gerard Malanga; John Palmer and Andrew Meyer; also, Freddie Herko, Johny Dodd, Charlotte Gilbertson, Philip van Rensselaet, Pierre Restaney, Marisol. All filmed November-December 1963.
The Naomi Levine kisses premiered at the Gramercy Arts Theater, 138 West 27th Street, New York, September 1963 under the title *Andy Warhol Serial*.
Each kiss runs 100 feet.

Kiss, 1963

Tarzan and Jane Regained Sort Of
16mm. 2 hours. Color and B&W. Sound-on-tape prepared by Taylor Mead. 16FPS.
With Taylor Mead (Tarzan), Naomi Levine (Jane), Dennis Hopper, Claes and Pat Oldenburg, Wally Berman.
Premiered by the Film-Makers' Cooperative at the New Bowery Theater, 4 St. Mark's Place, New York, February 24, 1964.
Taylor Mead fools around in a playground near the sea, making "Tarzan" faces and poses; Naomi swims in the nude; Naomi and Taylor wash each other in a bathtub; Taylor plays with dogs, dances in his falling-off "bikinis."
"Oh, it's Warhol all right...in the sense that he'd film no matter what's going on in front of the camera."

— Paul Morrissey, after reseeing the film.

Andy Warhol Films Jack Smith Filming Normal Love
16mm. 3 min. Color. Silent. 16FPS.
Premiered by the Film-Makers' Cooperative at the Gramercy Arts Theater, November 11, 1963.
A "newsreel" film showing Jack Smith shooting *Normal Love*. The original was seized by the New York police in March 1964 together with Jean Genêt's film *Un Chant D'Amour*. The fate of the original is unknown. No print exists.

146

Dance Movie (also known as *Roller Skate*)
16mm. 45 min. B&W. Silent. 16FPS.
Filmed late September 1963.
Premiered by the Film-Makers' Cooperative at the Washington Square Art Gallery, 530 West Broadway, New York, March 16, 1964.
With Freddy Herko on roller skates, in Brooklyn Heights and/or Gramercy Park.

Haircut
16mm. 33 min. B&W. Silent. 16FPS.
Filmed November 1963.
Premiered by the Film-Makers' Cooperative at the Gramercy Arts Theater, January 10, 1964.
Billy Linich gets his hair cut.

Eat
16mm. 45 min. B&W. Silent. 16FPS.
Filmed November 1963.
Premiered by the Film-Makers' Cooperative at the Gramercy Arts Theater, January 10, 1964.
Robert Indiana eats one mushroom.

''Interviewer: What was the purpose of it?
Warhol: Well, it took him that long to eat one mushroom.
Interviewer: I mean, why did you have to film it?
Warhol: Uhhh, I don't know. He was there and he was eating a mushroom.'' —*Bay Times*, April 1, 1966.

Blow Job
16mm. 30 min. B&W. Silent. 16FPS.
Filmed winter 1963-64.
Premiered by the Film-Makers' Cooperative at the Washington Square Art Gallery, March 16, 1964.
A sustained closeup of a boy's face as someone, out of camera range, performs fellatio on him.

Batman Dracula
16mm. 2 hours. B&W. Silent. 16FPS.
Filmed July 1964.
John Palmer assisted in shooting.
With Jack Smith as Dracula; Baby Jane Holzer, Beverly Grant, Ivy Nicholson.
Filmed on the beaches of Long Island, on the roofs of New York, at The Factory. Contains Warhol's first ''zooms for zooming's sake,'' shots through Cellophane gauzes. Less fragmented than *Tarzan and Jane*. The film was never completed. Exists in original only.

Empire
16mm. 8 hours. B&W. Silent. 16FPS.
Filmed June 25, 1964, from the 44th floor of the Time-Life Building. Arranged by Henry Romney. Co-director, John Palmer. Cameraman, Jonas Mekas (who happened to know something about the Auricon camera—this being Warhol's first Auricon movie).
Premiered by the Film-Makers' Cinemathèque at the City Hall Cinema, New York, March 6, 1965.

Blow Job, 1964

Empire, 1964.

147

Henry Geldzahler
16mm. 100 min. B&W. Silent. 16FPS.
Filmed July 1964 (same week as *Empire*).
Premiered by the Film-Makers' Cinémathèque at the 125 West 41st Street Theater, New York, December 18, 1965.
A portrait of Henry Geldzahler smoking a cigar.

Salome and Delilah
16mm. 30 min. B&W. Silent. 16FPS.
Filmed late 1963 (around the same time as *Dance Movie*).

With Freddie Herko, Debby Lee.
Exists in original only.

Soap Opera (also known as *The Lester Persky Story*)
16mm. 70 min. B&W. Silent. 16FPS.
Filmed 1964.
Co-director: Jerry Benjamin.
With Baby Jane Holzer.
Exists in original only.

Couch
16mm. 40 min. B&W. Silent. 16FPS.
Filmed July 1964.
With Gerard Malanga, Piero Heliczer, Naomi Levine, Gregory Corso, Allen Ginsberg, John Palmer, Baby Jane Holzer, Ivy Nicholson, Amy Taubin, Ondine, Peter Orlovski, Jack Kerouac, Taylor Mead, Kate Heliczer, Rufus Collins, Joseph Le Seuer, Bingingham Birdie, Mark Lancaster, Gloria Wood, Billy Linich.
Premiered at the Film-Makers' Cinémathèque, 125 West 41st Street, April 17, 1966.
A nude woman on a couch tries to get a man's attention. Later, there is much banana eating, and love-making attempts are seen, man to man, as other men sit in front of the couch, or walk around it. The camera is stationary, framing the couch.

Gerard Malanga, Kate Heliczer and Rufus Collins in *Couch*, 1964

Shoulder
16mm. 4 min. B&W. Silent. 16FPS.
Filmed summer 1964.
The shoulder of Lucinda Childs.

Mario Banana
16mm. 4 min. B&W. Silent. 16FPS.
Filmed November 1964.
Premiered at Los Angeles Film-Makers' Festival, January 1965.
Mario Montez eats a banana.
There exist a few other versions of this film, one in color.

Harlot
16mm. 70 min. B&W. Sound. 24FPS.
Filmed December 1964, with Auricon (Andy bought his Auricon in December 1964). Warhol's first movie to use sync-sound (optical) directly on film.
With Mario Montez, Gerard Malanga, Philip Fagan, Carol Koshinskie. Sound track (out-of-frame dialogue) by Ronald Tavel, Harry Fainlight, Billy Linich.
Premiered at the Cafe À-Go-Go, early January 1965; at the Film-Makers' Cinémathèque March 8, 1965.

"Jean Harlow is a transvestite as are Mae West and Marilyn Monroe, in the sense that their feminineness is so exaggerated that it becomes a commentary on womanhood rather than the real thing or representation of realness."
—Ronald Tavel, *Film Culture*, No. 40.

Baby Jane Holzer in *13 Most Beautiful Women*, 1964

13 Most Beautiful Women
16mm. 40 min. B&W. Silent. 16FPS.
Filmed winter 1964-65.
With Baby Jane Holzer, Anne Buchanan, Sally Kirkland, Barbara Rose, Beverly Grant, Nancy Worthington Fish, Ivy Nicholson, Ethel Scull, Esabel Eberstadt, Jane Wilson, Imu, Marisol, Lucinda Childs, Olga Kluever.
A series of portraits, 100 feet each, mostly in close-up.

13 Most Beautiful Boys
16mm. 40 min. B&W. Silent. 16FPS.
Filmed 1964-65.
With Freddie Herko, Gerard Malanga, Dennis Deegan, Kelly Eddy, Bruce Rudo.
Exists in original only.

Barbara Rubin in *50 Fantastics*, 1964

Edie Sedgwick in an early screen test, *13 Most Beautiful Women*, 1965

50 Fantastics and *50 Personalities*
Filmed 1964-66.
Some of the people filmed: Allen Ginsberg, Ed Sanders, Jim Rosenquist, Zachary Scott, Peter Orlovski, Henry Rago, Ted Berrigan, Roy Lichtenstein, Gregory Battcock, Barbara Rubin, Daniel Cassidy, Harry Fainlight.
Two series of 100-foot portraits of artists, friends, passers-by, models, poets, film-makers. Exist in originals only.

Taylor Mead's Ass
16mm. 70 min. B&W. Silent. 16FPS.
Filmed September 1964.
Premiered at the Film-Makers' Cinemathèque, January 3, 1966.
Close-ups of Taylor Mead's buttocks, very white, overexposed, rather abstract; later, more concrete. Taylor holds a book and other objects.

''Dear Sir:
...Mekas, however, seems to thrive on criticism and *The Voice* continues to give him his weekly allotment of space. I have tolerated his praise of films shot without lenses, films shot without film, films shot out of focus, films focusing on Taylor Mead's ass for two hours, etc....But the August 13 column in praise of Andy Warhol was a bit too much...''
—Excerpt from a letter by Peter E. Goldman, *Village Voice*, August 27, 1964.

''Dear Sir:
Re Peter Goldman's letter in *The Voice* (August 27), Andy Warhol and I have searched the archives of the Warhol colossus and find no 'two-hour film of Taylor Mead's ass.' We are rectifying this undersight with the unlimited resources at our command. Love and kisses.''
—Letter by Taylor Mead, *Village Voice*, September 3, 1964.

Ivy and John

16mm. 35 min. B&W. Sound. 24FPS.
Filmed early January 1965.
Premiered at the Film-Makers' Cinemathèque, January 18, 1965.
The camera frames Ivy's cluttered room. Framing, lighting and focus are casual. Ivy and John walk in and out, drink, sit down, kiss, talk incoherently (the sound is very poor). ''I'm not going to get involved with the camera,'' says Ivy, at one point.

Suicide

16mm. 70 min. Color. Sound. 24FPS.
Filmed first part of 1965.
Only a wrist is seen, with cuts and bruises. Someone is telling something about his life, some of it inaudible; there are some street noises and music. Exists in original only.

Screen Test #1

16mm. 70 min. B&W. Sound. 24FPS.
Filmed January 1965.
Written by Ronald Tavel. With Philip Fagan.

Screen Test #2

16mm. 70 min. B&W. Sound. 24FPS.
Filmed January 1965.
Written by Ronald Tavel.
Premiered by the Film-Makers' Cinemathèque, June 12, 1965. With Mario Montez as himself/herself taking a screen test. Tavel, from out of camera range, asks questions, orders actions.

The Life of Juanita Castro

16mm. 70 min. B&W. Sound. 24FPS.
Filmed January 1965. Written by Ronald Tavel.
With Marie Menken as Juanita; Elecktrah as Raoul; Waldo Diaz Balart, Mercedes and Marina Ospina, Ronald Tavel, and others. Premiered by the Film-Makers' Cinemathèque, March 22, 1965. Juanita criticises her brother's regime and condemns the infiltration of homosexuality into their lives.

Drunk

16mm. 70 min. B&W. Sound. 24FPS.
Filmed January 1965.
With Emile de Antonio getting drunk on whiskey. Exists in original only.

''He got completely drunk before we even finished reloading the camera.'' —Andy Warhol.

Horse

16mm. 105 min. B&W. Sound. 24FPS.
Filmed early March 1965.
Written by Ronald Tavel.
With Larry Latrae, Gregory Battcock, Daniel Cassidy Jr., Tosh Carillo.
Premiered at the Film-Makers' Cinemathèque, November 22, 1965.

A man sits on a black horse at the back of the set. In the foreground, four men drink milk. Then, to loud music, they perform operatic movements. The men play cards. They jump on one man (upon the instructions of a commentator), bind him to the horse, and beat him up. ''Beat it, beat it,'' they repeat. ''Get out of town.'' Again they do the ''opera.'' Credits on the sound track are interspersed throughout the movie. The lighting is dark, details not visible; sound not good.

Poor Little Rich Girl

16mm. 70 min. B&W. Sound. 24FPS.
Filmed March-April 1965.
Directorial assistance: Chuck Wein. With Edie Sedgwick.
Premiered at the Film-Makers' Cinemathèque, April 26, 1965.
The first reel (35 min.) is out of focus, except for a brief moment. Edie moves about her bed and telephone, tells about her spent inheritance, shows her beautiful coat.

Vinyl

16mm. 70 min. B&W. Sound. 24FPS.
Filmed March 1965.
Written by Ronald Tavel.
With Gerard Malanga as the young punk Victor, and Edie Sedgwick, Ondine, Tosh Carillo, Larry Latrae, Jacques Potin, John MacDermott.
Premiered by the Film-Makers' Cinemathèque, June 4, 1965.

Gerard Malanga and Edie Sedgwick in *Vinyl*, 1965

Bitch
16mm. 70 min. B&W. Sound. 24FPS.
Filmed in 1965, immediately after *Vinyl*.
With Marie Manken, Willard Maas, Edie Sedgwick, Gerard Malanga. Exists in original only.

Restaurant
16mm. 35 min. B&W. Sound. 24FPS.
Filmed May 1965.
Chuck Wein assisted on the shooting and scripting.
With Edie Sedgwick and Ondine as her bodyguard.
For the first 10 minutes the camera holds a close-up of a round dining table loaded with bottles and glasses. Occasionally a waiter passes; Edie's hand uses a Cinzano ashtray. Later the camera almost unnoticeably begins to pull back; we see Edie and her guests at the table as they drink, argue and wait for their meal. The camera pulls back further, swings for a moment to the next table, then zooms back to the close-up as they begin to eat.

Kitchen
16mm. 70 min. B&W. Sound. 24FPS.
Filmed late May 1965.
Written by Ronald Tavel.
With Edie Sedgwick, Roger Trudeau, Donald Lyons, Elecktrah, David MacCabe as the photographer, René Ricard as the houseboy.
Premiered at the Film-Makers' Cinemathèque, March 3, 1966.
A murder is committed on the table in a white kitchen. A photographer keeps coming into the frame; the "actors" interrupt what they are doing and pose for pictures; pages of script are handed to the actors, who follow them. The happenings inside and outside the frame are equally important and interchange. Everybody sneezes throughout the film.

Edie Sedgwick and René Ricard in *Kitchen*, 1965

"Kitchen is illogical, without motivation or character, and completely ridiculous. It is very much like real life."
—Andy Warhol, Film-Makers' Cinemathèque program note.

Prison
16mm. 70 min. B&W. Sound. 24FPS. Sound is on tape, recorded separately during the shooting.
Filmed July 1965.
With Edie Sedgwick, Bibie Hansen, Marie Menken.
Edie and Bibie are sitting on a box in a bare room, Bibie telling her jail experiences. Marie brings coffee. Women guards come in and rob them of all their belongings. The camera is static. Exists in original only.

Face
16mm. 70 min. B&W. Sound. 24FPS.
Filmed April 1965.
With Edie Sedgwick.
A close-up of Edie's face. A variation on the *Poor Little Rich Girl* theme.
Premiered at the Film-Makers' Cinemathèque, February 8, 1966.

Afternoon
16mm. 105 min. B&W. Sound. 24FPS.
Filmed June 1965.
With Edie Sedgwick, Ondine, Arthur Loeb, Donald Lyons, Dorothy Dean.
Edie Sedgwick at home with her friends. Reel One was originally shown as part of *The Chelsea Girls* during the screenings at the Film-Makers' Cinemathèque, later taken out.

Beauty #2
16mm. 70 min. B&W. Sound. 24FPS.
Filmed early July 1965, right before *My Hustler*.
Writer and assistant director, Chuck Wein.
With Edie Sedgwick, Gino Pisechio.
Premiered by the Film-Makers' Cinemathèque, July 17, 1965.
An evening on the bed with a boy friend and a dog. Edie's dialogue with a former boy friend, out of frame, is mostly about her past.

Space
16mm. 70 min. B&W. Sound. 24FPS.
Filmed summer 1965.
With Edie Sedgwick, Eric Andersen.

Outer and Inner Space
16mm. 70 min. Sound. B&W. 24FPS.
Filmed July 1965.
Premiered by the Film-Makers' Cinemathèque, February 8, 1966.
Edie Sedgwick talks with her image on a television set. The dialogue is about space, mysticism, and herself. During the Cinemathèque screening Reel One and Reel Two were projected simultaneously, side by side.

My Hustler
16mm. 70 min. B&W. Sound. 24FPS.
Filmed July 1965 on Fire Island.
Director: Chuck Wein.

With Paul America as the hustler, Ed Hood as the "john," John MacDermott as the bodyguard/houseboy, Genevieve Charbon as the next-door neighbor, Joseph Campbell as the "Sugar Plum Fairy," Dorothy Dean as the hustler's future 'keeper.'
Premiered by the Film-Makers' Cinemathèque, October 1965.
This is basically a triangle play in which the hustler challenges the neighbor to take away from him a young man who is sunning on the beach. Genevieve proceeds, but fails. The second reel takes place in the bathroom.

Camp

16mm. 70 min. B&W. Sound. 24FPS.
Filmed August or September 1965.
With Paul Swan, Baby Jane Holzer, Mar-Mar Donyle, Jodie Babs, Tally Brown, Jack Smith, Fu-Fu Smith, Tosh Carillo, Mario Montez, Gerard Malanga.
Premiered by the Film-Makers' Cinemathèque, November 22, 1965.
The actors sing, dance, entertain or clown. Jack Smith in a tour-de-force opens a closet door. The set is arranged like a home theater: when one performs, the others watch and applaud.

Paul Swan

16mm 70 min. Color. Sound. 24FPS.
Filmed fall 1965.
Paul Swan in a solo performance.
Exists in original only.

Hedy (also known as Hedy the Shoplifter and The 14 Year Old Girl)

16mm. 70 min. B&W. Sound. 24FPS.
Filmed November 1965.
Written by Ronald Tavel. Musical soundtrack by John Cale and Louis Reed.
With Mario Montez as Hedy; Mary Woronov as the policewoman; Harvey Tavel as the judge; Ingrid Superstar as the saleslady; Ronald Tavel as the walk-on. The five husbands are played by Gerard Malanga, Rick Lockwood, James Claire, Randy Borscheidt, David Meyers. Jack Smith plays the soothsayer, Arnold Rockwood the surgeon.
Premiered at the Film-Makers' Cinemathèque, March 3, 1966.
The film displays further ingenious manipulations of space (begun in Vinyl) through shifting and replacing of props. "Camp" and "private" acting are integrated into a wider dramatic scheme, achieving the utmost of realism through the utmost absurdity.
"The story of a wealthy and beautiful woman getting a face-lifting to look more beautiful, and then getting caught at shoplifting to face her five former husbands and her past climbing up and down the ladder of success."
— Gerard Malanga, in Film-Makers' Cooperative Catalogue.
"Tavel's last scripted movie for us." — Gerard Malanga.

The Closet

16mm. 70 min. B&W. Sound. 24FPS.
Filmed November 1965 at Panna Grady's apartment.
Based on an idea by Barbara Rubin.
With Nico and Randy Borscheidt.
Two children live in a closet. The film exists in original only.

More Milk, Evette (also was known as Lana Turner)

16mm. 70 min. B&W. Sound. 24FPS.
Filmed November 1965, prior to Hedy.
Written by Ronald Tavel.
With Mario Montez, Paul Caruso and Richard Schmidt.
Premiered by the Film-Makers' Cinemathèque, February 9, 1966.
"An opera. The story of a son who murders his mother's boy friend." — Gerard Malanga.

Lupe

16mm. 70 min. Color. Sound. 24FPS.
Filmed December 1965 at Panna Grady's apartment.
With Edie Sedgwick and Billy Linich.
Premiered at the Film-Makers' Cinemathèque, May 7, 1966, as a double-screen projection, Reel One on the left, Reel Two on the right, simultaneously.
Reel One: A long shot of a luxurious room with many pink flowers. Edie walks in with more flowers; she has on a long blue dress, and the whole set has a clear blue cast. She sits down, drinks some wine, walks around, plays with the cat, puts a record on, dances, takes a pill, smokes, tries to eat, drinks, gets up. CUT. After the cut, the last five minutes of Reel One show Edie lying on the bathroom floor motionless, with her head on the toilet seat.
Reel Two: A close-up of Edie sleeping in bed, in a pink dress. She wakes up, smokes, makes a telephone call. Billy comes in, trims her hair for 15 minutes. Slight conversation; the sound quality is very poor.
"The last evening in the life of Lupe Velez." — Gerard Malanga.

Bufferin (also known as Gerard Malanga Reads Poetry)

16mm. 35 min. Color. Sound. 24FPS.
Filmed early 1966.
Gerard Malanga reads poetry. A girl (Ronna) outside the frame makes critical remarks and distracts him. This was the first film in which Andy used the strobe cut, Gerard notes.
"The strobe cut is Warhol's typically audacious means of investing his work with camera presence. With the strobe cut I believe Warhol has invented a technique of major importance in film form. It's sort of a Brechtian-Godardian ploy which distances the viewer by interrupting a scene to remind him that it is, after all, only a movie shot with a camera that can be turned on and off, giving birth to, or killing, cinematic life with the flick of a switch. At the same time the strobe cut invests the sequences with added thematic power, punctuating or underscoring a scene in much the same manner as a zoom or a pan can intensify traditional theatrical dramatics by striking the right visual coordinate at the right moment. In I, a Man, for instance, a character is about to speak, about to answer some intimate personal question, and just as her mouth opens the film is shattered with a zap-zap-zap-zap strobe cut like a record skipping."
— Gene Youngblood, L.A. Free Press, February 16, 1968.

Eating Too Fast

16mm. 70 min. B&W. Sound. 24FPS.
Filmed 1966.
With Gregory Battcock.
A sound version of Blow Job. Exists in original only.

The Velvet Underground and Nico
16mm. 70 min. B&W. Sound. 24FPS.
Filmed January 1966.
"Andy Warhol's rock-n-roll electronic group presenting a 70-minute symphony of sound, broken up by the New York police."
—Gerard Malanga.
Andy Warhol's mixed-media show, *Plastic Inevitables (Velvet Underground)* opened at the Film-Makers' Cinemathèque February 8, 1966.

Chelsea Girls
16mm. 3 hours 15 min. Color and B&W. Sound. 24FPS.
Filmed summer 1966.
Premiered by the Film-Makers' Cinemathèque, September 15, 1966.
Includes *The Bed, The John, The Trip, The Duchess, Hanoi Hanna, The Pope Ondine Story, The Gerard Malanga Story, Their Town (Toby Short).*
The Gerard Malanga Story: With Marie Menken, Mary Woronov, Gerard Malanga.
Hanoi Hanna (Queen of China): Written by Ronald Tavel. With Mary Woronov, "International Velvet," Ingrid Superstar, Angelina "Pepper" Davis.
The Pope Ondine Story: With Bob "Ondine" Olivio, Angelina "Pepper" Davis, Ingrid Superstar, Albert René Ricard, Mary Woronov, "International Velvet," Ronna.
The John: With Ed Hood, Patrick Flemming, Mario Montez, Angelina "Pepper" Davis, "International Velvet," Mary Woronov, Gerard Malanga, René Ricard, Ingrid Superstar.
Their Town: With Eric Emerson. Strobe lighting by Billy Linich.
The Program of September 15, 1966, lists: Room 732—*The Pope Ondine Story;* Room 422—*The Gerard Malanga Story;* Room 946—*George's Room;* Room 116—*Hanoi Hanna;* Room 202—*Afternoon;* Room 632—*The John;* Room 416—*The Trip;* Room 822—*The Closet.*
After the management of the Chelsea Hotel threatened a lawsuit, all references to rooms were omitted in subsequent screenings.

Gerard Malanga and Mary Might in screen test for *Chelsea Girls,* 1966

Gerard Malanga and Marie Menken in *Chelsea Girls,* 1966

**** (also known as *Four Stars*)
16mm. 25 hours. Sound. Color. 24FPS.
Filmed August 1966—September 1967.
Show in full version only once, at the New Cinema Playhouse, 125 West 41st Street, New York, December 15 and 16, 1967. The two projectors' images were superimposed on a single screen. During 1968 and 1969 **** was gradually taken apart. No list was made of the reels and parts projected at the original show. Today it is impossible to reconstruct the original film. From some of the markings on the film cans, and from conversations with Paul Morrissey, Gerard Malanga and Andy Warhol, I managed to get together the following partial listing of the materials included in the original version of ****

153

International Velvet and Alan Midgette in **** *(Four Stars)*, 1967

International Velvet (Segment of ****)
16mm. 30 min. Color. Sound.
Filmed January 1967.
With Alan Midgette and Dickin.
A kitchen/bathroom, with a symphony of typical sounds. The men take a bath, drink beer and stare into each other's faces; one climbs on the sink and washes his feet; they bang pans, clap hands, whistle. Strobe cuts are used.

Alan and Dickin (Segment of ****)
16mm. 2 hours. Color. Sound. 24FPS.
Filmed January 1967.
With Alan Midgette and Dickin.
Alan and Dickin are in bed, Alan reading from an LSD-Buddhist pop text. Alan: "What do you do in New York on Sunday afternoon?" "I really love you." Alan stands on his head. They talk about movies and their schooldays as they smoke and drink coffee, lie across the bed, play with a pillow, and caress each other's hands in close-up; Alan jumps up and down on the bed. Almost everything is in medium shots with no panning; the camera concentrates on the two men all the time, with great respect and curiosity but maintaining casualness. The sound is good. (This "plot" description covers only the first 30 minutes.)

Imitation of Christ (Segment of ****)
16mm. 8 hours. Color. Sound. 24FPS. (There is a 100-min. version of this segment.)
With Patrick Tilden, Nico, Ondine, Tom Baker, Taylor Mead, Bridgid Polk. Ondine as Patrick's father, Bridgid as mother.
Patrick is a moody, mystical, silent protagonist. Nico reads from *Imitation of Christ*. They spend much time together, but little is said. Mother and Father (in bed) discuss their son and try to figure out what's wrong with him. Occasional intercuts show Patrick and Taylor in the streets of San Francisco or thereabouts. All is very quiet and brooding. As one sits through the eight hours, a feeling of some existential concern is slowly established, mostly through the face, tone and presence of the two men. The two-hour version, prepared in late 1969, achieves some of the same feeling, though the time element is missing. In the 8-hour version, the feeling and mood are established mostly through the silences and spaces; in the 2-hour version much of that is gone, and the mood is set through confrontations and their pacing.

Courtroom (Segment of ****)
16mm. 30 min. Color. Sound. 24FPS.
Filmed December 1966.
Ondine is in the judge's seat, Ivy on the floor; someone seems to be raping her. Ultra Violet climbs up on the judge's table. A party of people storms into the courtroom. René Ricard is a Russian prince. The room gradually becomes a madhouse court; this feeling is emphasized by the dark lighting. The sound is very noisy.

Gerard Has His Hair Removed with Nair (Segment of ****)
16mm. 30 min. Color. Sound. 24FPS.
Filmed in July 1967.
Four girls remove hair from Gerard's chest. (The film was conceived "as a commercial.") Filters are constantly changed from red to green to blue, etc. A spotlight is on Gerard; the rest is darkness. The second part shows the girls posing with Gerard (now with no hair on his chest).

Katrina Dead (Segment 23 of ****)
16mm. 30 min. Color. Sound. 24FPS.
A woman, supposedly dead, lies on a table. A number of people kiss her and put photographs on her body. René Ricard makes nasty and sacrilegious remarks. At the end the "dead" woman gets up. Ondine comes in, talks and lies down on the table. The sound is largely pure confusion.

Sausalito (Segment of ****)
16mm. 30 min. Color. Sound. 24FPS.
Filmed September 1967.
Images of Sausalito: water, docks, boats, street, with Nico's voice over, but broken to pieces by the strobe cuts. Nico speaks slow, disconnected lines: "A man is walking on the sea," "The sea is walking," "The sea is after me." Occasional cuts to Nico's face in close-up and in sync. It is getting darker; the color is dark, deep blue, with some red in the sky. "Night is light," "The night grows into the sky," "The light grows back into the earth." By now it is quite dark. Boats are silhouetted against the sky. Some figures pass across the frame. A band begins to play. Lights appear in windows, far away, and the band stops. Nico's voice comes in for a moment.

Alan and Apple (Segment of ****)
16mm. 30 min. Color. Sound. 24FPS.
Filmed late January 1967.
Alan Midgette appears in close-up, his face in red filtered light. In the background, a girl is washing a sheet. Alan eats an apple, while the filter changes to green, and back to red. He tells about his cross-country travel adventures, smokes, and eats a banana. There are close-up of the apple, with color filters, and close-ups of Alan's chest and armpits. The sound quality is good throughout. The color filters achieve the effect of an impersonal face telling us a computerized travel story, like a million others.

Group One (Segment of ****)
16mm. 30 min. Color. Sound. 24FPS.
The scene is a party, with a series of confrontations between couples, some elderly. The camera snaps very brief glimpses. An elderly woman and a youngish man have a personal argument on the rug. Ingrid Superstar and a young man then appear in a kitchen. Cut back to the elderly woman who is alone in a corridor, in stark Zavattinian neo-realism of sublime order. Cut back to the woman talking to a woman friend about boy friends, marriage, etc.

Sunset Beach on Long Island (Segment of ****)
16mm. 30 min. Color. Sound. 24FPS.
Four or five couples play on the beach while a man with a guitar sings. A child plays in the waves. The camera pans through the sand dunes, with the sound of waves and the guitar over. A couple dances; a young man stands high on a grassy hill and looks down to the beach. There is much strobe cutting. Ondine clowns with a green scarf. Sunset colors appear on the water, the evening sun on the bay. The camera returns to the singer as he sings about the sea and the sun.

High Ashbury (Segment 76 of ****)
16mm. 30 min. Color. Sound. 24FPS.
With Ultra Violet, Ondine, Nico.
Overexposed, very short shots and strobe cuts show a room in San Francisco. It is all very flowery, with rock music and people smoking, sitting on the floor. There is little movement, except that I haven't seen so many cuts in a Warhol movie. A baby in blue light becomes very central; cut to his crib, in another room, swinging against the daytime light. Someone begins to play a clarinet or flute, and a drummer joins in. (*Velvet Underground* record in the background.)

Tiger Morse (Segment of ****)
16mm. 20 min. Color. Sound. 24FPS.
Filmed November 1966.
Tiger, in a silvery background of costumes and lights, has a silver ball in her hand; the camera cuts in to close-ups of the ball. She talks about love. Single-frame sequences, medium and long shots.
Other reels that were part of ****
(each reel 30 minutes):
Ondine and Ingrid, Segment 68
Ivy and Susan
Sunset in California
Ondine in Yellow Hair
Philadelphia Story
Katrina, Segment 25
Barbara and Ivy
Ondine and Edie
Susan and David, Segment 82
Orion, Segment 42
Emanuel, Segment 35
Rolando, Segment 37
Easthampton Beach, Segment 43
Swimming Pool
Nico-Katrina, Segment 21
Tally and Ondine
Ondine in Bathroom
Susan Screen Test
Susan Bottomly, Segment 1

I, a Man
16mm. 100 min. B&W. Sound. 24FPS.
Filmed late July 1967.
With Tom Baker, Ivy Nicholson, Ingrid Superstar, Valerie Solanis, Cynthia May, Betina Coffin, Ultra Violet, Nico.
Opened at the Hudson Theater, New York, August 24, 1967.

Tom Baker in *I, A Man*, 1967

Bike Boy
16mm. 96 min. Color. Sound. 24FPS.
Filmed August 1967.
Joe Spencer is the man. Others: Viva, Ed Weiner; fetishes, symbols of masculinity; Bridgid Polk, Ingrid Superstar.
Opened at the Hudson Theater, October 5, 1967.
The boy showers, dries himself, combs his hair very, very slowly. He tries on underwear in a store, buys perfume, goes to a flower shop. Later, Ingrid rambles about food and cooking, but he says nothing. A woman wants to ride on the bike with him.

Nude Restaurant
16mm. 96 min. Color. Sound. 24FPS.
Filmed October 1967.
With Viva, Taylor Mead, Louis Waldon, Alan Midgette, Ingrid Superstar, Julian Burroughs.
Opened at the Hudson Theater, November 13, 1967.
Viva takes a bath with a man, "Exploding the Freudian myth," she says, "for the benefit of the American females at large." Later, in a restaurant, Viva tells about her convent school days in close-up: priests always want to rape her. After 10 minutes we zoom out and see the restaurant and the people, nude, of course. Taylor sings, plays the harmonica, and later converses with a member of the Resistance about contemporary politics. "I don't like walking in circles. I gave up weight lifting because you have to keep repeating everything," Taylor says. A later scene shows Alan Midgette by the table. Later, Viva has a reel-long soliloquy about her jail experiences, her mother, her father. Taylor is a very good listener. Viva: "Are you bored?" Taylor: "I like to listen to parts of conversations. Besides, I believe that my subconscious is still listening."

Alan Midgette and Viva in *The Nude Restaurant*, 1967

Tom Hompertz and Louis Waldon in *Lonesome Cowboys*, 1968

The Loves of Ondine
(Originally a segment of ****)
16mm. 86 min. Sound. B&W. 24FPS.
Filmed August-October 1967.
With Ondine, Viva, Joe Dallesandro, Angelina Davis, Ivy Nicholson, Bridgid Polk.
Opened at the Andy Warhol Garrick Theater, 152 Bleecker Street, New York, August 1, 1968.
"Don't you know the difference between reality and pretense?" asks Ondine during an argument with Angelina, as he throws her out. Ondine goes through a series of confrontations. In the middle of the film, for a reel, there is a long, messy, Spanish-speaking party, with all kinds of gooey things thrown on naked participants.

Lonesome Cowboys
16mm. 110 min. Color. Sound. 24FPS.
Filmed December 1967-January 1968, in Arizona.
With Taylor Mead, Louis Waldon, Viva, Eric Emerson, Francis Francine, Alan Midgette, Julian Burroughs, Tom Hompertz, Joe Dallesandro.
Opened in New York at the Garrick Theater and 55th Street Playhouse, May 5, 1969.

Taylor Mead, Viva and Tom Hompertz in *Lonesome Cowboys*, 1968

Sleep
16mm. 6 hours. B&W. Silent. 16FPS.
Filmed July 1963.
Premiered by the Film-Makers' Cooperative at the Gramercy Arts Theater, January 17, 1964.
The film consists of 10-minute segments—each repeated twice—showing a man sleeping. The camera focuses on different parts of the body.
"Warhol: It started with someone sleeping and it just got longer and longer and longer. Actually, I did shoot all the hours for this movie, but I faked the final film to get a better design."
—*Tape Recording*, October 1965.

Blue Movie
16mm. 90 min. Color. Sound. 24FPS.
Filmed July-August 1968.
With Viva and Louis Waldon.
Premiered by the Film-Makers' Cinemathèque at the Elgin Theater, June 13, 1969.

Schrafft's Commercial
October 1969.
"The screen fills with a magenta blob, which a viewer suddenly realizes is the cherry atop a chocolate sundae. Shimmering first in puce, then fluttering in chartreuse, the colors of the background and the sundae evolve through many colors of the rainbow. Studio noises can be heard. The sundae vibrates to coughs on the sound track. "Andy Warhol for a SCHRAFFT's?" asks the off-screen voice of a lady. Answers an announcer: "A little change is good for everybody."
—Harold H. Brayman,
"Warhol and Underground Sundaes,"
National Observer, October 28, 1969.

"I really love Schrafft's ice cream, particularly strawberry. I eat it every day." —Andy Warhol.

Surfing Movie
16mm. Color. Sound. 24FPS. In production, 1968—
With Viva, Taylor Mead, Louis Waldon, Ingrid Superstar, Eric Emerson, Tom Hompertz, Joe Dallesandro.
Most of the film has been shot around La Jolla, Calif.

Selected Bibliography: Painting and Sculpture

ONE-MAN EXHIBITIONS

Los Angeles. Ferus Gallery. 1962.
New York. Stable Gallery. 1962.
Los Angeles. Ferus Gallery. 1963.
Paris, France. Galerie Ileana Sonnabend. 1964.
New York. Stable Gallery. 1964.
New York. Castelli Gallery. 1964.
Turin, Italy. Gian Enzo Sperone Arte Moderna. 1965.
Toronto, Canada. Jerrold Morris International Gallery. 1965.
Paris, France. Galerie Ileana Sonnabend. 1965.
Buenos Aires, Argentina. Galeria Rubbers. 1965.
Stockholm, Sweden. Galerie Buren. 1965.
Philadelphia. Institute of Contemporary Art, University of
 Pennsylvania. 1965.
Turin, Italy. Gian Enzo Sperone Arte Moderna. 1966.
New York. Castelli Gallery. 1966.
Cincinnati, Ohio. The Contemporary Art Center. 1966.
Boston. Institute of Contemporary Art. 1966.
Hamburg, Germany. Galerie Hans R. Nuendorf. 1966.
Paris, France. Galerie Ileana Sonnabend. 1967.
Cologne, Germany. Galerie Rudolf Zwirner. 1967.
London, England. Rowan Gallery. 1968.
Stockholm, Sweden. Moderna Museet. 1968.
Oslo, Norway. Kunstnerneshus. 1968.

SELECTED BOOKS

Amaya, Mario. *Pop Art and After*. New York, The Viking Press, 1965. (cl.ill.) ["Andy Warhol" pp. 102-105; selected bibliography; index.]

Arnason, H. H. *History of Modern Art: Painting, Sculpture, Architecture*. New York, Harry N. Abrams, Inc., 1968. (cl.ill.) [23 parts; bibliography; index; "Art Since Mid-Century" p. 251.]

Battcock, Gregory (ed.). *The New Art*. New York, E. P. Dutton & Co. Inc., 1966. (ill.) ["Andy Warhol" by Samuel Adams Green, pp. 229-234; "Humanism & Reality—Thek and Warhol" by Gregory Battcock, pp. 235-242.]

Calas, Nicholas. *Art in the Age of Risk*. New York, E. P. Dutton & Co. Inc., 1968. (ill.) [Introduction by Gregory Battcock.]

Calvesi, Maurizio. *Le Due Avanguardie dal Futurismo alla Pop Art*. Milan, Lerici Editori, 1966. (not ill.) [Name index; bibliographical notes; Italian text.]

Dienst, Rolf-Gunter. *Pop Art: eine kritische information*. Wiesbaden, Rudolf Bechtold & Co., 1965. [German text; artists' statements; bibliography.]

Herzka, D. *Pop Art One*. New York, Institute of American Art, 1965. (ill.) [Short text; photos of artists.]

Lippard, Lucy (ed.) *Pop Art*. New York, Frederick A. Praeger, 1966. (cl.ill.) [Preface and introduction by L. Lippard; essays by Lawrence Alloway, Nancy Marmer and Nicholas Calas; notes; selected bibliography.]

——————————. *New Art Around the World: Painting & Sculpture*. New York, Harry N. Abrams, Inc., 1966. (cl.ill.) ["United States" by Sam Hunter, pp. 9-58; index.]

Pelligrini, Aldo. *New Tendencies in Art*. New York, Crown Publishing Co., 1966. (ill.)

Rose, Barbara. *American Art Since 1900: A Critical History*. New York, Frederick A. Praeger, 1967. (cl.ill.) [Notes: selected bibliography; index.]

Rose, Barbara. *American Painting: The Twentieth Century*. Cleveland, Ohio, The World Publishing Co., Skira editions, 1969. (cl.ill.) ["The Sixties" pp. 89-116; selected bibliography; index.]

Rublowsky, John. *Pop Art*. New York, Basic Books, 1965. (ill.) [Foreword by Samuel Adams Green; photography by Ken Heyman.]

Russell, John, and Gablik, Suzi. *Pop Art Redefined*. London, Thames and Hudson, 1969. (cl.ill.) [Also catalogue for *Pop Art* at Hayward Gallery, London 1969.]

Warhol, Andy. *a, a novel by Andy Warhol*. New York, Grove Press, Inc., 1968.

Warhol, Andy. *Andy Warhol's Index (Book)*. New York, Random House, undated. (ill.) ["An interview with Andy at the Balloon Farm"; photo and collage elements.]

Warhol, Andy; Konig, Kasper; Hulten, Pontus; Granath, Olle (ed.). *Andy Warhol*. New York, Worldwide Books, 1969 (2nd edition). (ill.) (This book was published on occasion of the Andy Warhol Exhibition at the Moderna Museet in Stockholm February-March 1968.) [Quotations from the artist; English/Swedish text.]

SELECTED PERIODICALS

Alfieri, Bruno. "The Arts Condition—The Arts Future." *Metro* 9:5-13 1965. (ill.)

Antin, David. "Warhol: The Silver Tenement." *Art News* 65/4:47-49; 58-59 Summer 1966. (ill.) [Review of Castelli Gallery exhibition, April 1966.]

Bergin, Paul. "Andy Warhol: The Artist as Machine." *Art Journal* XXVI/4:359-363 Summer 1967. (ill.)

Carroll, Paul. "What's a Warhol?" *Playboy* 16/9:132-134; 140; 278-282 September 1969. (cl.ill.)

Clay, Jean. "Andy Warhol." *Réalités* 259:36-41 1967. (cl.ill.) [French text.]

Coplans, John. "The New Paintings of Common Objects." *Artforum* I/6: 26-29 November 1962. (ill.) [An exhibition assembled by Walter Hopps at the Pasadena Art Museum, September 25-October 19, 1962.]

_____. "Crazy Golden Slippers." *Life* 42:12-13 January 21, 1957. (cl.ill.)

Finch, Christopher. "Warhol Stroke Poussin." *Art & Artists* I/11:8-11 February 1967. (ill.)

Fitzsimmons, James. "Irving Sherman, Andy Warhol." *Arts Digest* 26:19 July 1952.

Fried, Michael. "New York Letter." *Art International* VI/10:54-58 December 1962. (ill.) [Review of Stable Gallery exhibition, 1962.]

Gassiot-Talabot, Gerald. "Lettre de Paris." *Art International* VIII/2: 78-80 March 1964. (ill.) [French text; review of Sonnabend exhibition 1964.]

Geldzahler, Henry. "Andy Warhol." *Art International* VIII/3:34-35 April 1964. (ill.)

Glaser, Bruce. "Oldenburg, Lichtenstein, Warhol: A Discussion." *Artforum* IV/6:20-24 February 1966. (ill.) [Broadcast over radio station WBAI in New York, June 1964; transcript edited for publication, September/October 1965.]

Guest, Barbara. "Clarke, Rager, Warhol." *Art News* 53:75 June 1954.

Guest, Barbara. "Warhol and Sherman." *Art News* 51:47 September 1952.

Hess, Thomas B. "Andy Warhol." *Art News* 63:11 January 1965. (ill.) [Review of Castelli Gallery exhibition, November/December 1964.]

Hopkins, Henry T. "Andy Warhol." *Artforum* I/4:15 September 1962. (ill.) [Review of Ferus Gallery exhibition, 1962.]

Hunter, Sam. "Neorealismo, Assemblage, Pop Art in America." *L'Arte Moderna* XIII/112 1969 (Fratelli Fabbri Editori). (cl.ill.) [Italian text.]

Johnson, Ellen H. "The Image Duplicators—Lichtenstein, Rauschenberg and Warhol." *Canadian Art* XXIII/1:12-19 January 1966. (cl.ill.)

Judd, Don. "Andy Warhol." *Arts* 37:49 January 1963. (ill.) [Review of Stable Gallery exhibition, November 1962.]

Karp, Ivan. "Anti-Sensibility Painting." *Artforum* II/3:26-27 September 1963. (ill.)

Kenedy, R. C. "Paris." *Art International* XI/8:66-69 October 1967. [Review of Sonnabend exhibition, May 1967.]

Leider, Philip. "Saint Andy: Some Notes on an artist who, for a large section of a younger generation, can do no wrong." *Artforum* III/5:26-28 February 1965. (ill.)

Malanga, Gerard. "Andy Warhol: Interviewed by Gerard Malanga." *Kulchur* 4/16:37-39 Winter 1964-65.

Moritz, Charles (ed.). "Warhol, Andy." *Current Biography* 29/2:39-42 February 1968.

Nordland, Gerald. "Marcel Duchamp and Common Object Art." *Art International* VIII/1:30-32 February 1964. (ill.)

Plagens, Peter. "Present-Day Styles and Ready-Made Criticism." *Artforum* V/4:36-39 December 1966. (ill.)

Rockman, Arnold. "Superman Comes to the Art Gallery." *Canadian Art* XXI/1:18-22 January/February 1964. (ill.)

Rose, Barbara. "ABC Art." *Art in America* 53/5:57-69 October/November 1965. (ill.)

Rose, Barbara. "Pop Art at the Guggenheim." *Art International* VII/5:20-22 May 1963. N.B. (ill.) [Review of *Six Painters and the Object*.]

Rose, Barbara. "The Value of Didactic Art." *Artforum* V/8:32-36 April 1967. (ill.)

Rosenblum, Robert. "Pop and Non-Pop: An Essay in Distinction." *Canadian Art* XXIII/1:50-54 January 1966. (ill.) [Reprinted from *Art and Literature* 5:80-93 Summer 1965.]

_____. "Saint Andrew." *Newsweek* 64:100-104 December 7, 1964. (ill.)

Sandberg, John. "Some Traditional Aspects of Pop Art." *Art Journal* XXVI/3:228-233;245 Spring 1967. (ill.)

Sandler, Irving Hershel. "New York Letter." *Quadrum* 14:115-124 1963. (ill.)

Sandler, Irving Hershel. "The New Cool Art." *Art in America* 53/1:99-101 February 1965.

Scott, Zachary. "New Talent U.S.A.—Prints and Drawings." *Art in America* 50/1:40-43 1962 (ill.) [Statement by the artist, p.42.]

Seckler, D. G. "Folklore of the Banal." *Art in America* 50/4:60 Winter 1962. (ill.)

Selz, Peter. "A Symposium on Pop Art." *Arts* 39:36-45 April 1963. (ill.)

Solomon, Alan. "The New American Art." *Art International* VIII/2:50-55 March 1964. (ill.).

Sorrentino, Gilbert. "Kitsch into Art: The New Realism." *Kulchur* II/8:10 Winter 1962.

Swenson, G. R. "Andy Warhol." *Art News* 61:15 November 1962. (ill.)

Swenson, G. R. "The New American 'Sign Painters.'" *Art News* 61:44-47; 60-62 September 1962. (ill.)

Swenson, G. R. "What is Pop Art?" *Art News* 62:24-27;60-63 November 1963. (ill.)

Tillim, Sidney. "Andy Warhol." *Arts* 38:62 September 1964.

Tyler, Parker. "Andy Warhol." *Art News* 55:59 December 1956. [Review of Bodley Gallery drawing exhibition, December 1956.]

Vance, Ronald. "Andy Warhol." *Art News* 55:55 March 1956.

von Meier, Kurt. "Los Angeles Letter." *Art International* X/8:43-45 October 1966.

Wilson, William. "'The Prince of Boredom': The Repetitions and Passivities of Andy Warhol." *Art and Artists* 2/12:12-15 March 1968. (ill.)

SELECTED EXHIBITION CATALOGUES

Amsterdam, Netherlands. Stedelijk Museum. *American Pop Art.* June 22-July 26, 1964. ["De Nieuwe Amerikaanse Kunst" by Alan R. Solomon, reprinted from *Art International* VIII/2:50-55 March 1964.]

Berlin, Germany. Akademie der Kunst. *Neue Realisten und Pop Art.* November 20, 1964-January 3, 1965. (ill.) [Essay by Werner Hofmann; brief bibliography; definition of terms.]

Berlin, Germany. Kunstverein. *Sammlung 1968 Karl Ströher.* March 1-April 14, 1969. (cl.ill.) [German text; "Die offene Sammlung" by Hans Strelow; traveled.]

Boston, Institute of Contemporary Art. *Andy Warhol.* October 1-November 6, 1966. (ill.) [Introduction by Alan Solomon; notes on Warhol's silk-screen technique; selected bibliography.]

Brussels, Belgium. Palais des Beaux-Arts. *Pop Art, Nouveau Realisme, Etc.* March 1965. (ill.) [French text; preface in five parts by Jean Dypréau; essay by Pierre Restany; brief biographical sketches.]

Buenos Aires, Argentina. Galeria Rubbers. *Andy Warhol.* July 29-August 14, 1965. (ill.) [English/Spanish texts; essay by Jorge Romero Brest; photograph of the artist.]

Buffalo, New York. Albright-Knox Art Gallery. *Mixed Media and Pop Art.* November 19-December 15, 1963. (ill.) [Foreword by Gordon Smith.]

Cincinnati, Ohio. The Contemporary Arts Center. *An American Viewpoint, 1963.* December 4-21, 1963.

Detroit, Michigan. The Detroit Institute of Arts. *Form, Color, Image.* April 11-May 21, 1967. (ill.) [Preface by W. Hawkins Ferry; introduction by Gene Baro.]

Frankfurt, Germany. Frankfurter Kunstverein. *Kompas III, New York.* December 30, 1967-February 11, 1968. (cl.ill.) [English/German texts; preface by Jean Leering and Paul Wember; text by J. Leering; brief biographies and list of exhibitions.]

Helsinki, Finland. The Art Museum of Ateneum. *Ars 69 Helsinki.* March 8-April 13, 1968. (cl.ill.) [Finnish/English texts; foreword by Aune lindstrom; "Current Trends in Fine Art" by Salme Sarajas-Korte; traveled.]

Houston, Texas. Contemporary Art Museum. *Pop Goes! The Easel.* April 1963. (ill.) [Catalogue essay and exhibition by Douglas MacAgy.]

Houston, Texas. Institute for the Arts, Rice University. *Raid the Icebox 1 with Andy Warhol.* October 29, 1969-January 4, 1970. (ill.) [Foreword by Dominique de Menil; "Confessions of a Museum Director" by Daniel Robbins; "Andy's Dish" by David Bourdon; traveling.]

Huntington, New York. Hecksher Museum. *Pop, Pop, Whence Pop?* February 27-March 21, 1965. (ill.)

Irvine, California. University of California Art Galleries. *The Second Breakthrough 1959-1964.* March 18-April 27, 1969. (ill.) [Essay by Alan Solomon.]

Kansas City, Missouri. Nelson Gallery, Atkins Museum. *Popular Art.* April 28-May 26, 1963. (ill.) [Essay by Ralph T. Coe; brief biographies.]

Kassel, Germany. Museum Fridericianum/Orangerie. *Documenta IV: International Exhibition.* June 27-October 6, 1968. (cl.ill.) [German text; essays by Arnold Bode, Max Lindahl, J. Leering; list of one-man and group exhibitions.]

London, England. Hayward Gallery. *Pop Art.* July 3-August 30, 1969. (cl.ill.) [Book/catalogue, *Pop Art Redefined*: dual introductions; comparative chronology, U.S.A./England; critical statements by L. Alloway, John McHale and Robert Rosenblum; statements by the artists; index; brief biographies.]

London, England. Institute of Contemporary Art. *The Obsessive Image 1960-1968.* April 10-May 29, 1968. (cl.ill.) [Forewords by Roland Penrose and Robert Melville; exhibition and essay by Mario Amaya; brief biographies.]

London, England. Institute of Contemporary Art. *The Popular Image.* October 24-November 23, 1963. (ill.) [Essay by Alan Solomon; brief biographies.]

Los Angeles. Dwan Gallery. *Boxes.* February 2-29, 1964. (ill.) [Acknowledgment by John Weber; text by Walter Hopps.]

Los Angeles. Dwan Gallery. *My Country 'Tis of Thee.* November 18-December 15, 1962. (ill.). [Essay by Gerald Nordland.]

Middletown, Connecticut. Davison Art Center, Wesleyan University. *The New Art.* March 1-22, 1964. (ill.) [Exhibition by Samuel Adams Green; essay by Lawrence Alloway; brief statements by the artists.]

Milwaukee, Wisconsin. Milwaukee Art Center. *Directions 1: Options.* June 22-August 11, 1963. (ill.) [Essay by Lawrence Alloway; artists' statements; biographies; traveled.]

Milwaukee, Wisconsin. Milwaukee Art Center. *Pop Art and the American Tradition.* April 9-May 9, 1965. (ill.) [Text by Tracy Atkinson.]

Montreal, Canada. The United States Pavilion-EXPO '67. *American Painting Now.* April 28-October 27, 1967. (cl.ill.) Boston. Horticultural Hall, December 15, 1967-January 10, 1968. [Essay, "The Americans at EXPO '67" by Alan Solomon; photographs of the artists; brief biographies.]

New York. Leo Castelli Gallery. *Poem Visuals — The New Realism, Yeah Yeah, Fashion, and Disaster Series by Andy Warhol and Gerard Malanga.* (cl.ill.) [December 16, 1964, reading; introduction by Ivan Karp.]

New York. Finch College Museum of Art. *The Dominant Woman.* December 13-January 26, 1969. (ill.) [Foreword by Elayne H. Varian; "The Dominant Woman" by Walter Gutman; brief biographies.]

New York. The Solomon R. Guggenheim Museum. *Six Painters and the Object.* March 14-June 12, 1963. (ill.) [Essay and exhibition by Lawrence Alloway; selected bibliography, general and individual.]

New York. Sidney Janis Gallery. *Homage to Marilyn Monroe.* December 6-December 30, 1967. (ill.)

New York. Sidney Janis Gallery. *New Realists.* October 31-December 1, 1962. (ill.) [Essays by John Ashbery, Pierre Restany and Sidney Janis.]

New York. The Metropolitan Museum of Art. *New York Painting and Sculpture: 1940-1970.* October 16, 1969-February 8, 1970. (cl.ill.) Exhibition and catalogue/book by Henry Geldzahler. New York, E.P. Dutton & Co. Inc., 1969. [Essays by Henry Geldzahler, Harold Rosenburg, Robert Rosenblum, Clement Greenberg, William Rubin and Michael Fried; biographical data; selected bibliography by artist; index.]

New York. Museum of Modern Art, New York, International Council. *Two Decades of American Painting.* (cl.ill.) [Catalogue essays by Waldo Rasmussen, Irving Sandler and Lucy Lippard; traveled in Asia and South Pacific.]

New York. The Whitney Museum of American Art. *1967 Annual Exhibition of Contemporary American Painting.* December 13, 1967-February 4, 1968. (ill.)

Oakland, California. Oakland Art Museum. *Pop Art U.S.A.* September 7-29 1963 (cl.ill.) [Essay by John Coplans; brief

biographies.]

Oslo, Norway. Kunstnerneshus. *Andy Warhol*. November 23-December 15, 1968. (ill.) [Norwegian text by Morten Krohg; statement by the artist, English/Norwegian; photograph of the artist; list of one-man and group exhibitions.]

Paris, France. Galerie Ileana Sonnabend. *Warhol*. January-February 1964. (ill.) [French text; essays by Jean-Jacques Lebel, Alain Jouffroy and John Ashbery; brief biography and bibliography.]

Pasadena, California. Pasadena Art Museum. *Painting in New York: 1944-1969*. November 24, 1969-January 11, 1970. (cl.ill.) [Catalogue essay by Alan Solomon; bibliography.]

Pasadena, California. Pasadena Art Museum. *Serial Imagery*. September 17-October 27, 1968. (cl.ill.) [Catalogue essay by John Coplans; bibliography; traveled.]

Philadelphia. Institute of Contemporary Art, University of Pennsylvania. *Andy Warhol*. October 8-November 21, 1965. (cl.ill.) [Essay by Samuel Adams Green.]

Philadelphia. Institute of Contemporary Art, University of Pennsylvania. *The Atmosphere of '64*. April 17-June 1, 1964. (ill.) [Statement by Ti-Grace Sharpless.]

Philadelphia. Institute of Contemporary Art, University of Pennsylvania. *The Other Tradition*. January 27-March 7, 1966. (ill.) [Text by G. R. Swenson; selected bibliography.]

Philadelphia. Arts Council YM/YWHA. *Air Art*. March 13-31, 1968. (ill.) [Essay by Willoughby Sharp; photos of the artist; brief biography and bibliography; traveled.]

Philadelphia. Arts Council YM/YWHA. *Art 1963—A New Vocabulary*. October 25-November 7, 1962. (ill.) [Catalogue edited by Anice Kandell; contributions by B. Kluver, Oldenburg, Rauschenberg, Tinguely and others; brief biographies; list of group exhibitions.]

Providence, Rhode Island. Rhode Island School of Design. *Recent Still Life*. February 22-April 4, 1966. (ill.) [Introduction by Daniel Robbins; brief biographies.]

São Paulo, Brazil. Museu de Arte Moderna. *São Paulo 9: United States of America 1967*. (cl.ill.) (Published for the National Collection of Fine Arts by the Smithsonian Institution Press, Washington, D.C.) [Portuguese/English texts; essays by Brian O'Doherty, Lloyd Goodrich and William C. Seitz; biographies; statements by the artists; extensive bibliography and list of exhibitions.]

Stockholm, Sweden. Moderna Museet. *Amerikanst Pop-Konst*. February 29-April 12, 1964. (ill.) [Foreword by K. G. Hultén; Swedish text, by Alan Solomon, reprinted from catalogue of Stedelijk Museum, Amsterdam, *American Pop Art*; English bibliography; traveled to Louisiana Museum, Denmark.]

Tokyo, Japan. The National Museum of Modern Art. *Contemporary Art—Dialogue Between the East and the West*. June 12-August 17, 1969. (cl.ill.) [Japanese/English texts; introduction by Masayoshi Homma; biographies in Japanese.]

Turin, Italy. Gian Enzo Sperone Arte Moderna. *Warhol*. February 1965. (ill.) [Italian text by Luigi Carluccio; list of one-man and group exhibitions.]

The Hague, Netherlands. Haags l'Aja Gemeente Museum. *Nieuwe Realisten*. June 24-August 30, 1964. (ill.) [Catalogue in newspaper format; Dutch text by L. J. F. Wijsenbeek; essays by Jasia Reichardt, Pierre Restany and W. A. L. Beeren; bibliography; biographies.]

Vancouver, Canada. Vancouver Art Gallery. *New York 13*. January 21-February 19, 1969. (cl.ill.) [Catalogue text by Lucy Lippard; introduction by Doris Shadbolt; bibliography; photographs of the artists; traveled.]

Vienna, Austria. Museum des 20 Jahrhunderts. *Pop Etc*. September 19-October 31, 1964. (ill.) [German; foreword and text by Werner Hofmann; essay by Otto A. Graf; brief bibliography, biographies; quotations and documentation.]

Washington, D.C. Washington Gallery of Modern Art. *The Popular Image Exhibition*. April 18-June 2, 1963. (ill.) [Essay, "The New Art" by Alan Solomon.]

Worcester, Massachusetts. Worcester Art Museum. *The New American Realism*. February 18-April 4, 1965. (ill.) [Statements by the artists.]